KEITH CROWN WATERCOLORS

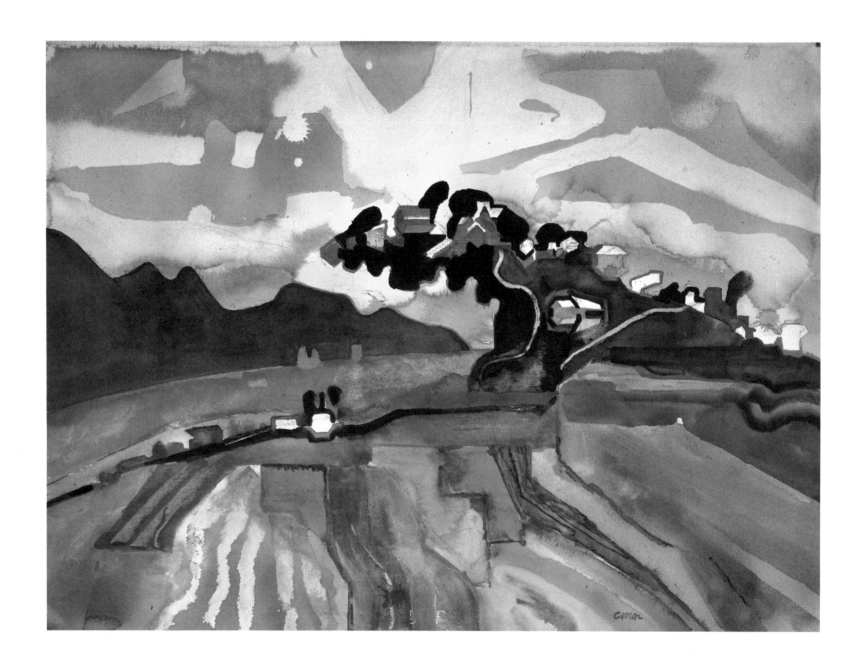

KEITH CROWN
WATERCOLORS

SHELDON REICH

UNIVERSITY OF MISSOURI PRESS
Columbia, 1986

Copyright © 1986 by
The Curators of the University of Missouri
University of Missouri Press, Columbia, Missouri 65211
Printed and bound in Japan

Library of Congress Cataloging-in-Publication Data

Reich, Sheldon.
Keith Crown watercolors.
Bibliography: p.
Includes index.
1. Crown, Keith. 2. Watercolorists—United
States—
Biography. I. Crown, Keith. II. Title.
ND1839.C78R45 1986 759.13 86–6955
ISBN 0-8262-0606-9

This book has been brought to publication with
financial assistance from the Mt. Lake Consortium
of the Virginia Tech Association.

Illustration, p. 1. *Taos Pueblo II*, 1977, watercolor, 30 × 22.
Collection of Edzard Baumann, Columbia, Mo.

Illustration, p. 2. *Llano Quemado near Taos*, 1984,
watercolor, 22 × 30.

Illustration, facing page. *Talpa, near Taos*, 1982,
watercolor, 30 × 22.

TO MY LATE AUNT, BERTHA GUBMAN

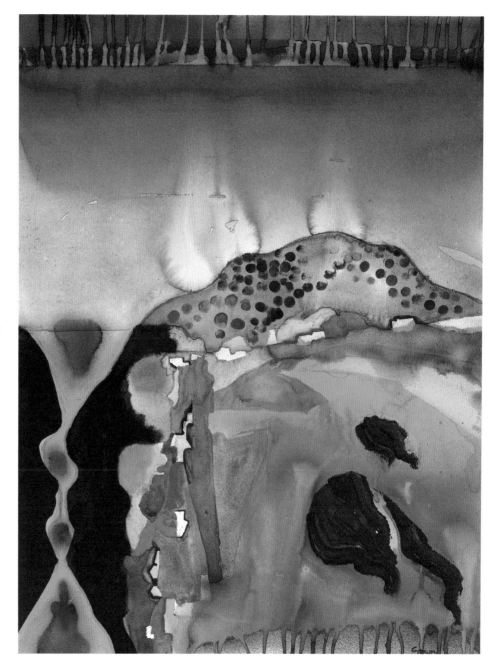

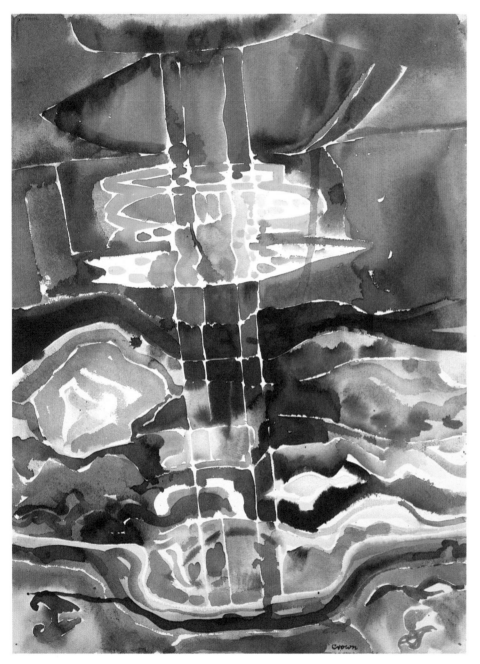

4. *Sea and White Line Symbol*, 1964, watercolor, 30 × 22. Collection of Constance Perkins, Pasadena, Calif. Photograph by Claire Henze, 1986.

Contents

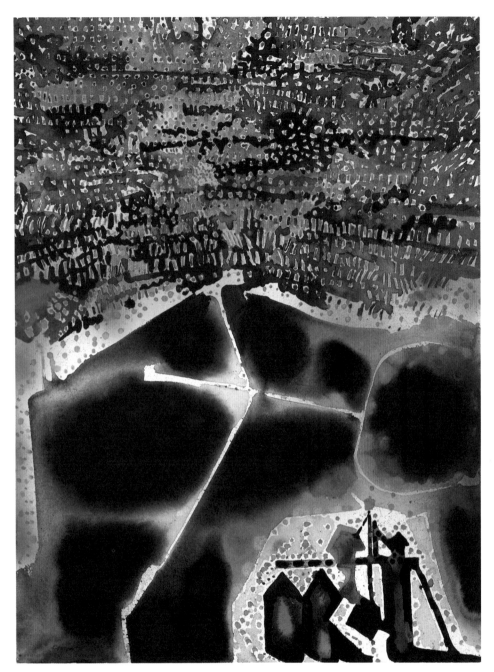

5. *Soybean Field with Grain Elevator, III*, 1971, watercolor,
30 × 22. The Phillips Collection, Washington, D.C.

Foreword

By Ray Kass

In the late 1960s, a year or so after I had formally studied with him in Chapel Hill, I visited Keith Crown in Taos. While there, I took advantage of an invitation to paint outdoors with him, as we had often done in North Carolina. We drove around just gazing at scenery until Keith thought we had arrived at an inviting place; then we investigated the area on foot in search of a good spot to paint. Everything seems spectacular in the New Mexico mountains, even the viewless backsides of the steep gulches, but what deeply impressed me was how Keith's implicit criteria for a "good place" to make a painting did not require a spectacular view or a picturesque subject. He seemed to respond most to varieties of subtle shapes and textures as well as to the movements and sounds of a particular place. Often he would lay small stones or bits of dried shrubbery on his watercolor paper and trace them with his loaded brush, or he would draw with twigs or a stick that he'd dipped in color. His activity appeared very site-specific to me both in terms of the manner in which he developed his work and in terms of the feeling conveyed by the beautiful abstracted paintings that often resulted.

Keith usually drew for a while before getting started, and then would paint steadily, sometimes completing several works in a day. He concentrated intently on the character of the desert and mountains, changing their features into personal marks or symbols without losing a sense of the place, as if he were truly participating in nature at some depth beyond superficial appearance. I found myself pulled along in my own painting by the energy of his presence at work and also, as Keith had often pointed out to his students, by the extraordinary variety of stimulation in the natural environment.

Later that same year, on a visit to Willem de Kooning's studio on Long Island, I told him about Keith and my experiences painting outdoors. With evident fascination, he mused that he would be "scared" to paint outside in the midst of so much space, but he acknowledged that the space of the West was extremely compelling. The idea that one could "like" a space that was so intimidating appealed to me. We agreed that abstraction was a natural way for a painter to deal with a subject on such a scale.

As a landscape artist or, more aptly, as an artist whose abstract works convey his sense of the environment, Keith's works span an important interval in the evolution of American modernism, an interval that extends from the pioneering works of the post-Cubists, who invented new images of the American landscape, to the transcendent works of the Abstract Expressionists, whose philosophically oriented and dramatic paintings provide a new context in which to imagine both the natural and the human-made environment. The open vista of the Pacific and the spacious landscapes of the plains and the western mountains inspired him ultimately to reject conventional pictorialism in favor of a more independent and existential approach to painting in which the nature of the subject evolves as a commentary of personal gestures. His best works seem to have been allowed to paint themselves while simultaneously implying the subjective intimacy of a diary-like relationship between the artist and his work.

Keith has always been interested in exploring the inherent nature of watercolor paint, inventing ways to use the paint for its own beautiful effect. The intrinsic qualities of water media so readily lend themselves to envisioning the changing masks of

nature that it is not uncommon for an admiring spectator of Crown's paintings to sense the weight of the world in a small, pigment-soaked patch of paper.

I believe that Keith's contribution to art has been to extend an as yet inadequately documented phenomena of artistic development that may be defined as partaking in the recent tradition of American modernism. Like the work of his predecessors, Winslow Homer and John Marin, Keith Crown's watercolors, in particular, represent a personally insightful experience of the natural world, a world that he has described in the visual terms of a unique, mature style that is his own successful idiom. Also, I believe that he has achieved an exemplary fulfillment of one of modernism's implicit promises: the potential of an individual to work adjacent to but outside the mainstream in order to invent an authentic sense of self that is based in art and from which art may proceed. His strong identity as an artist was sustained by the imaginative dialogue with the landscape that was the basis of his work.

In this sense, I have long felt that the outdoor environment was an especially auspicious choice of subject matter for Keith, because it encouraged him to progress as an artist while working in relative isolation from major art centers in New York and Europe.

Circumstances of time, place, and, importantly, a shy personality have denied Keith the support of a circle of equally committed artists, critics, or dealers. The few and intermittent significant "groups" of artists working in the Los Angeles area during Keith's years were generally oriented toward the more European-influenced modernism of Rico Lebrun or the conceptual and formal aesthetics represented in important galleries in New York at the time. In either case, Keith's unique involvement with the landscape and commitment to watercolor as a major painting media certainly would have seemed less relevant—even *retardataire*—to those involved in the mainstream concerns of contemporary art than those qualities may appear now that he has developed a personal statement that represents a lifetime of work.

As a teacher, Keith has quietly but profoundly changed people who have come into contact with him. He provided a good model because he was a serious artist and was a good teacher because he was a well-informed humanist who related art to life by giving both a philosophical respect and attention. Keith's teaching career concurred with the rapid expansion of university art departments in which serious artists found liberal teaching schedules a form of much-needed patronage. For him, teaching was a marginally inconvenient but practical means of earning a living, and nevertheless one for which his uncompromising temperament was an important asset. By painting with his students on many occasions, he taught us in the manner of an "artist in residence," demonstrating a true sense of artistic authenticity. We were directed to take the problems of self-motivation and technical development upon ourselves. When it came to critiquing our work, however, whether in a group or individually, Keith's self-critical and demanding spirit really was shared with us, and his own love of painting gave us insight into the countless possibilities of the inventive nature of art.

Much of Keith Crown's career as an artist has occurred outside the "mainstream" of an art world that emerged in America with Crown's own generation. Sheldon Reich's valuable and conscientiously attended text shows that Crown is an artist of uncommon quality who shared deeply in modernism's spirit of freedom from the authority of tradition. I think it is significant that Keith has always admired those early American modernists whose work exemplified an independent spirit—Arthur Dove, Georgia O'Keeffe, and John Marin. Perhaps even more so than they, he has pursued the exploration of a solitary but successful path in art.

Preface

Keith Crown is one of this country's most distinguished and respected artists. He has gained special recognition as a leading practitioner of watercolor painting. Crown is from the heartland of America—born in Iowa, raised in Indiana, schooled as an artist in Illinois. From the end of World War II until 1983 he worked in Los Angeles, training other artists there while on the faculty of the University of Southern California and making the city itself his chief subject.

While Crown must be acknowledged as primarily a West Coast artist, he has traveled widely in this country and painted on his journeys to places that have become important for his art—Illinois, New Mexico, Missouri, and Kansas. Married to Patricia Crown, a historian of English art, he has often visited England and from there toured other countries. Yet it was England alone that he painted.

The goal of this book is to chronicle Keith Crown's artistic development from boyhood in Indiana to mid-1985. Biography is not the intention of this book, although the artist has lived a rich and varied life. Only when events in his life have directly influenced his work are they included. However, a full chronology is appended to this volume.

At this writing, Keith Crown is sixty-seven years old and in good health. No book can claim to be a definitive study if the artist is still working. It is my hope that this book will provide the essential base for future scholarship. That probability is reinforced by the fact that this study consists entirely of primary material.

Even though Crown is thought of primarily as a watercolorist, his earlier works in oil, casein, and acrylic cannot be ignored. Regardless of its medium, if a work illuminates his artistic growth, it is treated in this book.

Much of the book is made up of taped interviews with the artist, letters, and Crown's own suggestions and corrections of early drafts. I have tried to adjust the material into written form without impinging on its authenticity.

A Note on the Art

All paintings for which no ownership is designated are in the collection of the artist. In the dimensions, height precedes width.

Acknowledgments

The people who played significant roles at the start of this effort are Dr. Shirley Gish, who first suggested this book be undertaken, and Ray Kass, artist and art writer, was most helpful during the later stages of this volume. In addition to writing the Foreword, Kass, a former student of Crown's, provided invaluable assistance in acquiring additional funding.

Most of the credit belongs to the artist himself, who functioned as a collaborator rather than purely a resource. Crown put up with three years of taping interviews in addition to going through the transcripts of those interviews to clarify and elaborate on important points. The generous contribution of his time and effort was made at the sacrifice of many watercolors that were never created. Finally, he willingly allowed me to hold over one hundred of his best paintings so that during the writing of this text I could confront the actual work.

Sheldon Reich
Tucson, Arizona

March 1986

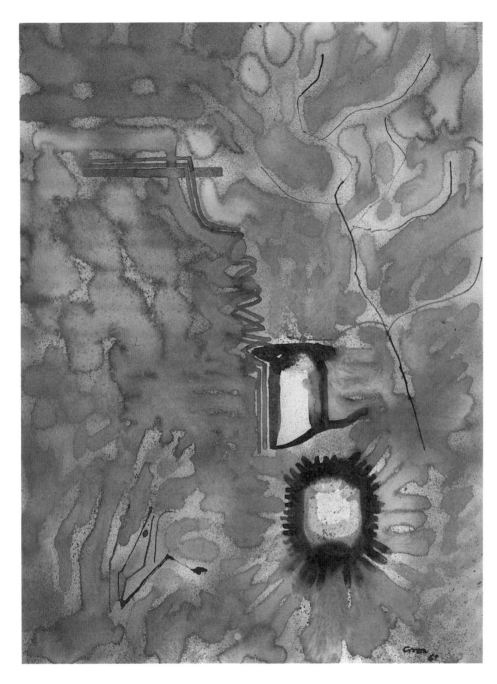

6. *Sunset and Sea from Palos Verdes Hills*, 1969, watercolor, 30 × 22. Collection of Ray Kass, Blacksburg, Va.

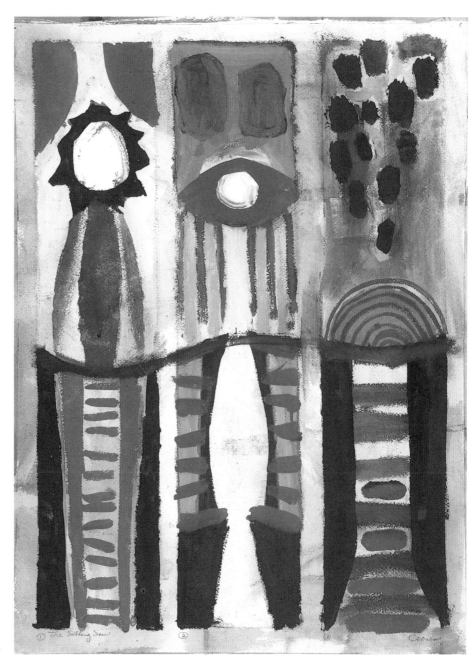

7. *Serial Painting—Sunsets on Sea*, 1949, casein, 28 × 20.

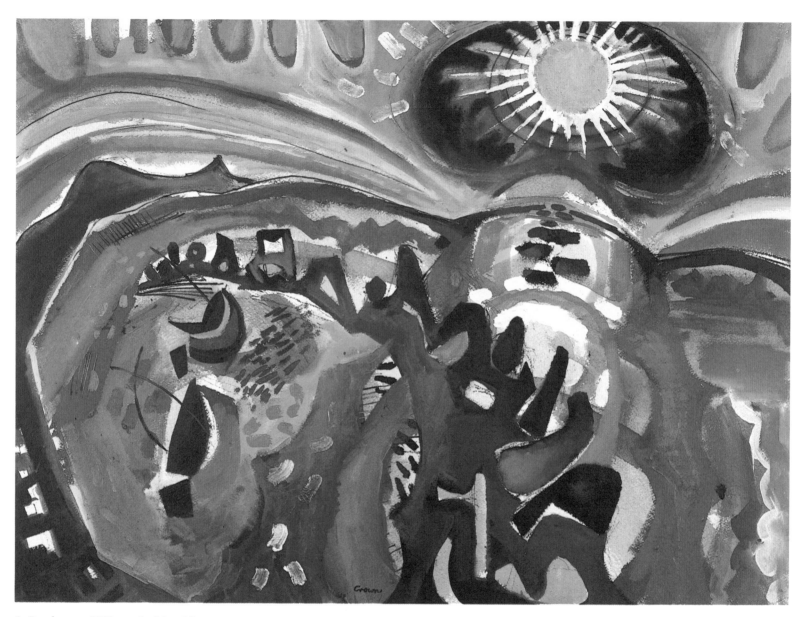

8. *Breakwater*, 1952, casein, 20 × 28.

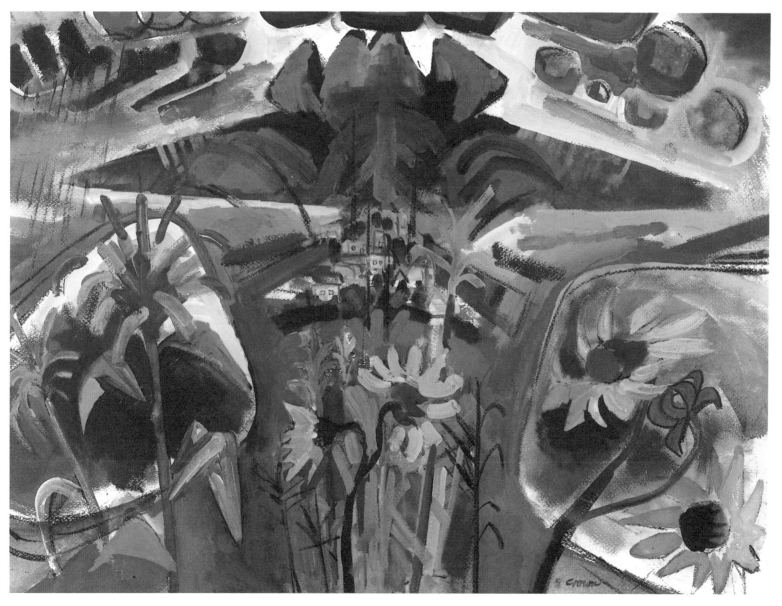

9. *Taos Landscape*, 1957, casein, 20 × 28. Collection of Barbara and Manuel Morris, Bethesda, Md.

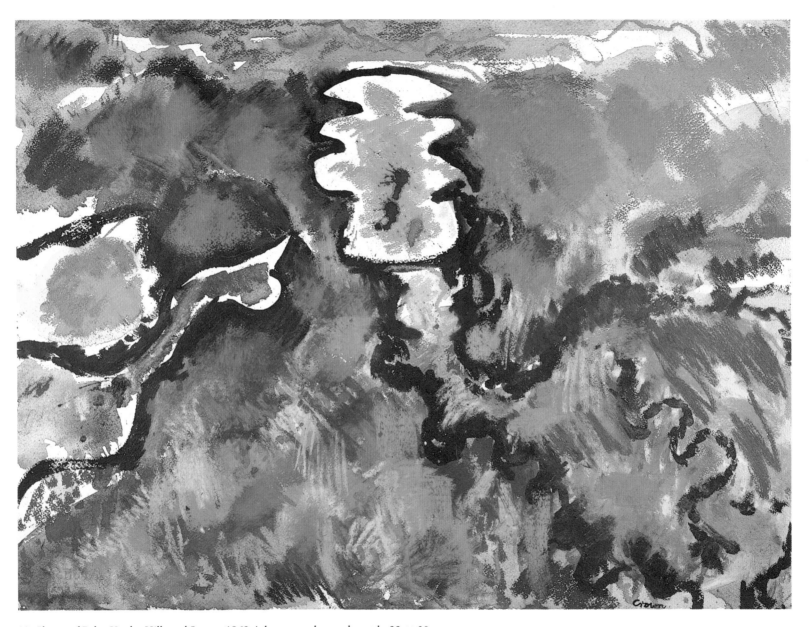

10. *Slopes of Palos Verdes Hills and Sunset*, 1962, ink, watercolor, and pastel, 22 × 30.

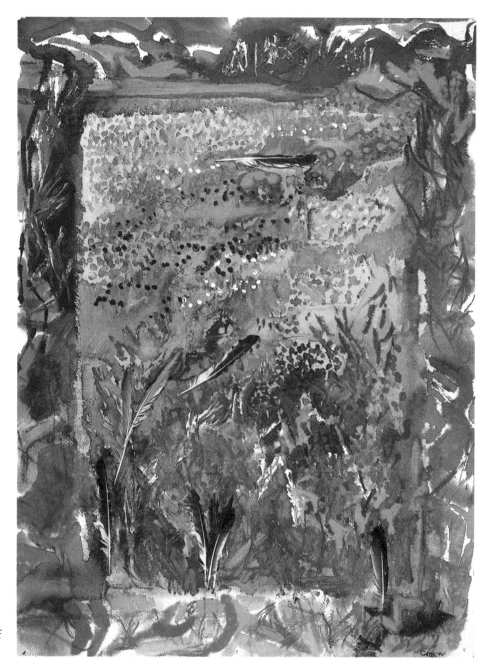

11. *Above Williamstown, Massachusetts, with Feathers*, 1964,
acrylic, pastel, watercolor, and feathers, 30 × 22. Collection of
Paul Kennedy, Oakland, Calif.

12. *White Line—Manhattan Beach Pier and Sun*, 1966, watercolor, 30 × 22. Collection of Haine Crown Gresser, Kensington, Md.

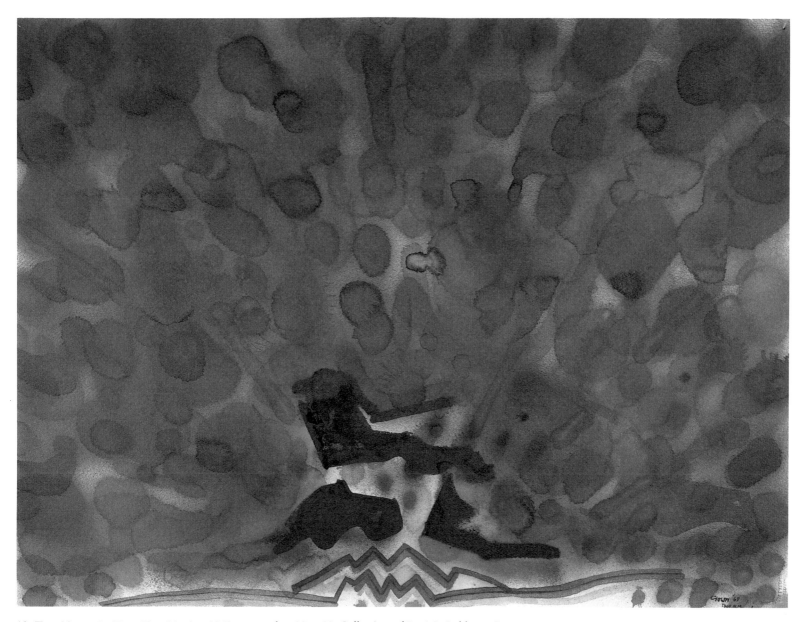

13. *Taos Mountain, Taos, New Mexico*, 1969, watercolor, 22 × 30. Collection of Patricia Dahlman Crown.

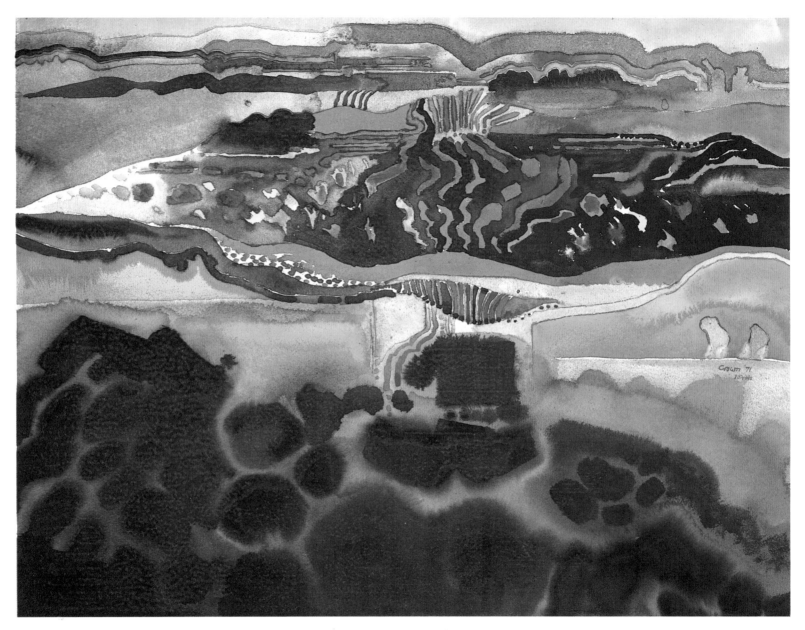

14. *Illinois*, 1971, watercolor, 22 × 30. The E. Gene Crain Collection, Laguna Beach, California.

15. *Taos Pueblo*, 1972, watercolor, 30 × 21⅝. The E. Gene
Crain Collection, Laguna Beach, California.

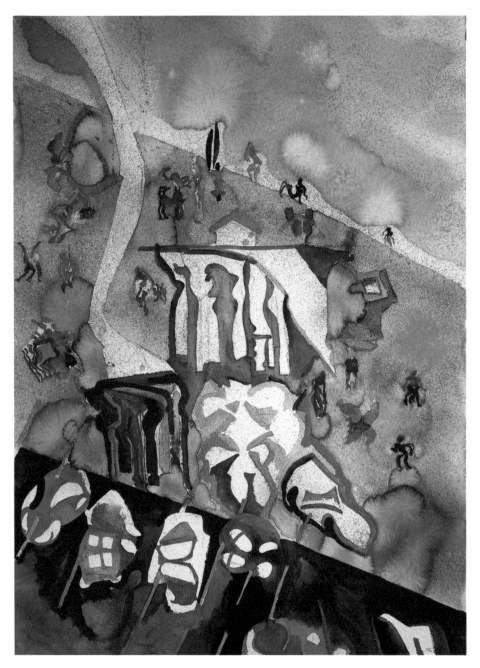

16. *Cars, Palms, Pier and Ocean*, 1976, watercolor, 30 × 22.
Collection of Katie Crown Webster, Phoenix, Ariz.

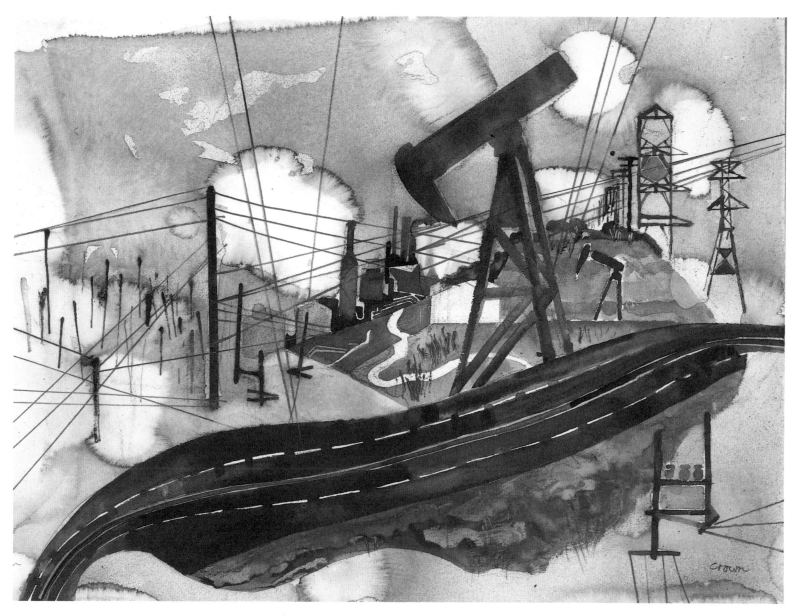

17. *Baldwin Hills, Los Angeles*, 1980, watercolor, 22 × 30.

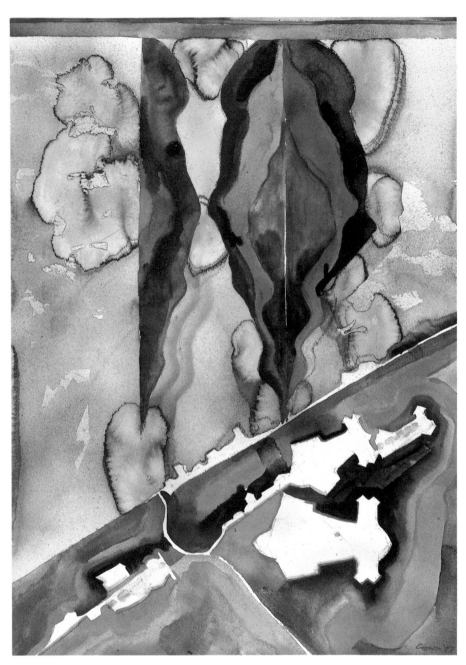

18. *The Sangre de Cristo Mountains and Ranchos de Taos,*
1977, watercolor, 30 × 22.

 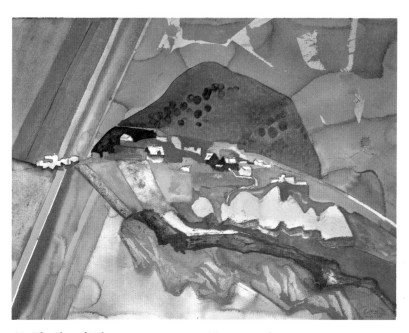

19. *The Flag of Talpa, New Mexico*, 1984, watercolor, 22 × 30.

20. *The Flag of Talpa, New Mexico, II*, 1984, watercolor, 22 × 30. Collection of Patricia Crown (daughter).

25

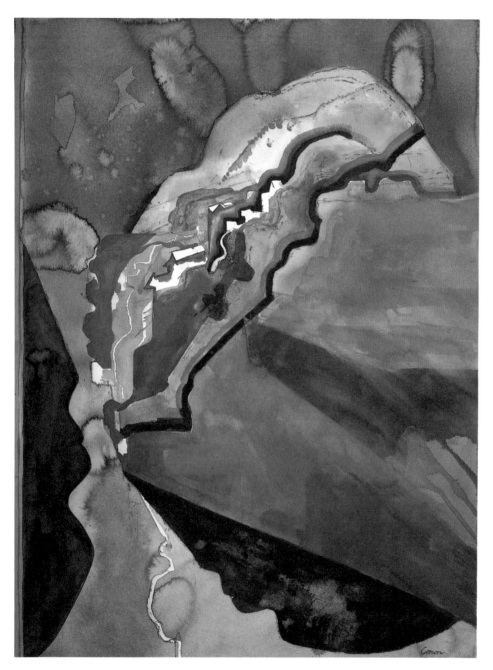

21. *Talpa, New Mexico*, 1984, watercolor, 30 × 22.
Collection of Haine Crown Gresser, Kensington, Md.

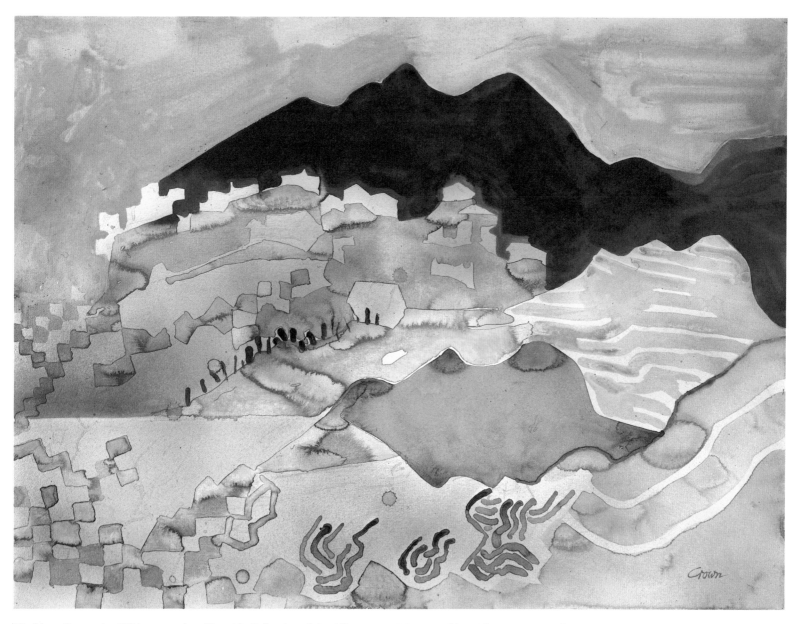

22. *Llano Quemado*, 1984, watercolor, 22 × 30. Collection of the Albuquerque Museum of Art, Albuquerque, N.M.

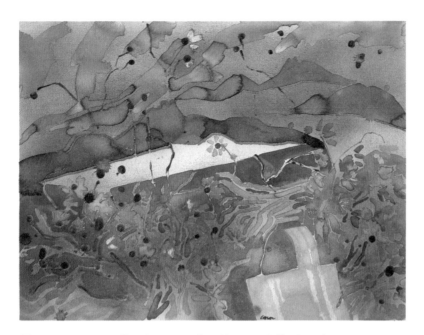

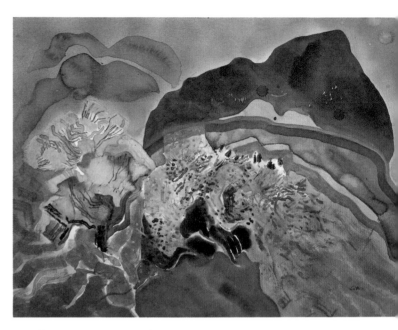

23. *Tres Orejas in Fall*, 1984, watercolor, 22 × 30. Collection of
Sheldon Reich, Tucson, Ariz.

24. *Chamisa*, 1984, watercolor, 22 × 30.

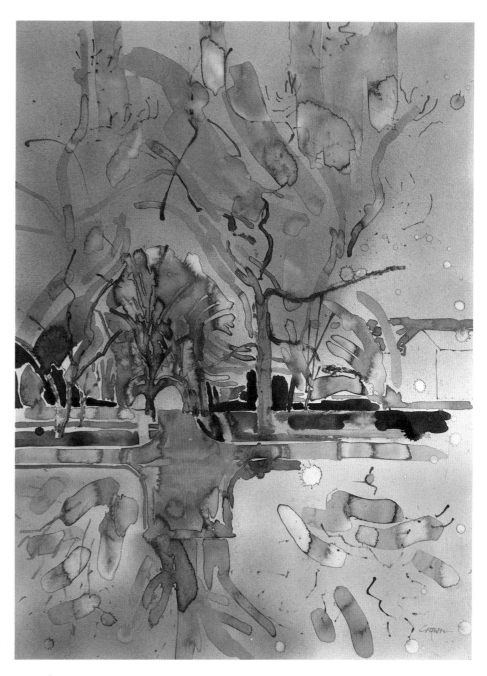

25. *Edgewood Avenue, Columbia, Missouri,*
1984, watercolor, 30 × 22.

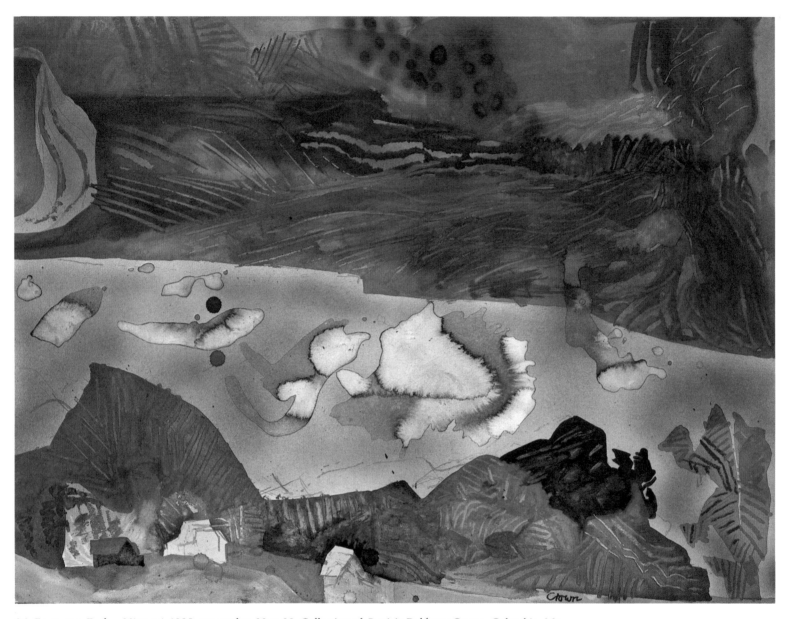

26. *Farm near Easley, Missouri*, 1985, watercolor, 22 × 30. Collection of Patricia Dahlman Crown, Columbia, Mo.

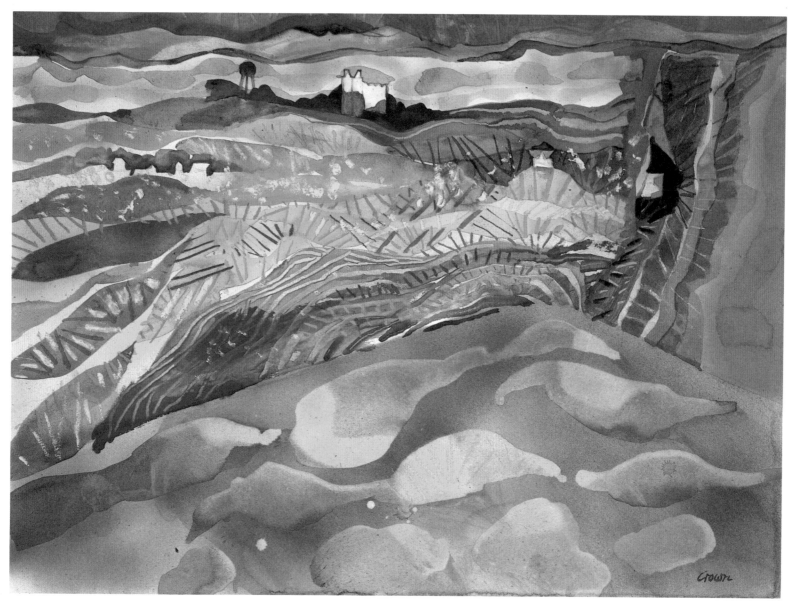

27. *Lindsborg, Kansas, from Coronado Heights*, 1985, watercolor, 22 × 30. Collection of Patricia Dahlman Crown, Columbia, Mo.

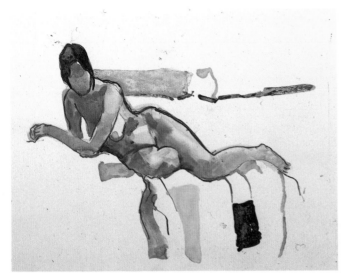

28. Sketchbook drawing of model, 1984, watercolor and pencil, 11 × 14.

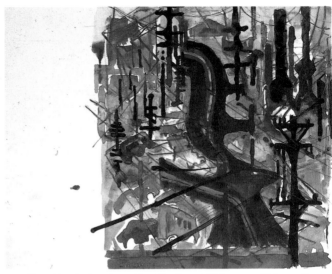

29. Sketchbook drawing of Pacific Coast Highway at El Segundo Standard Oil Refinery, ca. 1982, watercolor and pencil, 11 × 14.

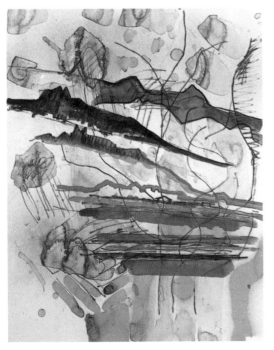

30. Sketchbook drawing of Tres Orejas in surrounding environment, 1984, watercolor and pencil, 14 × 11.

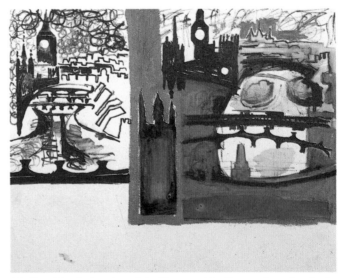

31. Sketchbook drawing of the Houses of Parliament from Lambeth Bridge, 1980, watercolor, pencil, and metallic crayon, 11 × 14.

32

1. The Early Years

Keith Crown's watercolor *Soybean Field with Grain Elevator, III*, 1971 (Fig. 5), was painted outdoors when the weather was so cold that the water froze on the paper. One of the things that caught his eye at that particular place was the gray of the field: the cigar-ash color of the ground with its stubble left standing after the harvest.[1] The land is very flat in that part of Illinois. He found as he stood at the foot of the field that the gray earth appeared to end abruptly. It seemed to him that if you stepped beyond the far boundary of the field you would find yourself at the very edge of the world. To capture this sensation he painted right to the upper border of the paper so that the top edge of the paper became the horizon line. In this manner he transmitted the feeling of sudden termination.

Crown had been drawn to the landscape by the color of the field and the presence of a grain elevator. The shape of the elevator and its placement in the scene were necessary if he was to realize the full potential of the place. His solution was deceptively simple: create another horizon at the base of the composition and silhouette the grain elevator against its own sky. To provide a visual transition between the two horizons, he used a stick, creating the rhythm of the choppy field with dashlike strokes. Crown brought into existence a work of art that remained faithful to the idea of a particular locale, but not to its ordinary appearance. Thus, for Crown, art reflects the appearance of nature, the feeling aroused in the artist by the landscape, and the combining of these experiences into an abstrac-

tion that paradoxically has a reality of its own. This simple truth Crown understood at the outset of his life as an artist.

Keith Crown was born in Keokuk, Iowa, in 1918 and was raised in Gary, Indiana, where his father was a high school athletic coach. Although his parents were not involved in the arts, they noted Crown's talents when he was about twelve, and they were supportive. At the advice of the public school art teacher, Crown entered the School of the Art Institute of Chicago in 1936.

Being at the Art Institute was an entirely new experience for Crown. His previous knowledge of art had been limited to pictures in magazines and to a collection of what Crown refers to as competent American impressionist paintings at Horace Mann High School in Gary. A small intaglio print of a cat done in 1931 (Fig. 32) gives us some sense of the caliber of Crown's talent at the age of thirteen. In any event, in contrast to his previous, artistically insulated life, he found himself not only an art student but also virtually living within one of the great museums in America.

Nothing could better describe Crown's artistic naiveté at this stage than his reaction to a Van Gogh exhibition when he first arrived at the Art Institute.[2] While impressed by Van Gogh's strong color, Crown interpreted distortions as drawing errors and decided that his own work was better than that of the great postimpressionist. That innocence was lost quickly. In the Institute, lining the walls and overflowing the basement storage rooms, was to be found great art of all periods and

1. Crown was reacting, in part, to how chemicals change the land. "[The farmers] use so many chemicals [fertilizers and insecticides] that [the field] looked like cigar ashes kind of broken up, and the dark part is sort of silver gray." Interview, 28 May 1982.

2. An exhibition organized by the Museum of Modern Art and shown at the Art Institute of Chicago 26 August to 23 September 1936.

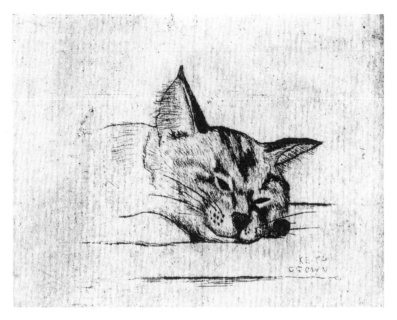

32. *Cat*, 1931, etching, full sheet 6¾ × 4⅝.

forces in World War II, during some of the moments he had to himself, he thought about and worked on the precepts he had learned at the Art Institute. "I began to understand and use the tool of adjusting shapes (negative and positive shapes) to each other, and I began to see my subjects as possibilities for interesting shapes. I worked on the use of the motif and counter-motif and their repetition."[4] Some of these concepts had come to him not through studio classes but through art history courses he took with Helen Gardner.[5] In her classes students were taught how to dissect and analyze works of art diagrammatically as well as iconographically.

During his period of study at the Art Institute, Crown decided he would combine the careers of artist and teacher. America was in the midst of the Great Depression, and his decision was based on concern about securing a livelihood. He felt that he would be unable to make a living from the kind of research and poetic painting he planned to do. While still in the

places. Thrust into this milieu, the inexperienced young man from Gary enjoyed advantages many other prospective artists did not. The outstanding collection of late nineteenth- and early twentieth-century art housed in this museum gave Crown the opportunity to inspect and study Gauguins, Monets, Cézannes, Matisses, and Picassos at his leisure. He came to understand them and respect them, and to build on the foundation these artists had so carefully laid. This aspect of his tenure at the Art Institute was perhaps the most significant.

Among his teachers was Francis Chapin. The fact that Chapin himself had been influenced by Matisse, Raoul Dufy, and Oskar Kokoschka indicates that Crown's training was not exclusively academic.[3] When Crown served in the armed

had studied with André Lhote. Chapin taught lithography and landscape painting. Helen Gardner and Kathleen Blackshear taught art history. Crown took art education courses with a Mrs. Hadley and Carolyn Svarluga. Another painting instructor was Laura Van Pappelendam, and, although Crown never officially took courses from her, he liked to listen to her talk to her students. He told me, "She was extremely enthusiastic—largely because she was really good—she knew her stuff—and was confident in this knowledge. Perhaps the thing I was most attracted to was her knowledge of materials. She could tell you about the lasting qualities of colored pigments, proper method of preparing canvases to paint on (and why they were proper), etc." Katherine Kuh was director of museum education during Crown's tenure at the school and arranged exhibitions that had a lasting impact on him. Crown also remembers visiting in 1937 the New Bauhaus in Chicago run by Maholy-Nagy.

4. Interview with Crown, 7 October 1984. The majority of the quotations from Crown are derived from a series of twelve conversations with the artist between 1982 and 1985. All are listed here and numbered. Hereafter only the tape number will be cited. 1. 26 May 1982; 2. 28 May 1982; 3. 20 July 1983; 4. 8 August 1983; 5. August (day not recorded) 1983; 6. 20 February 1984; 7. 28 February 1984; 8. 6 October 1984; 9. 7 October 1984; 10. 8 October 1984; 11. 10 October 1984; 12. 18 and 20 February 1985.

5. Best known for her textbook *Art Through the Ages*, currently in its seventh revised edition but first published by Harcourt, Brace & World in 1926.

3. According to Crown, Hubert Ropp was his main painting teacher from 1937 to 1940. Ropp, as Crown recalls, insisted that painting is essentially an intellectual process. Ropp introduced Crown to the writings of Clive Bell, Herbert Read, Roger Fry, and Sheldon Cheney. Crown studied figure drawing with Allen Philbrick and Edmund Giesbert. Giesbert

undergraduate program at Chicago, he began to take course-work in art education. Even though his motive for taking art education courses derived from practical considerations, he benefited artistically. Essentially, the education courses turned Crown toward a study of children's art, and from there toward an appreciation of all so-called primitive art. To be certain, others before him had made these discoveries, but, in Crown's artistic evolution, art education helped him to understand the nature of primitive art and its link with the modern tradition.

Undoubtedly, the artist's wisdom in equipping himself to teach helped him to secure a post at Luther College in Iowa after his graduation from the Art Institute in 1940. Before the end of the first academic year, he was conscripted into the United States Army, although he was allowed to finish that school year. Drafted during peacetime, he was soon caught up in the war, and he remained in the army four years.

Looking back at his education from the vantage point of 1984, Crown said, "I've been thinking a lot about why I paint. I paint partly because that's what I can do best. I could do that in high school, even in grade school . . . and my teachers found I could draw and they exploited my talent. I produced things that could be pointed to in their classrooms. By the time I got into the second or third year at the School of the Art Institute, I recognized that my talent would not be used for splashy magazine illustrations to make money. Exposed to teachers at the School, hearing from them what art was, I began to get much more serious. I started to comprehend that there was an intelligence in art; that it was not just flashy stuff. I discovered it was interesting, like a puzzle you could put together that, assembled, had meaning beyond the sum of its individual pieces. I was caught up by this new understanding. There were formal ideas that could be applied. I developed too a sense of artistic integrity, of what goes in and what is left out of a painting. You could use your skill to 'pretty up' a picture that would bring you instant attention. But if you had integrity you avoided such superficial ways."[6]

6. Tape 8.

Crown described how the war interrupted his artistic maturation: "I really started painting at the age of twenty-eight or twenty-nine. I got my schooling over, and the war took four years of my life. One of my teachers said it takes about eight years to digest one's education. He did not say anything about digesting a war."[7]

Keith Crown served with distinction in the Pacific theater of operations and was awarded a bronze star for meritorious achievement. He was a member of the 161st Infantry Regiment, 25th Division (James Jones, the author of *From Here to Eternity* and *The Thin Red Line*, was also in the same division), which fought long and hard in the Pacific and lost many men. Crown was assigned to the regiment's intelligence platoon and rose rapidly to the rank of staff sergeant. There were official war artists, but Crown was not one of them. He was unofficially designated as regimental artist by the young commanding officer, Col. James L. Dalton, but this unofficial designation did not keep Crown out of the fighting, as the bronze star testifies.

Crown filled sketchbooks with drawings derived from the scenes around him—burning tanks, tired guerrillas, and the faces of his fellow soldiers (Fig. 33). He also designed pages for the regimental history called, at his suggestion, *The Golden Gate in Forty-Eight: A History of the 161st Infantry* (Figs. 34, 35). This title was chosen over one more optimistic (and more correct as it turned out), *Home Alive in '45*. They all knew that some were not coming home. And as it turned out, Dalton, the youthful colonel promoted to general, was one of those killed in the campaign in Luzon. More than forty years later, Crown remembers him with affection and respect.[8]

Curiously, some of the pages of Crown's regimental history, showing aerial maps combining the real with cartographers' symbols, seem to point ahead to his paintings many years later. There is also a drawing from imagination of a Japanese sniper, dead and hanging limp from a palm tree (Fig. 36). In

7. Tape 9.
8. See the Sydney, Australia, newspaper *The Bulletin*, 20 October 1943, p. 9. The article is accompanied by a portrait of Dalton by Crown.

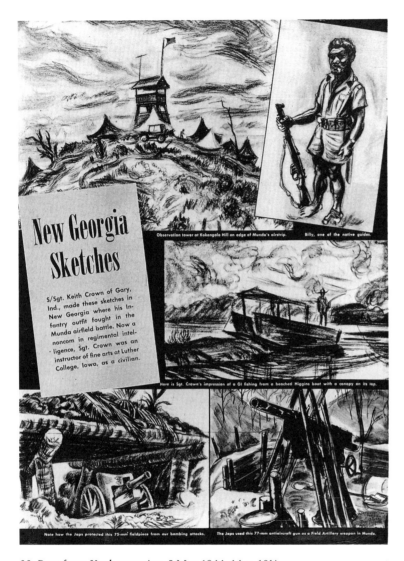

33. Page from *Yank* magazine, 5 May 1944, 14 × 10½.

34. Page from *The Golden Gate in Forty-eight: A History of the 161st Infantry*, 10½ × 8.

35. Page from *The Golden Gate in Forty-eight: A History of the 161st Infantry,* 10½ × 8.

36. *Dead Japanese Sniper,* india ink drawing, 1943, 8 × 10.

this work he tried to apply some of the lessons he had learned from studying Picasso's *Guernica*—especially the overwhelming sense of pain and death the great Spaniard had captured in his mural.[9]

Finally, in August 1945, Crown was honorably discharged. He returned, now married to Helen Elaine Talle, to the Art Institute for the academic year 1945–1946 to take additional classes. Then he accepted an offer to teach painting and drawing at the University of Southern California at Los Angeles.

9. *Picasso: Forty Years of His Art* organized by the Museum of Modern Art and the Art Institute of Chicago. At the Art Institute 15 November 1939 to 7 January 1940. Picasso's *Guernica* was included along with related studies.

By his own definition, Crown's career as an independent artist commenced when he accepted the teaching position and moved to USC. For the first time in his adult life, he could begin considering in what direction his art should go. In Los Angeles, a long way from Chicago, isolated from the artistic ferment underway in New York during this same period, he faced hard and solitary decisions. Here there appeared to be no single, cohesive movement in an artistic environment dominated by individuals as different as Rico Lebrun, Stanton Macdonald-Wright, and Millard Sheets, none of whom Crown knew personally, although subsequently he became well acquainted with Lebrun and Sheets.[10]

Rico Lebrun (1900–1964) was perhaps the most potent influence on young artists in the Los Angeles area in the 1940s and 1950s. His impact on younger artists was partly the result of his having accepted a teaching post at the influential Chouinard Art Institute in 1938. In 1947 he moved to the newly founded Jepson Art Institute and in 1951 became its director. It would be difficult to imagine an artist whose approach was more antithetical to what Keith Crown stood for than Lebrun. The Italian-born artist was an expressionist who built his own art firmly on Picasso of the *Guernica* period. By the time Crown arrived, Lebrun in his art had virtually abandoned color for black, gray, and white. His single focus was the human figure, and his art had no connection with a sense of a specific place. If it is accurate to observe that Crown found himself artistically isolated when he arrived in Los Angeles in 1946, then Lebrun with his legion of followers aided that isolation.[11]

Stanton Macdonald-Wright (1890–1973), although not born in California, did move with his family to Santa Monica at the age of ten. Despite the fact that Wright was only ten years Lebrun's senior, he seemed to represent an earlier epoch. He was, with Morgan Russell, the founder of Synchromism,

a short-lived movement that came together about 1913 and ended by 1918. After the 1914–1918 war, Wright became increasingly interested in oriental art and absorbed with esoteric color theories. By 1942 he was teaching art history, oriental aesthetics, and iconography at UCLA, but he occasionally taught summer classes at USC. Crown did not know him. And Wright's obsession with orientalism was of no particular interest to Crown.[12]

Millard Sheets was born in Pomona in 1907 and was an influential figure in the Los Angeles art world. One can guess that to Lebrun and his circle Sheets must have appeared the quintessential provincialist. While Crown had no exceptional interest in watercolor painting until 1956, Sheets already had a reputation as a major California watercolorist when Crown appeared. Sheets, a generation older than Crown, came of age first in the era of Regionalism and the American Scene. His paintings of the thirties did focus on the countryside, the people, and the city of Los Angeles and therefore might very well have had an influence on Crown. As a student during the thirties, however, Crown was acquainted with the major regionalists of that period. Paradoxically, by the time Crown showed up, Sheets, who had returned from being an artist-correspondent during World War II, was moving through a sort of Braque-inspired cubism.[13]

Reviewing this crucial point in his development, Crown noted that he began sorting through his artistic goals and determined them as follows: "1. Become some kind of abstract painter. (I wasn't quite certain of what that meant, because I wanted to work it out myself, not ride on the . . . backs of other abstract artists.) 2. I resented the arrogant dominance of the School of Paris, and European art in general. I wanted to push forward that area of art that does seem occupied by some of the best American painters—of paintings representing un-

10. See *Painting and Sculpture in Los Angeles, 1900–1945* (Exhibition Catalogue, Los Angeles County Museum of Art, 1980).

11. See *Lebrun* (Exhibition Catalogue, Los Angeles County Museum of Art, 1967).

12. See *Stanton Macdonald-Wright* (Exhibition Catalogue, National Collection of Fine Arts, 1967). Also see Gail Levin, *Synchromism and American Color Abstraction 1910–1925* (New York: George Braziller in association with the Whitney Museum of American Art, 1978).

13. See Janice Lovoos and Edmund F. Penny, *Millard Sheets: One-Man Renaissance* (Flagstaff: Northland Press, 1984).

seen natural forces—the invisible, but no less real. The artists: John Marin, Lyonel Feininger, and, later, Arthur Dove. This was not only a decision of the intellect, but of the heart." [14]

Los Angeles was the site of Crown's struggle for independence. He hammered out his own balance between perception and feeling in oils, acrylics, caseins, and watercolors, in subjects as diverse as the beach, sea, and pier he found close to his Manhattan Beach home, the Chevron Refinery at El Segundo, and the Los Angeles Airport. But putting theory into practice took time and enormous effort.

It is not surprising that realism lingers in some of Crown's initial efforts after arriving in Los Angeles. *Old Yellow House on Vermont Avenue near Exposition Boulevard and USC* of 1947 (Fig. 37) is a straightforward representation of a street corner in a Los Angeles neighborhood and is a bit reminiscent of both Charles Burchfield and Edward Hopper. Illustrating the derivative nature of Crown's work at this moment in his career, another 1947 oil, *Exposition at Figueroa* (Fig. 38), is basically representational, but the artist heightened the color and stressed the unity of interacting structural forms, imparting to the work a sort of cubist veneer. While he was more sympathetic to Stuart Davis's subject matter than to his style, Crown, in this painting, may indeed show some influence from that American cubist.

Crown had no need to learn Cubism from Americans. The first oil painting he executed in Los Angeles, a still life, incorporates elements from Cézanne as well as from European Cubism. (We have already noted the large Picasso exhibition he saw at the Art Institute in late 1939.) In any case, while formalistically eclectic, both the city scenes and the still life reflect Crown's firm belief that the artist must draw on what he knows best, what is around him.

From about 1948 to 1951, Crown produced a number of still lifes (Figs. 39, 40). Still lifes are not numerous in his work, but he did paint many in these early years (and his sketchbooks from all periods contain drawings of still lifes). Such paintings,

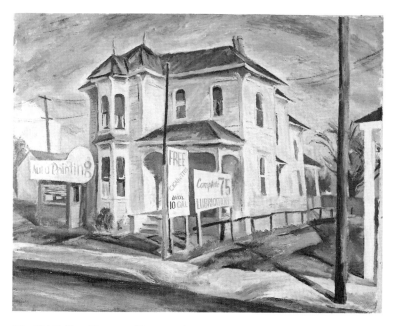

37. *Old Yellow House on Vermont Avenue near Exposition Boulevard and USC*, 1947, oil, 24 × 30.

38. *Exposition at Figueroa*, 1947, oil, 26 × 60. No longer extant.

14. Letter to author, 4 October 1982.

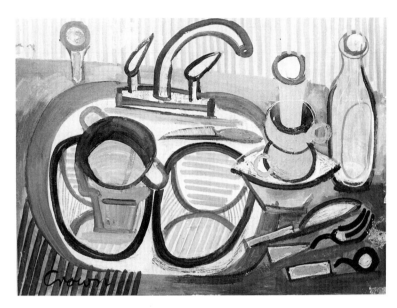

39. *The Sink*, ca. 1952, oil. No longer extant.

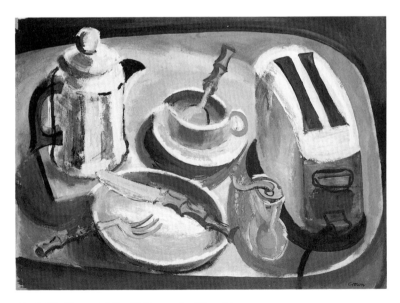

40. *Still Life*, ca. 1949–1950, casein, 20 × 28.

as already noted, are connected with the artist's conviction that one should work with *what is there*, including even such humble subjects as a stove, pans, dishes, and the like. In teaching, he tried to convey that you must have a meaningful link with your subject, that is, the artist must call upon his or her own life experience. Thus the objects Crown used in his still lifes represent a part of his life. "At the time I did these, all my still lifes were of the same everyday things. They are pieces of my life. Everything I paint is drawn from my life."[15]

Looking back from a perspective of more than thirty years, Crown explained these ideas in more detail. Still lifes "represent my idea to get away from especially prepared setups. You can paint anything—like your bathroom, or your living room, and I painted such subjects. You could have breakfast and there are your dishes, and there too is your still life. Of course, you could paint it before you eat breakfast, but I'd advise you to eat it first. Picasso said 'first I eat the apple then I paint it.' There is more about the apple than just the look of it. This same idea relates to what I believe about nature. To sit in a studio and paint nature makes no sense when you can go out and experience it. It is exactly like the apple: there is its appearance, but also its smell and taste. There is no cosmic meaning in my still lifes. I wanted to paint something, it is as simple as that. I did not arrange the motif. I feel that the design should be part of the process of painting, not worked out elaborately in arranging the objects in advance."[16]

Some have interpreted Crown's early still lifes as containing proletarian meanings by virtue of their emphasis on the banal. The artist, who has strong political beliefs but insists they have no overt place in his art, replied to such a reading of these paintings in this way: "I intend no meaning of class struggle in the use of utilitarian objects. In fact these objects are commonly found in the households of the middle class."[17]

From a formalistic point of view, most of the still lifes of this period represent serious investigations of Cézanne's still lifes—especially the multiple eye levels notable in the French-

15. Tape 8. 16. Ibid. 17. Ibid.

man's later still lifes—and of early proto-cubist works by Picasso and Braque. For the most part, and without detracting from their individual merit, they represent a brief episode of experimentation. Most of Crown's original ideas are to be found first in his dominant theme—landscape.

In 1949 Crown broke through the tentative beginnings represented by the cityscapes and still lifes discussed above. In one of those flashes of understanding that open vistas for an artist, he created *Serial Painting—Sunsets on Sea* (Fig. 7). Many of the early paintings done in Los Angeles and its environs dealt with the Pacific Ocean. He was drawn to it by memories of the recent war and especially of the many he knew who had never returned home over this same ocean. In a very profound, moving, and personal way these paintings became, in addition to whatever else they are, tributes to those men.

The 1949 casein is atypical in that it was done in the studio—it is one of what Crown calls "desperation" paintings because he was prevented from going outdoors. In the proper setting (New York), and with the critical support of Thomas Hess (*Art News*), Clement Greenberg, or Harold Rosenberg, this painting might have placed Crown squarely in the front rank of American painters of his generation. Unfortunately, the special nature of Crown's artistic development came from the fact that he was situated in southern California and, therefore, separated from the struggle in New York that led to the rise of Abstract Expressionism. The New York artists were acquainted with one another, met regularly, talked constantly. Of all this Crown knew nothing at the time. "In the years 1941 to 1945 the people destined to be labeled Abstract Expressionists were painting their asses off—fighting the good battle in New York. I never heard of them in the Pacific Islands where I was avoiding getting my ass shot off." In the same letter he stated categorically that his "development towards a mature artist owes [nothing] to any [of them]."[18] By the time this picture was done, however, he had arrived at a point similar to that of the New York painters in a number of ways.

18. Letter to author, 4 October 1982.

He had in fact evolved a painterly style that was the hallmark of the New Yorkers. In addition, he was pushing into the realm of abstraction, although not carrying it as far as most of them were. Finally, his arrival at symbols suggests a link to Surrealism, and the Abstract Expressionists were also deeply influenced by that movement. Indeed, André Breton and a number of major surrealist painters were in New York during the war years.

During the same time *Serial Painting—Sunsets on Sea* was painted, Adolph Gottlieb, fifteen years Crown's senior, was creating paintings in which he placed signs and symbols within an irregular grid on the surface of the canvas that bears at least a superficial resemblance to the 1949 painting by Crown. Executed between 1941 and 1951, these Gottlieb paintings are usually termed *Pictographs*.[19] It should be noted at once that Crown was not familiar with the older man's work. Indeed, Crown's entire approach was unlike that of Gottlieb, whose motive, in part, was to create evocative mythical symbols hauled up from the subconscious—in line with the Freudian precepts of the movement. It is not the same source Crown tapped, and, despite surface similarities between the artists' work, this is a crucial distinction. There is no question, however, that Crown was interested in Surrealism. As a student he admired some of the surrealist elements in Picasso's later works and was familiar with the work of such individual surrealists as Joan Miró, Matta, and Max Ernst. But his appreciation and feel for that movement went deeper still.

In 1982 Crown wrote about a meaningful link between his own improvisational approach and surrealist automatism. "I . . . have admired from student days the dreamlike imagery that, with automatism and poetic meaning, are essentials of surrealist painting. I believe I'm drawn to landscape or other subjects that also, in reality, have intrinsic qualities of surrealism."[20] While never considering himself a surrealist, Crown

19. See Robert Doty and Diane Waldman, *Adolph Gottlieb* (New York: Frederick A. Praeger, 1968).
20. Tape 14.

identified certain of his affinities with their aims: "I like my paintings to be enigmatic. I suppose I lean my paintings on actuality—the substantive presence of things—but also acknowledge the uncertainty, the mystery as experienced by our shifting, wandering, undependable minds."[21] Another trait he shares with the surrealists and artists like Jackson Pollock and Robert Motherwell might also be noted here: He makes full use of serendipitous incidents while working on a painting. If useful, those "accidental occurrences" become a conscious component of his painter's repertoire.

In a statement written in 1966 for the catalogue of an exhibition titled *Arts of Southern California XVIII: Watercolor,* organized by the Long Beach Museum of Art, Crown identified such gratuitous events as specifically American and not limited to painting. "Fluidity, directness, stream of consciousness, encouraging the fortuitous, living with rather than working against the medium, are peculiarly suited to the American temperament. These qualities ripple through our writers: Whitman, Emerson, Thoreau, Wolfe, Dos Passos, Stein, Hemingway; and their painter peers all of whom are at their best when they use watercolor: Homer, Sargent, Hassam, Prendergast, Demuth, Marin, Burchfield."

The symbols in *Serial Painting—Sunsets on Sea* are not dredged up from some more profound level of human awareness but rather are based on American Indian art and African shields Crown had admired—although he was not at the time a totally enthusiastic admirer of African art. He was already a collector of Navajo rugs and pots and was especially interested in Northwest Indian arts and artifacts. Indeed, the vertical divisions in this painting owe something to totem poles.

The painting itself depicts three sunsets, placed in narrow vertical divisions, sun over sea. The idea of seeing the same landscape at three different stages simultaneously could have been derived from any number of sources: Cézanne, Cubism, or children's art. (Several of Crown's early sketchbooks are filled with drawings by his children.) The form this concept assumes

here is quite a fresh one. The painting is episodic in that it records, from left to right, the sun descending over the ocean. The artist has allowed his record of this event to develop abstractly, possibly facilitated by the fact this was a studio painting. Crown treats the seascape intuitively. Present are the sun, the rays emanating from it, the phenomenon of sun spots, and the reflections on the water, and all are transformed in a complex and unique way that avoids what could have been a mundane and saccharine picture.

The entire concept of serial painting is interesting and is not new in the history of art. Two examples immediately come to mind: Constable's paintings of Salisbury cathedral executed in different seasons and Monet's of Rouen cathedral at different times of a day. Yet these two artists—greatly admired by Crown—were primarily concerned with recording changes of light and atmosphere under certain conditions. It is obvious that the recording of such natural variations is not the major concern in Crown's experiments. However, he is not insensitive to the changing moods of nature.

To illustrate Crown's receptivity to the elements present in nature, we can turn to another casein landscape called *Windstorm—Redondo Beach,* probably executed in 1954 (Fig. 41). While painting this piece Crown was responding to certain conditions: "What I call a rocky day. A heavy or rocky day. It seems that the sky is clear, but there is something in the air. It's like a sandstorm, but there is no sand. It is near the ocean. There is a lot of moisture in the air and the wind blows like mad. Everything seems to be coming apart and your brain seems to be blown out. And the buildings bend."[22] Crown equates weather conditions with states of mind. Neither Constable nor Monet was quite as sensitive to the connection between appearance and emotion. Another point may be made here. The heavy, rough shapes and execution of such a painting are purposeful: the wind in this seascape is not a graceful or gentle breeze, but a strong blunt wind that disquieted the artist.

Clearly Crown was searching for a way of materializing

21. Ibid.

22. Tape 4.

forces in nature that lie beyond visual perception. In a sketchbook from about 1956, the artist jotted down these thoughts: "I'm trying to bridge the gap between the symbol and reality—to knit together the character of each in painting—to invent personal, poetic symbols that express visually the sound, taste, smell, movement, as well as appearance. *A symbol is generally universal—mine I wish to be more specific*" (emphasis added).

We are concerned now with the artist's relationship to his subjects, a relationship that remains essential to Crown today. That relationship is always a miraculous, constantly changing balance of what is seen, felt, and known. He has been consistently abstract throughout his career but has never stepped beyond into the realm of the nonobjective. As usual, Crown explains it best: "I see something and I get to looking at it and I try to figure out how I can bring out that thing which I see—exaggerate it or characterize it—more than it is. I like to take extreme measures to do that, something that I think the viewer hasn't seen before. But I want to try to keep my feet in reality—an anchor—and try to make people look at the painting, and while they might be puzzled by it, they are attracted to it because they notice an element of recognition. They feel like they've been here before. They know what this is in spite of the fact that it's odd or unconventional."[23]

In some respects Crown's sense of what constitutes reality is close to that of Van Gogh—an artist he came to admire greatly—and Expressionism in general. In the terms of this analogy, it is possible to broaden the artist's understanding of reality beyond just the things in front of him. The reality of what he sees is affected by everything about him, including events not obviously part of the subject in any ordinary way: "My state of being: [whether I was] tired, alert, excited, particularly aware, particularly in possession of my faculties, hungry, sexually full or empty, and so on. All the infinite states of being pushed and pulled and impinged on by all that goes on outside of the self. [All] these [things] affect the understanding of what the light in a painting is to be. The vagaries of na-

23. Tape 9.

41. *Windstorm—Redondo Beach*, ca. 1954, casein, 20 × 28.

ture."[24] Crown uses his painting as a vehicle to express himself, but he has always understood that art has meanings transcending the individual. In that 1956 sketchbook he wrote: "There must be a purpose to painting. Experimenting is not a purpose but a means to an end—of achieving the purpose. To bring order to men out of chaos is the purpose. To give meaning to life—to find meaning."

There is an intellectual foundation to Crown's art as well as a link to the world of seeing and feeling. Crown's word for the intellectual base is *idea*. He has stated this concept quite succinctly: "I've wanted to have a new idea—not to repeat myself. I've often had an idea from which many versions, each unique, came."[25] It is possible to follow one such idea. Crown is tireless in painting pictures of the shore, ocean, and sky in the Los Angeles vicinity. It is feasible to chart his constant struggle for new insights, for ways to avoid repetition. In a

24. Sketchbook dated 1970–1971. 25. Tape 9.

42. *Sun, Waves, Birds*, ca. 1951, casein, 20½ × 28. No longer extant.

casein of circa 1951 called *Sun, Waves, Birds* (Fig. 42) he approached nature in one of her more somber moods. Even in this dark seascape he sought to create a sense of the vibrating color he perceived between sky and water. The combining of rectangular shapes with a more representational treatment of waves owes much to his great interest in John Marin.

Similar in subject is a painting done in 1952 titled *Sunset and Pier* (Fig. 43). This canvas quite simply represents a setting sun, the way the sun seems to melt into the water at the edge of the horizon, the reflections at that moment, and the pier. How to arrive at a more effective and original manner of depicting the sun was reached, for this particular work, during a visit to the dentist. The light over the chair with its dark center and radiating circles of silver gray seemed just right for this painting. The column of blue linking sun and ocean symbolizes that instant of unity between water and the golden disk, and curving

forms of black aerosol-sprayed paint represent the curtain of heat descending from the sun.

The use of spray paint requires a slight digression. Crown is very sensitive to the fact that, although he was probably one of the first American artists to make use of this new possibility, he has never been credited for that use. In a 1982 sketchbook Keith wrote, "Since late 1948 or early 1949 I had [already] taken cans of spray paint out with me [when I painted]. I thought spraying paint would become an important part of artists' techniques, but I wanted to use it differently from Siqueiros who painted smoothly using subtle gradations or modeling of light. (Siqueiros was the first [artist] to my knowledge to use spray paint.) I used the aerosol can to draw with. . . . Not once in the many reviews I received did one of the L.A. critics write anything indicating they observed [the drawing with spray paint] in my very early work."

In *Sunset and Pier*, again as an example of Crown's pursuit of all the possibilities inherent in a subject, we note that the familiar sight of the sun over the Pacific Ocean is transformed into a dramatic and complex work of art. For Crown the inventions here—the dentist's lamp or aerosol spray paint—are identical with his sense of *idea*. Despite the continual growth of Crown's art, that simple definition—idea is invention—remains as meaningful today as it did thirty or thirty-five years ago.

Breakwater, painted in 1952 (Fig. 8), incorporates one of Crown's most far-reaching and fertile ideas—the curved horizon (see also Fig. 44). Crown points to this concept as an important breakthrough, and he explained the genesis of this significant concept in a letter dated 18 July 1985. "I was painting an ocean sunset one day but the beachfront in back of me with its houses shining in the sunlight was a subject I also wanted to do. I kept swiveling around in frustration to look at the houses in back, then the idea came to me. 'Why not swivel the horizon around on my paper and do the beach houses in back also.' (This put the houses upside down and at the bottom of the paper.) The resulting breakthrough opened my painting to vast possibilities. I began to paint whatever segments of the curved

43. *Sunset and Pier*, 1952, oil, acrylic, enamel spray, 50 × 38. No longer extant.

horizon I desired, painting material in front at the sides and/or in back. A large number of my ideas for painting have [their] origins in that first breakthrough (it was the first breakthrough for me). The *Soybean Field with Grain Elevator* is a distant—

44. *Breakwater*, 1952, india ink on watercolor paper, 20 × 28.

quite distant relative of the above."[26] What Crown accomplished here placed the artist himself, and therefore the spectator, in the center of the work. There are certain analogies between this device and the treatment of time and space in analytic Cubism, but there is nothing cubist in the vocabulary applied by the artist. As we shall see, even this sort of tenuous connection with Cubism later disappeared from Crown's art.

What Crown devised in landscapes—a way to penetrate fixed static space—he utilized in paintings of interiors. A 1947 oil, *Chairs* (Fig. 45), is, by his standards, a representational painting in the same class as earlier cityscapes. *Chairs* contains what is absent in the early beach scenes: bright, relatively flat, decorative colors. The source for these latter qualities might be Matisse, Picasso, Stuart Davis, or any combination thereof.

26. A note attached to the manuscript by Crown after he read the first draft of this chapter. Hereafter all quotes not attributed to other sources are taken from Crown's written responses to each chapter, and all are dated the summer of 1985.

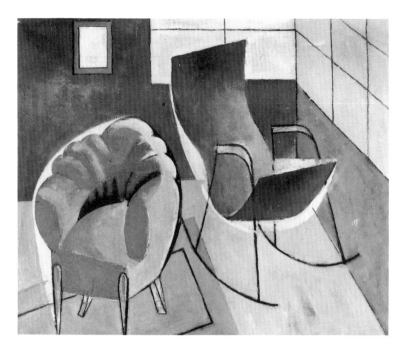

45. *Chairs*, 1947, oil, 22 × 30.

46. *Kitchen*, 1952, oil, 30 × 20.

Davis seems a likely source because of the geometric configuration of forms and the particular nature of the use of line.

Davis might also have influenced a 1952 oil titled *Kitchen* (Fig. 46). This canvas illustrates an adaption of the curved horizon to the depiction of a room. Crown has already explained why he selected such humble subjects—they were there and they interested him. His great admiration for Van Gogh may also have contributed to his sense that he could transform ordinary subjects into powerful autobiographical symbols as Van Gogh did in the depiction of his bedroom at Arles. In *Kitchen*, the artist places himself in the center of his kitchen, showing us what is in front, to the sides, and behind, using very much the method he employed in the landscapes from 1949 on. (One interesting result of this approach is that we always seem to be looking down on the scene.) If we compare the 1947 *Chairs*

with the 1952 *Kitchen*, we observe that the later work is more abstract, more complex in space and multiplication of shapes. All these features are accomplished without sacrificing rich texture, decorative forms, and strong color.

In a very real sense, Crown views painting, at least in part, as an unending sequence of attacks on self-defined challenges: "I see [painting] as a kind of problem—sort of an intellectual problem at least in the sense that you put your mind to it—a solution to some extent, but also a problem I suppose of the subconscious or instinct. I worry about too much control in [my] painting."[27] (He is fond of quoting Picasso's remark that "Skill is an excuse to abandon the struggle.")

In the late fifties Crown wanted to explore further what he called series painting. This exploration started with the 1949 casein *Serial Painting—Sunsets on Sea* and was developed to a high degree in a 1958 oil and in a 1959 canvas in the collection at Arizona State University titled *Serial Painting of Sea and Sun* (Fig. 47). Here the artist assembles several views of the same scene on a single canvas. Crown explained that such paintings "all deal with a single subject shown more than once in which the passage of time has caused each division of the painting to alter—for example: the sun gets lower as it is setting into the sea. Monet did exactly the same thing except on a series of canvases. I did my series of any one subject on a single canvas or paper."

The work does have a flat decorative appearance that Crown explains: "My interest in Navajo and Turkish (Kilim) rugs and oriental carpets through the years has influenced me to do paintings that are rug-like. I didn't mind at all [if they] were seen as single, decorative units first—like a rug. Then if you examined them long enough you might come to see there several divisions with land or seascape qualities." (It was in 1964, in New England, that Crown first applied his interest in rugs to paintings, with astonishing results.)

A more complex series is one in which Crown has divided the picture plane into two or more sections for the purpose lit-

27. Tape 7.

47. *Serial Painting of Sea and Sun*, 1959, oil, 35⅝ × 45¹³⁄₁₆. University Collections, Arizona State University, gift of Gloria and Jules Heller, Scottsdale, Ariz.

erally of separating the most basic elements of the art of painting: shape and color. About this concept Crown said that he has "swung back and forth throughout my painting career. I would work for a long period on shapes, not worrying [about] the color. Then gradually my interest would shift to color letting the shapes in my paintings take care of themselves." The artist continued, explaining that in an oil painting such as the 1964 *Seascape* (Fig. 48) he worked out an idea for separating the shapes from the color so that he could "give each individual attention on the same canvas, so that in one area (or areas) I noodled out the shapes *in black and white*, in other areas I

forgot about the shapes putting down just formless, but meaningful, color. It was left for the viewer to put the two together mentally. Except for the variations of space division I worked out on each canvas, composition hardly existed, since the treatment of color and of shapes possessed a tendency toward 'overall,' or 'even'—effect of interest."

Many of the early caseins and oils share an aesthetic of deliberate harshness of execution. In explaining why he avoided refinement, or traditional "finish," he contrasted John Ruskin's nineteenth-century sense of ideal beauty with his own. "My concept of beauty is generally without sentiment. I find toughness, harshness, often part of beauty. I suppose in the arts an artist who has the power to grasp and convey simple truths creates beauty. Whatever odd steps I take to create new images out of the same world everyone can see, I still adhere to the first principle of seeking insights into the truth of my subjects. It is this I intend to give my work intensity and tension." [28]

Working in casein and oil in these formative years allowed Crown to exploit the viscosity of those media, and he speaks of painting with a "sledgehammer." "I'd try to push the paint right through the paper or canvas. I have a sense that you can fix feeling almost electrically. Van Gogh personifies this—his feeling, his meaning, fixed in the paint itself." [29]

Looking at these early stages in Keith Crown's development, we see his art was rooted in nature, although he already recognized that he wished to create forms recording nonrepresentational elements as well as those from the world of ordinary appearances. To achieve these goals (to paraphrase W. B. Yeats) he will use the most extravagant images and manner if they suit his purpose.

It is important to be reminded that Keith Crown found himself cut off from any forum that might have facilitated his artistic development. There were, to be certain, artist friends, but few were strong enough or inventive enough to contribute to Crown's growth as a painter. The position at the University

28. Tape 8.
29. Ibid.

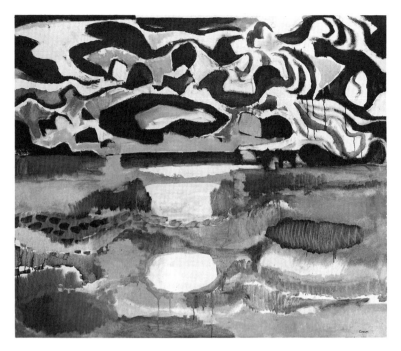

48. *Seascape*, 1964, oil, 50¾ × 60¾. Photograph by John O'Brien.

of Southern California provided hardly any intellectual support or stimulation and only a meager living for a young man with a wife and three small daughters. While such isolation may have had a negative impact during these crucial early years on Crown the man in terms of loneliness, the strength and courage he possesses in great quantities spurred him on. And isolation became a powerful positive factor, permitting him to evolve an art totally of his own making in his search for the essential.

"When an artist moves out into the area of truth," Crown recorded in a 1960 sketchbook, "when his work is most original—he must be a most lonely person—for except in a most general way, he finds no one traveling with him, or in his exact direction. Nor is there a predecessor (precisely)—but he must have courage and confidence in his own strength—his own ethics to see him to truth."

2. Growth

In the fall of 1956, Crown took his first sabbatical leave from the University of Southern California. In those early years at USC, he had worked as many as six days a week. Freed from teaching and committees for a semester, he could put all his energy and time into painting for the first time in his adult life. The previous summer, Paul Burlin, a well-known American artist, taught a summer session at USC, but Crown did not meet him. Burlin admired a Crown oil hanging in the art department office and left a message that he would like to see Crown the next time Crown found himself in New York. Crown responded promptly to that invitation. That very fall he traveled to New York with some caseins to show Burlin. Burlin had nothing to say about the pictures except this: "Your style needs to loosen up. Why not work with watercolor?" Crown had been hoping that Burlin would do something tangible for him, such as help him find a gallery in New York. He was disappointed, but he took the older man's advice and did begin to work with watercolor.

Up to this time, Crown had been concentrating on oil paintings and caseins. Of course he had studied watercolor painting at the School of the Art Institute and had painted approximately fifty watercolors while in the service. He did not abandon oil and casein all at once.[1] The artist recalls that it was in 1957 that he painted his last caseins, but he continued to work in oil into the sixties.[2]

Crown taught in the spring of 1957, did his last few caseins that summer, and returned to his studio to execute watercolor paintings on the backs of older caseins. He worked with large brushes creating bold forms painted in brilliant hues. "I might do four or five of them very fast out there—investigating watercolor. I just wanted to dig into this new medium."[3] Yet it was difficult for him to abandon working in the other media. The artist felt good about his paintings in oil and casein, and there were others in Los Angeles who admired them as well. For example, in 1957 Jules Langsner in *Art News* reviewed quite favorably an exhibition of Crown's oils and caseins at the USC art galleries. Langsner identified Crown's approach to nature as characterized by "intensity" and pointed to him "as a top-drawer West Coast painter." The critic described the paintings in the exhibition as "abbreviated images of sea and shoreline, of desert irradiated by scorching discs of fire . . . presented in tilted perspective. Shapes are designated by vibrant shorthand. Energetically brushed lines burst and crackle along the picture surface."[4] Langsner's interpretation was very close to the mark. In a sketchbook probably from about 1960, Crown urged himself "to go further—deeper—go mad—paint with passion—with all the colors light[ed] up—illumine the world. Break loose! Be free! Love—Paint with love—like love." But by the time he wrote that thought to himself, he had realized that watercolor was the most suitable of any medium he had used. "Watercolor," he wrote in an undated notebook, "has become

1. Crown has been a member of the California Watercolor Society since August 1949 when a painting he submitted to the annual exhibition was accepted. However, the Watercolor Society also accepted caseins and pastels in its shows. From 1958 to 1960 Crown was vice-president and then president of the society.

2. In 1965 Crown was the victim of an act of vandalism that de-

stroyed over one hundred of his oil paintings. The canvases were so mutilated that they were beyond repair.

3. Tape 8.

4. "Art News from Los Angeles," *Art News*, May 1957, p. 49.

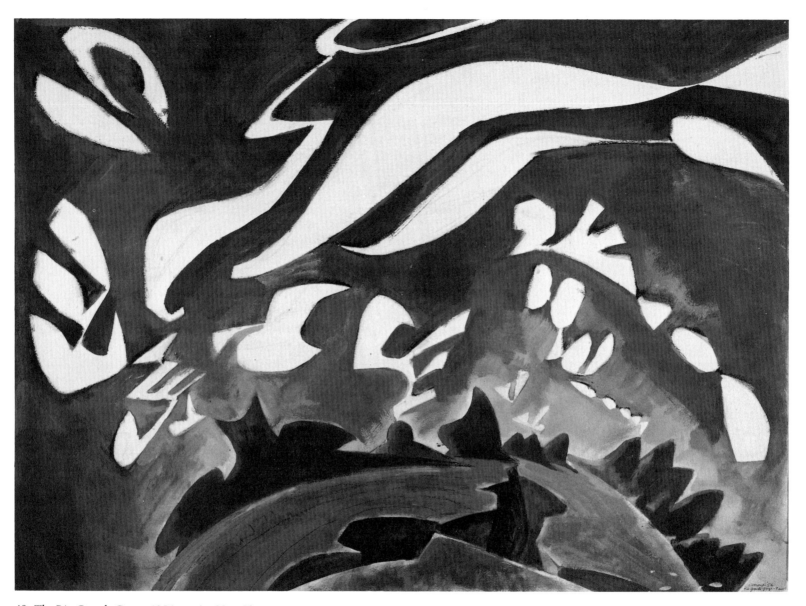

49. *The Rio Grande Gorge*, 1956, casein, 20 × 28.

my main medium of communication. Its fluid nature and susceptibility to improvisation are just right for me."

A significant artistic event that parallels Crown's shift to watercolor was his first stay in the high country of northern New Mexico. During his sabbatical, in 1956, the artist and his family—his first wife, Helen, and daughters Haine, Katherine, and Patricia—spent four months in the artists' colony of Taos.[5] Their plan, one they adhered to, was to remain until the cold made painting outdoors impossible. The landscape, color, clarity of atmosphere, and Indians provided Crown with a perfect alternative to Los Angeles. It was 1969, however, before he began to make annual visits to Taos. Eventually he purchased property in Talpa, in the vicinity of Taos, and built a house there.

Taos was to become an important source of new subject matter for Crown. He loved the look of Taos, its space and color. Even though he did not paint the Indians of the various pueblos, he admired how they existed in such intimate proximity to nature. He observed the manner in which their arts and crafts connected with the difficult reality of their existence, how they saw all living things as connected. In fact, Crown's interest in Indian arts and crafts goes back at least to 1951 when he made a brief trip to Mexico and was deeply impressed by pre-Columbian art.[6]

In many of the paintings executed during his 1956 visit to Taos, Crown understandably drew from his work in Los Angeles. For example, the 1956 casein called *The Rio Grande Gorge* (Fig. 49) employs the curved horizon of his Manhattan Beach pictures, and the patterns of clouds and mountains look very much like some of his slightly earlier pictures of the beach and ocean. The suggestion of change appears in *Fall in Taos*, also done in 1956 (Fig. 50). A more radical break with the immediate past, however, is the brilliantly colored *Taos Landscape*, painted during a brief stay in Taos in the summer of 1957 (Fig. 9).

Crown spoke about the work he did in Taos in the early days, and his statement could easily apply to *Fall in Taos* or the

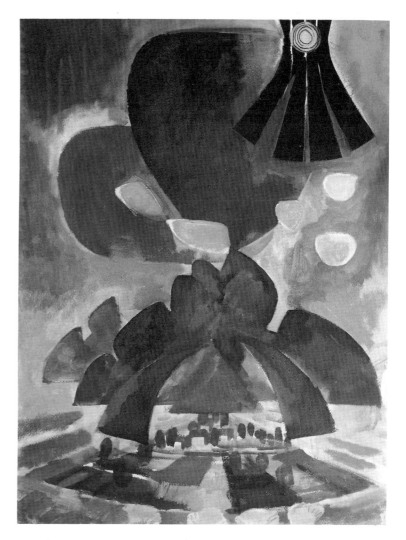

50. *Fall in Taos*, 1956, casein, 28 × 20. Photograph by Jack R. Towers.

5. The basic reference on Taos as an art colony is Van Deren Coke's *Taos and Santa Fe: The Artist's Environment 1882–1942* (Albuquerque: University of New Mexico Press, 1963). Also see Sharyn Udall, *Modernist Painting in New Mexico* (Albuquerque: University of New Mexico Press, 1984). 6. Tape 8.

striking *Taos Landscape*. "It seemed to me that when you look at the village of Taos that these big ridges of the [Taos] mountain come out like arms—like a mother giving an embrace. It is so dominant over the town that I lifted the mountain and shoved the town under it. If you look at the mountains you can see that these things are there, these peculiar hornlike combinations. I've done quite an unusual thing to [the mountain], of course. These arms and [the mountain pushed] up. I worked a lot on the use of scale—to try to get dominance of sky and put in these big shapes, and they look big because I used these little [shapes]. These [little shapes] are sort of cloud-like, they could be clouds. But they are not clouds. They are there to open up the sky in this scale relationship."[7]

About the same time *Taos Landscape* was painted, Crown noted in his sketchbook that his paintings "are abstract in order to be expressive—but above all poetic." The word *poetic* comes up frequently in Crown's writings and conversations about his work as a painter. For him, "Poetry is stripping away all that is superfluous to arrive at the nub of knowledge about the subject of a work. The poet's chosen medium is manipulated so all parts and means belong together in focusing on the subject. A successful effort is a truth evoking a sense of satisfaction unique and intrinsic."[8]

The change occurring in Crown's work is illustrated by *Slopes of Palos Verdes Hills and Sunset* of 1962 (Fig. 10) and by the 1964 *Spring and the Sea* (Fig. 51). Both these paintings demonstrate that the deliberately harsh manner of some of the earlier paintings has yielded to a lighter, happier, and more decorative style. In conversation I referred to this trend as "lyrical," and the artist objected. In Crown's lexicon "lyricism is a proneness to euphoria about a subject. This buoyant feeling is often, in the art world, thought lesser than the graver, leaner treatment of subject in poetry."[9] In 1974, however, Crown was included in an exhibition at the Lang Gallery at Scripps College in Claremont called "The Lyric View." Instead of the usual exhibition catalogue, the Lang Gallery provided a single sheet of

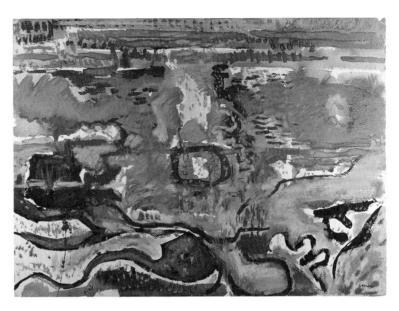

51. *Spring and the Sea*, 1964, watercolor and pastel, 22 × 30.

paper printed on both sides. The definition of lyricism included in this statement reads, in part, "Like the lyric poet, the lyric artist deals with personal feeling and emotion rather than with epic narrative and drama. His art is often personal and intimate, even private." Crown ranges over all these categories, so applying the rubric *lyric artist* to him requires a very careful selection of works. *Slopes of Palos Verdes Hills and Sunset* and *Spring and the Sea* are executed in both watercolor and pastel. "Watercolor," Crown stated, "does not allow for the kind of physical force you can get with a palette knife in an oil. But pastels give me a chance to push on the paper."[10] In 1962 the rainfall had been plentiful, and the lush vegetation may also have inspired these opulent landscapes.[11]

Climatic opulence was not a factor behind the many paintings Crown executed in Los Angeles, Wisconsin, and Massachusetts while on sabbatical leave in 1964, yet most of the

7. Tape 8. 8. Letter of 24 July 1985. 9. Ibid.

10. Tape 4. 11. Ibid.

watercolors and watercolor and pastel pictures reflect this new spirit. An almost unbelievable outburst of sensuous color fills such paintings as *Sunset on Seas from Palos Verdes* (Fig. 52). While he taught during the summer of 1964 at the University of Wisconsin at Milwaukee, this trend continued with works like *Wisconsin Garden* (Fig. 53) and *Wisconsin Countryside* (Fig. 54).

Even though Crown expressed the view that this ebullient style might have occurred whether or not Patricia Dahlman had come into his life, it seems clear enough that meeting her was decisive in stimulating the new direction in his work.[12] Crown began a relationship with Pat in 1961 that culminated in marriage, and the artist makes clear the link between her and his paintings of this period. "When Pat and I came together my life changed dramatically. I loosened up and enjoyed painting. Before that I was a tiger about learning how to paint and was very grim. Now I could relax and just respond to the colors and I called myself an abstract impressionist. I was immensely happy personally—my life was the happiest it has ever been, and I painted that way."[13]

From Wisconsin, Keith and Pat went to Massachusetts. Pat, trying to make clear that Keith's art cannot be divorced from his feelings, has written, "He's never cared for [the] New England landscape, yet he did remarkable paintings in Massachusetts. Because of the autumn and early winter seasons which he hadn't experienced for 15 years or so. Because we were living in this unheated, unplumbed, out-house, primitive place with a little (4 year old) kid. Because I was crazy about it, and we were crazy about each other. We went to New York and Boston to the museums too, taking a break from buying kerosene for the lanterns and picking up firewood [gathering it in the woods 'like Hansel and Gretel,' she noted]. During that particular sojourn we also went to Stonington, Maine. In other words we went to all the Marin places: New York, Maine, the

12. Patricia Dahlman Crown, Associate Professor of Art History at the University of Missouri-Columbia. Pat and Keith were married in 1966. 13. Tape 4.

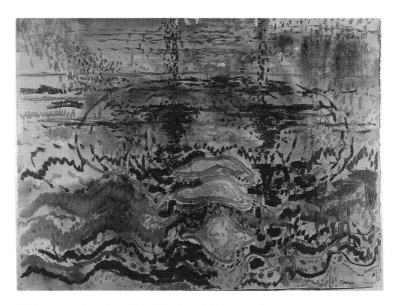

52. *Sunset on Seas from Palos Verdes*, 1964, watercolor and pastel, 22 × 30.

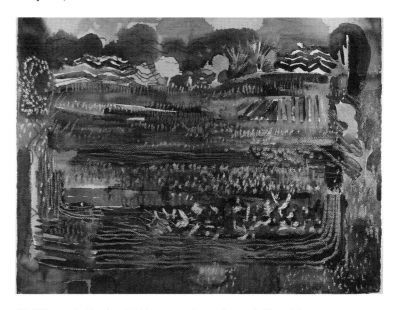

53. *Wisconsin Garden*, 1964, watercolor and pastel, 22 × 30.

Adirondacks, the Berkshires."[14] The four-year-old child was Pat's son, Paul Kennedy.

In Williamstown, Massachusetts, Keith and Pat shared a house set in a meadow, in the Berkshire hills with a view toward Vermont. Crown found the Berkshires "markedly different from California and the midwest. The light is blue and limpid, it's very northern, the vegetation (hardwood forests intersected by tough upland meadows), and prospects of cold heavily forested hills, create a real and poetic landscape much celebrated by Edna St. Vincent Millay, among poets, and Marin among painters." The spirit of renewal and release that filled the artist at this moment of his life transformed the paintings he did at this time into unrestrained celebrations of life.

While Crown hates the whole notion of collage, at least for himself, a number of the paintings from Williamstown have feathers glued to the surface of the paper. He explained that he and Pat "lived in our cabin and I painted out on the front porch. The meadow was covered with Queen Anne's Lace, which has a funny, pronged blossom. It develops these prongs when it wilts and dries, and they look tawny and in the sun they get a kind of pink-orange color. Every now and then also you'd see a flash of red-orange when a flicker passed through the sunlight. When we were driving one day I found a flicker lying dead on the road. It had probably been hit by a car but was in beautiful condition, and I brought the whole bird back [to our cabin], saved some of his feathers, and buried the bird. Some of these feathers are in several paintings I did there."[15]

Two outstanding examples of landscape with attached feathers are *Flicker in Queen Anne's Lace* (Fig. 55) and *Above Williamstown, Massachusetts, with Feathers* (Fig. 11). The latter painting is in a mixed media of watercolor, acrylic, pastel, and feathers on paper. Crown began to work in acrylic about 1962 or 1963.

Above Williamstown, Massachusetts, with Feathers is very intriguing because, among other things, the artist created in it a border—an inner frame—something that is rare in his work.

14. Note to author, August 1985. 15. Tape 9.

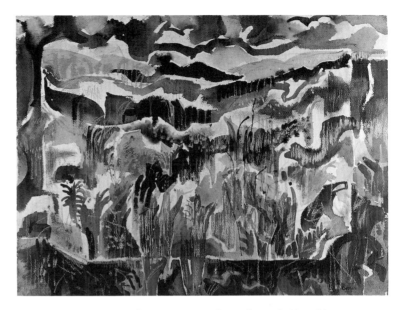

54. *Wisconsin Countryside*, 1964, watercolor and pastel, 22 × 30.

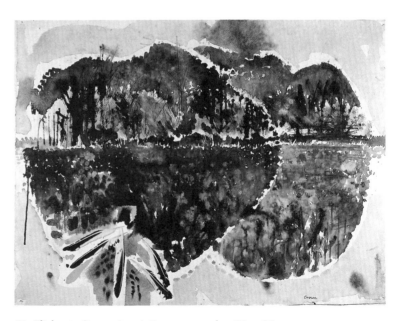

55. *Flicker in Queen Anne's Lace*, watercolor, 22 × 30.

This inner frame partly derived from his great interest in John Marin's art. "I always tremendously admired Marin's frame within a frame, and I tried to develop this idea on my own. It is what I call my peripheral area. Your eyes are fastened to a central part of the painting. The rest is peripheral, but does effect the painting subject. It is this peripheral power that greatly interested me—especially the power of peripheral color." [16] As Pat Crown informed us, Keith spent some weeks on the coast of Maine at Stonington. This visit to Maine appears in part to have been a tribute to Marin. Crown likened the Maine coast to the music of the Finnish composer Jean Sibelius. The more specific source for such a border, however, was closer at hand. Writing of this same painting Crown stated categorically, "This border derives from my love of oriental carpets, which generally have rich borders."

The best known of the Massachusetts paintings is *Flicker in Queen Anne's Lace*. In her introduction to the catalogue of Crown's one-man show in 1966 at the Long Beach Museum of Art, Constance Perkins commented on a side of Crown's approach to art that has been touched on here but requires greater elaboration. Perkins observed that Crown had "the feeling that he was becoming too facile with the medium of watercolor. Posing a unique obstacle for himself, he picked up a piece of Queen Anne's lace and putting it on his paper began to paint around and through the intricate network of its blossom. Thus it became the negative image—the unpainted paper—that was to carry the symbol. Crown has continued to use the device . . . he places the objects—rocks, shells, sticks, weeds of all varieties—on the canvas or paper, painting around them, painting further, replacing and painting again until a myriad of images appear imposed on each other."

To this moment Crown worries about over-controlling his medium—now increasingly watercolor—and employs all types of strategies to protect himself from what he perceives as the pitfall of his own facility. More than fifteen years after Perkins's essay, he explained that he was trying methods that would in-

troduce the element of chance in his painting. "I won't really know what it's going to look like [until he takes off the twigs, rocks, shells]. I was trying to anticipate, but I really won't be able to know." [17]

Crown had utilized all types of inventions that autumn in Massachusetts, including nipples he devised for his paints so he could draw directly on the picture with the tubes of acrylic color. The works from this time also reveal a prolific application of dotlike shapes. These shapes derive partly from Crown's great interest in Georges Seurat. One suspects he may have carefully studied the *Sunday Afternoon on the Island of La Grand Jatte* while he was a student at the Art Institute. But the artist emphatically points out that these dotlike brushstrokes were suggested mostly by "the dotlike appearance of Queen Anne's Lace."

Actually, these dot or dash strokes appeared in Crown's work at least as early as 1959, when he applied them on a very balanced, emotionally neutral landscape painted in watercolor and pastel, titled *Foggy Seascape* (Fig. 56). Done in the more exuberant manner of the sixties is *Ocean Sunset*, from 1962 (Fig. 57), painted in the free dynamic rhythms and baroque energy characteristic of this period of Crown's art.

In a watercolor from the summer in Wisconsin, *Summer Landscape* (Fig. 58), the dots are fewer, the texture less emphatic than in the Williamstown paintings, but they are present. In a picture already referred to, *Spring and the Sea* (Fig. 51), presumably painted in California, the dots become dashes, a variant of the pointillist brushstroke. Yet in another watercolor seascape, *Seascape with Clam Shells*, of 1964 (Fig. 59), there are virtually no such shapes. Therefore, Crown was not systematically exploring pointillism, but his fascination with that manner was to arrive at a superb climax in some of the watercolors he painted in Illinois in 1970–1971.

The artist explained his fascination with the dotlike brushstroke further: "I like dots in painting. I liked them much in Matisse [who went through a pointillist phase in 1904], in par-

16. Tape 4.

17. Tape 9.

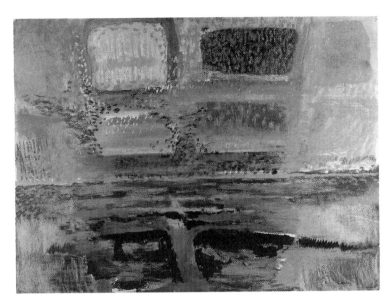

56. *Foggy Seascape*, 1959, watercolor and pastel, 22 × 30. Collection of Patricia Dahlman Crown, Columbia, Mo.

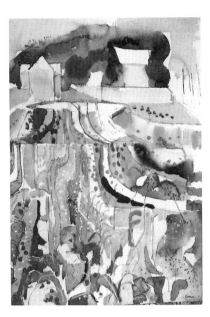

58. *Summer Landscape*, 1964, watercolor, 30 × 22. E. Gene Crain Collection, Laguna Beach, California.

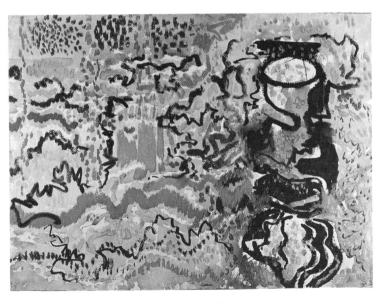

57. *Ocean Sunset*, 1962, watercolor, 22 × 30.

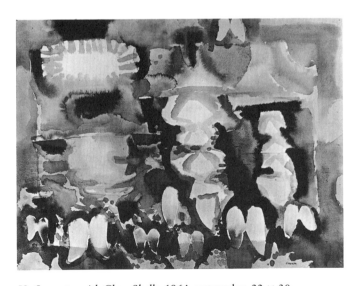

59. *Seascape with Clam Shells*, 1964, watercolor, 22 × 30. Present location unknown.

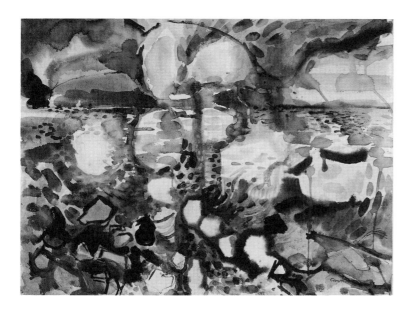

60. *Wet Seas*, 1965, watercolor, 22 × 30.

ticular, and in others. My dottiness eventually got to that post-impressionist, Seurat." He also noted that there was a revival in the application of pointillism in the sixties and seventies in the Los Angeles area for which he might have been the source. (Such a statement by Crown is not ego or idle fantasy. He taught scores of artists at USC, and a number of these students went on to successful careers of their own, for example, Peter Plagens. Many teach in colleges and universities around the country and in Canada.) Crown made clear that he "never did total pointillist painting, but rather used patches of it as an enrichment with other textural painting effects. I still do a bit when a good occasion to do so arises."

Crown credits his activity in watercolor with enabling him to penetrate some of the restraints of his earlier work. The fact that he was receiving more recognition as a watercolorist than as

a painter in oil or casein encouraged him to work more in that fluid medium and eventually to abandon entirely oils and acrylics as he had already abandoned casein. Watercolor liberated his style and greatly enhanced his color. As mentioned before, the richness of the countryside in California and Crown's meeting of Pat may also help to explain changes in his art in 1962.

There is at least one other component, however, to these changes in Crown's art: "strenuous and difficult working," the artist stated, "and then you reach a point where all of a sudden you just kind of let loose and relax and you break through into an area—not necessarily forward or backward—you just go into a period that's much freer, relaxing, and enjoyable."[18]

Crown believes that any artist who allows himself to be trapped in a specific style is lost—that part of the dilemma faced by artists such as Jackson Pollock and Mark Rothko is that their style and vision reached a point of stasis. It must have seemed to them that there was no place left to go without constantly restating the same idea and look. Crown feels that his ability to avoid such a trap is primarily based on his link with reality. That is, he allows the manner of the picture to be at least partially dictated by the subject itself.[19] He sees this same willingness to respond to the subject in American artists he greatly admires, such as John Marin and Winslow Homer.

Back in Manhattan Beach in 1965, Crown continued to explore the more sensuous path that had dominated his work from about 1962. And he returned to one of his favorite themes, the ocean. *Wet Seas*, a watercolor (Fig. 60), is remarkably distinct from the caseins done in the very late forties and into the fifties. The anger present in many of the earlier paintings dissolves into free, organic forms painted in a vivid range of color. To a large degree, Crown credits the familiar subject of the ocean with aiding him in advancing his style. "The ocean and its sky gave me great freedom to do whatever I was capable of because there is little or no articulation, just great empty plains of difficult color that require your complete attention and great imagination if a painting of any interest is to be produced."[20]

18. Tape 8. 19. Tape 12. 20. Tape 8.

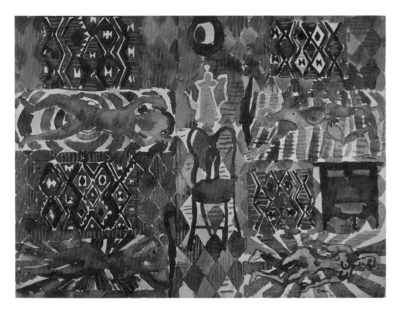

61. *Three Times My Love*, 1962, watercolor, 22 × 30. Collection of Patricia Dahlman Crown, Columbia, Mo.

As will be pointed out later, his experience painting the ocean served him well on his first visit to Illinois.

Crown's manipulation of color is too refined to attribute to instinct alone. In fact, Crown is something of a scholar in the area of color.[21] "I have assembled a small library of books and material on color. I have done a lot of experimenting in laboratory-like situations. I think I know a tremendous amount about color. It is not general information. I have figured out some things. I've made some discoveries on my own."[22] For example, he developed a color-music device and gave concerts. And, as a painter, Crown is greatly concerned with the ephemeral nature of pigments.

21. Ibid.
22. Crown reviewed a new addition of M. E. Chevreul's *The Principles of Harmony and Contrast of Colors and Their Applications to the Arts*, *Art Bulletin* 51 (1969):408–9. The review is reprinted in the Appendix.

Crown was motivated in his research on color by his desire to comprehend how Cézanne adjusted his color to build space as well as form. In a 1963 sketchbook he spelled out his admiration for Cézanne, seeing qualities he wished to use for his own work as well as recognizing differences. "Cézanne creates a plastic depth with colored planes. I love this, but more I am filled with the idea of color speaking, not just constructing." Crown's interest in color ranged further afield than Cézanne's. "I'll construct so that the painting holds together to create the formal aspect of my painting. Matisse is somewhat like this, but he mainly decorates with color as well as using enough structural color to maintain formality of design. I admit also to an amount of decorative color. Perhaps I am closest to Van Gogh's use of [symbolic] color. I also like many of Albers's ideas—the interaction of color." However, Albers's emotional neutrality and his commitment to geometry had no appeal to Crown.

In the sixties Crown did a series of paintings executed inside his house at Manhattan Beach (see Figs. 61, 62). He had painted indoors before, but these watercolors are distinguished from earlier efforts in that the theme is the female nude. His wife modeled for the paintings. Crown has always felt on uneasy artistic ground in paintings in which the figure dominates. He feels frustrated by what he perceives as a dichotomy: his degree of development in his landscapes, and his "inability" to abstract the human figure to the same degree. "I often came back to figures. I tried to bring them into my style, and I had difficulties. I still try, and it bothers me not to be able to accomplish it [to my satisfaction]."[23]

It can be argued that these paintings are successful but different from the landscapes. He took great liberties with the landscape that he was not willing to take with the human figure. Mainly, he was totally unwilling to lose the female form in the kind of abstraction he had evolved in his landscapes. And the paintings in which he did make such an effort appear frail and tenuous. In one of these watercolors Crown has flattened

23. Tape 6.

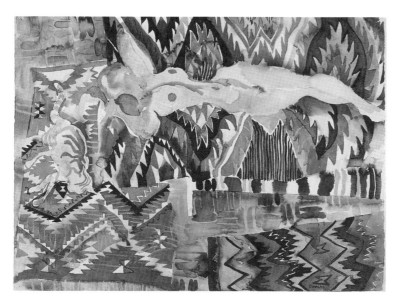

62. *Domestic Scene,* 1966, watercolor, 22 × 30. Collection of
Patricia Dahlman Crown, Columbia, Mo.

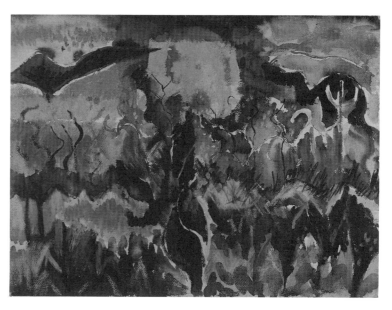

63. *Blossoming Spring,* 1966, watercolor, 22 × 30. Collection of
Patricia Dahlman Crown, Columbia, Mo.

the space of the entire room, which is layered with Navajo rugs,
and placed deliberately crude images of the nude in the four
corners of this space (see Fig. 61). Here he was pursuing unity
by bringing the figures into harmony with the setting—depict-
ing them like pre-Columbian images on Native American rugs.
However, by disguising the obvious sexuality of the female fig-
ure he blunts his entire reason for doing this subject.

Crown has to struggle between the reality of his sexual re-
sponses to this subject and his sense of what a painting should
be. "I believe a complexity of influences determine my aesthetic
judgments while painting, the most powerful being sexuality—
my response to the female: her visual aspect, motions, odor,
voice, tactility—which strongly tinctures consciously or sub-
consciously how I view the world."[24] He pointed to one of

24. Ibid.

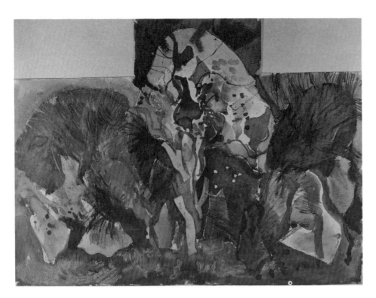

64. *Blossoming Orchard near Santa Barbara*, ca. 1966–1967, watercolor, pastel, collage, 22 × 30.

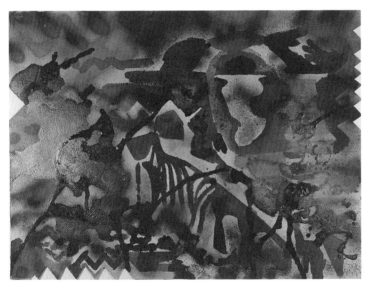

65. *Ocean and Manhattan Beach Pier*, ca. 1967, watercolor and acrylic spray, 22 × 30.

these pictures and said, "But see the eroticism in these blasting out like mad."[25] And it does.

In a larger sense, Crown incorporates sexuality in his work on the level of symbols. "I see palm trees as phallic symbols with great orgasms. I see the mountains as very feminine. I see these great vaginal forms."[26] An early example of sexual forms in the landscape is his *Blossoming Spring*, 1966 (Fig. 63), in which the center top shape and color symbolize a woman's belly. However, in this particular painting Crown feels the color is more crucial than the form. "While there is some abdominal shape, the vital thing is the color. It is *the* color of Patricia's abdomen—a color I knew and loved and set in the exuberance of spring floral weeds." *Blossoming Orchard near Santa Barbara* (Fig. 64), a watercolor, pastel, and collage, was executed in 1966 or 1967 and is an early example of Crown's experimentation with format. The artist remembers that when he was in the Pacific during World War II someone sent him art magazines, and he recollects reading an article on Charles Burchfield. What stayed with him is the information that Burchfield, to create a larger than typical watercolor, pieced papers together. Eventually, in the seventies, Crown utilized this method to make watercolors reaching eight or nine feet in width. However, this piecing together led him to question the traditional rectangular shape for a painting. *Blossoming Orchard near Santa Barbara*, cut from one piece of paper, demonstrates that the artist was already thinking about ways of varying the shape of the paper and, in this way, anticipates the more ambitious works of the following decade.

Another painting, *Ocean and Manhattan Beach Pier* (Fig. 65), executed in watercolor and acrylic spray, has notches cut into part of each side of the picture. Intriguing is the fact that the cuts into the paper preceded the painting itself. This experiment was carried through about eight pictures and no further.

Even in the midst of the creative flow of opulent color and biomorphic forms, Crown produced work that in comparison to the openness of the majority of paintings from the sixties is

25. Tape 2. 26. Tape 6.

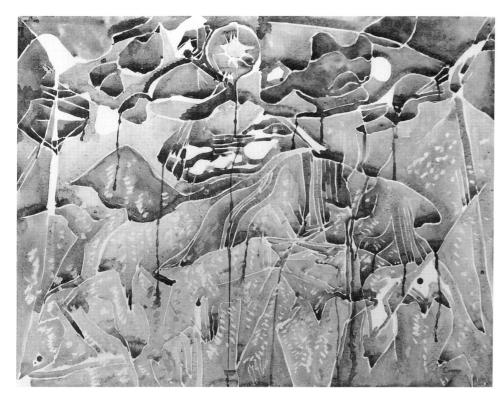

66. *White Line California Landscape*, ca. 1965, watercolor, 22 × 30. Courtesy Mr. and Mrs. Richard Couchman.

restrained and carefully structured (see Fig. 66). Such work is a reminder that the artist conceived of the world as a combination of spirit and intellect, of feeling and ideas—the "'ghost in the machine.'" In a 1968 sketchbook he elaborated this conviction. "All types of 'good' poets have the necessary formative sense. (The formative sense is a mental grasp of the growing unity within a single work that admits, rejects, creates the completion of the work—resolves it)." Crown believes the painter is a poet who relies on his visual senses. A poet must say or write something; the painter-poet must visualize the subject. There is a precarious balance between the world of ordinary appearances and the world as filtered through the artist's intellect and emotions. If these two elements—perception and conception—

conflict, it is the abstraction of thought and feelings that must triumph.

Crown's approach to his art involves a persistent search for new ways to revitalize his creative forces. In 1964 he painted a watercolor titled *Sea and White Line Symbol* (Fig. 4), which he feels is one of his most striking and successful works. The dominant feature of this painting is its white lines, which are unpainted areas surrounded by paint. The watercolors of this genre are part of the artist's ongoing struggle to explore and enlarge the range of his pictures. "The idea," he wrote, "was to achieve an unconventional painting in part. I studied the subject carefully (and, of course, I was well acquainted with the sea already), then created a simple linear symbol. I sketched this

simple linear symbol on my paper, then proceeded to paint the subject in full color and value contrast in back (or around) the lightly sketched symbol. The symbol and the painting seen through it dealt with the same content, and the linear symbol was a structure on which the meat of the painting was hung."

During the summer of 1967 in Calgary, Canada—Crown taught summer school at the University of Calgary—he painted one of his finest works of this period. *Plains of Calgary, Canada* (Fig. 67) departs from more orthodox versions of the white-line idea through the delightful addition of a feather glued to the painting's surface, recalling the wonderful paintings created in the Berkshires in 1964. In fact, the artist, in retrospect, feels the Massachusetts painting *Flicker in Queen Anne's Lace* "unwittingly fits this idea."

An analogous series of paintings was being created at about the same time, and to these Crown literally gave the title *White Line Paintings*. Two excellent examples of this series are *White Line—Manhattan Beach Pier and Sun* of 1966 (Fig. 12) and *White Line Pier Manhattan Beach* of 1968 (Fig. 68). While both these watercolors are successful and strong, the main thrust in creating them was the technical challenge. The 1968 picture is illustrated in Gerald Brommer's *Transparent Watercolor: Ideas and Techniques*, and the accompanying text written by Crown reads: "I call this . . . painting a white-line painting. No rubber cement, wax crayola, masking tape or a stop out of any kind has been used. A general color and value were determined at the outset. The general color varied according to nature only slightly. The value contrast is also slight, so that when the painting is complete, the most striking quality is the white paper left untouched between the painted passages. This method of painting is very strenuous. In a painting using stop out, the line achieved is an end in itself. In my painting, the white line is a by product of space left between painted shapes, and the character of the line is very different from a stopped out line."[27]

27. Gerald F. Brommer, *Transparent Watercolor: Ideas and Techniques* (Worchester, Mass.: Davis Publishing, 1973).

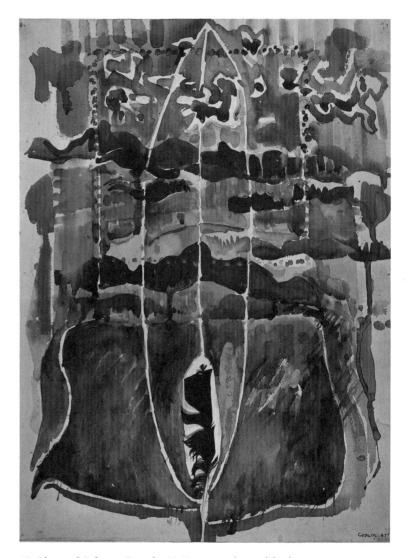

67. *Plains of Calgary, Canada*, 1967, watercolor and feathers, 30 × 22. Collection of Katie Crown Webster, Phoenix, Ariz.

Even taking into consideration that the book stresses technique, in correspondence with me Crown came to the conclusion that his emphasis had been too strongly weighted in the direction of technique, so he abandoned white-line painting. It was in his storehouse of what could be done in watercolor, however, and, in 1970–1971, while at the University of Illinois, he created some paintings that resurrected the white line with astonishing results. If anyone complained that pictures such as *White Line Pier Manhattan Beach* were decorative, that was all right. "Some people are scared of the word *decorative* . . . but I think most all really good paintings do have a certain decorative quality to them." In fact, referring to Matisse and Gauguin, Crown states simply that decorative values "are intrinsic to art."[28]

For Crown, who thinks of himself as a painter-poet, it was gratifying that, inspired by a white-line watercolor she possesses (Fig. 66), his friend Jane Couchman wrote this poem for him:

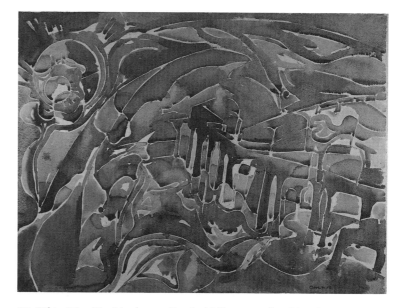

68. *White Line Pier Manhattan Beach*, 1968, watercolor, 22 × 30. Collection of Patricia Dahlman Crown, Columbia, Mo.

> One flexed muscle pushed him
> To the room's white line;
> He is delineated now by languorous prose,
> Gathered to ward off "colorist" and "limn."
>
> Half-light is soothing after a long day
> Riveted in that blinding eye,
> Shoulders broadening, chest expanding
> To absorb his own rebounded energy.
>
> It has shaped him for confrontation:
> From latent surfaces the geese take flight.

While creating the white-line paintings, in 1966 or 1967, Crown made a decision about his technique of watercolor painting that has had a strong impact on virtually all his watercolors since: He started to use the airbrush. This new instrument was initially part of his ongoing quest for challenges: "In

28. Tape 8.

that visible struggle lies the excitement. In that visible struggle is an awareness of a mind hard at work in the paint to wring some meaning from [it]."[29] The addition of the airbrush turned out to be momentous in Crown's career as an artist. It was in Taos in the summer of 1969 that the enormous artistic strides the airbrush was to bring to Crown's work first became visible, as we shall see.

In a 1978 article in *American Artist*, Crown referred to his watercolor spray as "the tool I believe has lent the most distinguishing character to my painting . . . an air tank, hose, and airbrush."[30] He noted that his interest in the airbrush grew naturally out of the aerosol spray he had used in his oil and acrylic paintings as early as 1948. He informed the readers of his article—it was aimed at watercolor enthusiasts—that the airbrush was developed partly as a commercial tool to quickly cover large areas with a smooth coat of paint. But he had converted the airbrush into what he termed a "painterly tool." In the same article Crown elaborated on the technical uses of the airbrush in his art. "An airbrush filled with watercolor will spray on top of and through layers of paint. It spatters broadly and makes wispy mists. It makes distinctive lines, spots, and shapes. The airbrush cup loaded with clear water can plow a fine, light line through delicate or heavily painted areas. One of the unique things I've done with the airbrush was to spray the different colors of a planned mixture, one by one, onto a wet area of clear water. In some places the mixture produced a lively, smooth color; in other places the colors of the mixture subtly dispersed. The overall effect is pearlescent." Despite the emphasis on technique, it is possible to see how the use of the spray broadened the possibilities of his work with watercolor and, in fact, propelled him toward his greatest accomplishments in that medium.

In 1969 Crown had an exhibition at Occidental College in the Los Angeles area. William Wilson, art critic for the *Los Angeles Times*, reviewed that show on 16 November 1969. Wilson stated that the artist was "right on the border between depicting real things or depicting pure abstraction." In the last paragraph of the review Wilson wrote: "Crown remains an authoritative painter who will not be bogged either by his chosen stance or his constant tendency to slip comfortably into some formula. He always attracts the relevant past and the exciting present. These works reach back to Marsden Hartley, Charles Burchfield and Georgia O'Keefe [*sic*]. [He overlooked the essential link with John Marin.] But, in their careful way, they are as mystical and psychedelic [a term two later critics would also employ] as a light show and probably a lot more clearly connected to American tradition." Crown has called this "perhaps the best and most perceptive review I ever received."

It is significant to understand that, while Crown made a few unsatisfactory experimental essays into nonobjective art, he in truth opposes totally abstract art. And, in Crown's view, he has spent much of his adult life avoiding the trap of nonobjective art. But he continues to feel that by remaining in touch with nature in his own art he was also assuring that he would be of lesser interest to the taste makers of the time. In an undated notebook he wrote: "I disagree with the implication that pure abstraction is the more difficult position to take. There is no *easy way* to make a really good painting. What is easier, if you want, is to be fashionable; which pure abstraction currently is. This is also apt to receive favorable critical attention."

What Wilson could not have known in 1969 is that this fifty-one-year-old painter had not yet reached his full creative potential. Most of Crown's artistic development from the time he arrived in Los Angeles was a necessary journey to understanding—of himself and of what he was capable of achieving. It wasn't an easy trip. "For me," Crown said, "painting is difficult work. It requires hard thinking."[31] Yet he knew he was not aiming only at his contemporaries. He understood that art must pass a test of durability. "I want," he stated, "to speak, exist in the time that has not yet passed."[32]

29. Undated notebook.
30. "Watercolor Page: Keith Allen Crown," *American Artist*, October 1978, pp. 44–47, 100–101. This article is reprinted in the Appendix.

31. Undated notebook. 32. Sketchbook about 1960 or 1961.

3. Fruition

It is impossible to know for certain whether the significant changes that started in Keith Crown's art in 1969 would have taken place if he had not gone to Taos. (*Sunset and Sea from Palos Verdes Hills* [Fig. 6] suggests he was already experimenting with the ideas he grappled with in Taos.) What is certain is that in the summer of 1969, in Taos, the artist figuratively brought together what he had learned up to that time and prepared the way for a marriage of vision and style that was to be fulfilled a thousand miles and one year away. Characteristic of Crown, he arrived in Taos with a self-styled task: to produce one hundred watercolors combining spray with brush and eschewing the usual preliminary sketches.[1] (As if that were not enough, he also created eight canvases in Magna acrylic, aerosol spray enamel, and oil paint, and a movie of himself working!) Crown returned to Taos almost every year, and the landscape of northern New Mexico became one of his chief subjects.

It would undoubtedly be instructive if all one hundred watercolors were available to study in their proper sequence, since Crown did number them consecutively. After so many years, however, many have passed into private collections scattered throughout the country. But with only a small sampling at hand it is still possible to see the metamorphosis taking place. The very first painting (Fig. 13) is overwhelmed by sky produced mostly by spraying, as he struggled to dominate and control his new tool. Yet at the very base of this same work can be seen a

mountain whose zigzag silhouette reveals one of the characteristic forms that now entered his repertoire of design. This particular shape is more dominant in other paintings of the series, although it is absent altogether in some.

The angular shape of the zigzag is a familiar one in Indian art of the American Southwest. It is a pattern that is found in weaving and pot decorations as well. Certainly, Crown, as a collector of Indian art, was familiar with such motifs. As was noted before, he used them quite literally in some watercolors of female nudes in an interior executed in the mid-sixties. However, in those works the zigzag motif maintained its identity as Indian rug decoration. In Taos, perhaps for the first time fully responding to the place itself, Crown arrived at the zigzag as the Indians must have discovered it: It is there, inherent in the mountains and mesas themselves.

The Pueblo Indians of northern New Mexico evolved a pictorial language that translated observable fact into symbolic form. In that process the zigzag of mountain and mesa was extracted and stylized and altered into a pictograph or a sign. In a similar way the sky, so prominent and dramatic in New Mexico, was also transformed into symbols by the Indians. Crown, in a real sense, shared with Native Americans the comprehension that to simply depict what you see would produce results that can only be a pale reflection of actuality.

His new spray technique allowed him to use the sky as a point of departure to create areas of the paper that parallel to some degree what is there (see Fig. 69). Crown is not the first Anglo to observe the almost overwhelming drama of a New Mexico sky—John Marin and Andrew Dasburg had focused

1. Crown cannot recall where he read that Marin had painted something like fifty watercolors in a short period of time. It is likely he read it in Mackinley Helm, *John Marin* (Boston: Pellegrini & Cudahy, 1948), p. 31.

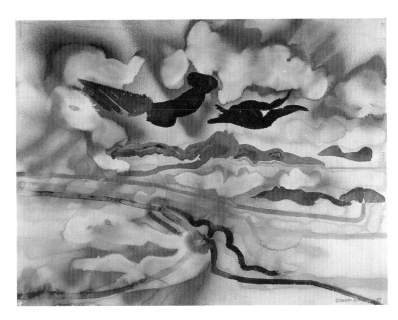

69. *Tres Orejas*, 1969, watercolor, 22 × 30.

on this great panorama before him.[2] However, the forceful and fanciful nature of Crown's skies has little to do with Marin or Dasburg. As always, the artist insists on developing his own language. As he might postulate it, "How can one express one's own feelings using another's language?"

Taos became a fulcrum of his art, not only because of the essence of the place itself but also because while there he was able to give his painting his full attention for long periods of time. "In Los Angeles I was teaching or would be between semesters and I didn't have a long block of time to paint. But when I go to Taos I paint every day and the paintings keep piling up. That ability to form all that complexity which goes

into a painting and have [it] ready [to use] develops well only if you have the time to work consistently. If you only paint three paintings a week you can't reach the stage I arrived at in Taos."[3]

Late in 1969 Crown had a one-man exhibition at Occidental College in Pasadena. It contained some examples of the work done in Taos during the summer of 1969. Crown's friend and former student Peter Plagens wrote in the February 1970 issue of *Art Forum*, "Crown bullies through the traditional restrictions, and the traditional overtones of his medium and pulls off some of the best small painting in my direct experience." He concluded, "If Crown is unpretentious to a fault, he is also a very good painter."

Plagens had written favorably about Crown in the sixties, but in this review he failed to grasp the new beginning now happening in Crown's art. More troublesome still is the writer's somewhat condescending tone as he states that Crown has been ignored because "he's a watercolorist, a landscapist and a college professor" without explaining why these facts should result in any artist being ignored. Perhaps, however, these factors motivated Plagens to omit Crown from his chronicle of recent southern California art, *The Sunshine Muse*.[4]

Influential art critic William Wilson, in the 20 March 1970 edition of the *Los Angeles Times*, expressed great enthusiasm for Crown's work shown at the Jacqueline Anhalt Gallery. "Keith Crown's art," he wrote, "shows one of the most underplayed of mature California talents. His second solo exhibition of the season shows a growth so continuous and organic its differences are as hard to express as they are noticeable. Crown remains essentially a watercolor landscapist transported into the realm of abstract imagination experiencing itself evermore in active, wet strokes, that blend toward a lively plane." Unfortunately, after a few more years Wilson became one of those contributing by silence to Crown's remaining "one of the most underplayed of mature California talents."

2. Crown knew Andrew Dasburg well in Taos. John Marin visited Taos in the summers of 1929 and 1930 and renewed his friendship with Dasburg. Marin exerted a powerful influence on Dasburg, part of which was his bringing to Dasburg's attention the suitability of focusing on the very dramatic New Mexico sky. The best known Marin painting of this type is the National Gallery of Art's 1930 *Storm over Taos*.

3. Tape 6.
4. *Sunshine Muse: Contemporary Art on the West Coast* (New York: Praeger, 1974).

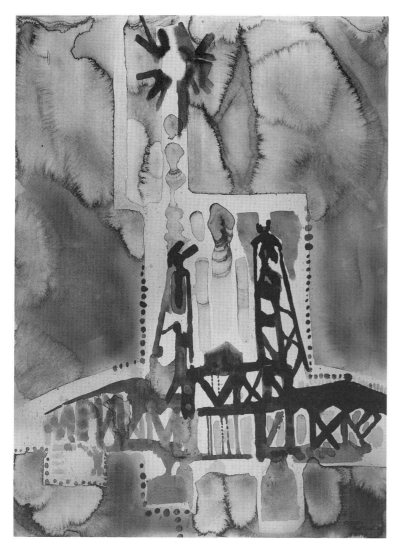

70. *A Steel Bridge, Portland, Oregon*, 1970, watercolor, 30 × 22.

In the summer of 1970, instead of returning to Taos (even though he did at this time purchase seven acres in the Taos area), Crown taught at Portland State University in Oregon. As a visiting professor he was not overwhelmed with teaching duties and had no committee assignments, so there was more time to paint. To the pictures created this summer (see Figs. 70, 71), Crown brought to bear what he had discovered in the one hundred Taos watercolors, and he began pushing that knowledge a little further, adding the effect of spraying paint from a Windex dispenser. The effect of the latter, not often repeated, was to establish a veil of atmosphere clearly distinct from the high, clear, brilliant atmosphere of northern New Mexico.

The coastline of northern Oregon, not far west of the city of Portland, is of an astonishingly different character than Redondo Beach. It is beautiful but rough, and its cold waters and treacherous currents make it generally unsuitable for swimming. One might assume that Crown would be attracted to

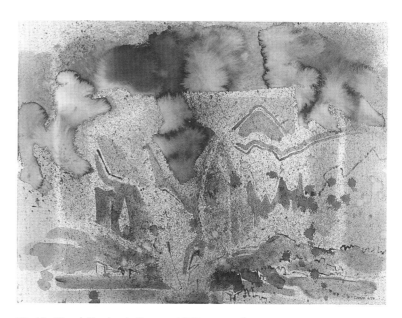

71. *Mt. Hood, Portland, Oregon*, 1970, watercolor, 22 × 30.

this rocky shore, rough water, and sun. He may very well have painted some works with this theme, but basically he chose subjects from the vicinity of Portland itself—its bridges over the Willamette River; the river itself; and such peaks in the distance as Mt. Hood.

In the Oregon watercolors a kind of order is imposing itself, different from the wilder, uninhibited rhythms of the Taos paintings. The forms and tints that result from his use of the spray gun tend to form a discernible pattern. Utilizing the Windex spray to symbolize the moist air was good practice for his first visit to England in 1973. In any event, the Oregon paintings, if not Crown's most impressive works, are solid and stately pictures that fit well into the important line of discovery going on at this crucial stage of his development. What is startling is that a sort of explosion in his art took place right on the heels of the Portland paintings.

Toward the close of the summer session in Portland, Crown received an invitation from the University of Illinois at Champaign-Urbana to become distinguished visiting professor of art for the 1970–1971 school year. Despite the poor timing of the invitation, he was able to arrange a leave of absence from USC.

There were strong emotional reasons the Illinois offer was extremely attractive to Crown. "I wanted to go back to the middle west where my roots are. From Champaign-Urbana it's 110 miles to Gary, Indiana, where I grew up, and about 110 miles to Keokuk, Iowa, in the other direction, where I was born. It is about 110 or 120 miles to the Art Institute of Chicago where I went to school, and my mother was in Springfield, Illinois. I was surrounded by familiar places. In a sense, I had come home." [5]

Crown felt he was in a place that was intimately related to who he was. Here there were subjects that struck empathetic chords that up to this time he had not dealt with. As a boy he had been to Champaign one summer with his father, who had graduated from the University of Illinois. He had forged his art in Los Angeles and Taos, in Calgary and Wisconsin, and in

Oregon and Massachusetts; nevertheless, he was "back with things from my past that I can still see as I saw them in the past and I have to try to make the transition and keep ahead with what I had gained." [6] In short, nostalgia was not to interfere with the progress of his art.

Crown's treatment by the University of Illinois certainly contributed to his sense of well-being and made it simpler for him to concentrate on his painting. He taught graduate painting and one course in advanced painting, teaching mostly in the evenings. Two other professors also taught graduate students—Jerome Savage, who had been a student of Crown's, and Peter Bodnar—and they welcomed him "into their midst, insisted I be consulted by the students and listened to what I had to say." This kind of respect and deference made returning to USC a little painful.

At the University of Southern California, when he returned in the fall of 1972, he was simply another person on the faculty. Crown was philosophical about it. "If Beethoven lived next door [to you] you probably wouldn't think anything of it. You would feed his cat when he went away for a weekend, and certainly you'd complain about all that banging on the goddamned piano at two in the morning. But you'd never think 'that's a musical genius right next door.'" [7]

In the final analysis, much more significant for Crown is what happened to his art during that time in Illinois. It was here that everything came together for him. It was here in 1971 that he stood at the edge of the soybean field and placed it within a totally unique artistic structure and logic. "I found," he said, "the direction more or less in Illinois that I had wanted to go for a long time." [8]

Some of the first paintings done in Illinois, such as *Illinois Landscape—Frozen* (Fig. 72; see also Fig. 14), utilize the zigzag motif that first became prominent in a number of the 1969 Taos pictures. But the motif is softened somewhat and could indicate a stream or a highway as the dark blue line snakes its way into the space of the watercolor. We also see how freely Crown ap-

5. Tape 2.

6. Tape 6. 7. Ibid. 8. Tape 10.

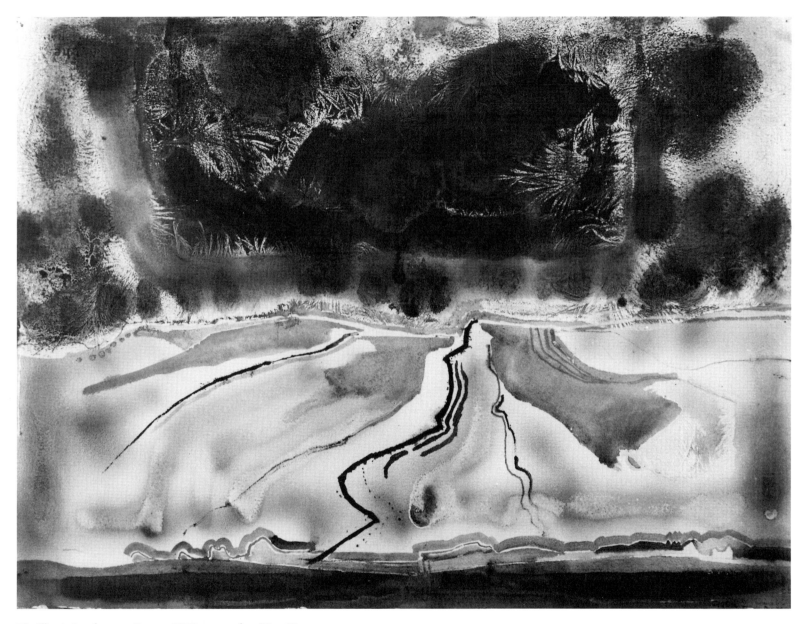

72. *Illinois Landscape—Frozen*, 1970, watercolor, 22 × 30.

plies ideas that liberate him from traditional perspective. Below the blue line, surrounded by pink and gray areas that could be fields on either side of the road or stream, is the curving silhouette of distant hills. Above the hills and stream or road, occupying half the space of the painting, is a very dark sky painted mostly in blue and black, with some russet hues. If you look carefully at this region of the sky you can see a network of short, pale lines in a fanlike pattern. These lines were caused by the freezing of the water on the paper as Crown worked.

He explained the phenomenon of frozen paintings: "Suddenly I'd be painting—I'd be very cold, chilled, and then I would realize something was the matter. It would take me a minute or two—it would so insidiously creep up on me—and I would realize the water on my brush had frozen—the water on the painting had frozen. And the brush would skid, and I would go over a passage to put another color over something, and I had this funny feeling and finally I would realize it was frozen."[9] The frigid weather had another impact on the work executed in Illinois: The cold was so intense that winter that it enforced a simplicity on the work. Since Crown believes he has a problem of putting too much in his paintings, he feels the simplicity imposed by bitter cold was beneficial to his art.[10]

Another visual idea evolved in Illinois figures prominently in the 1971 painting called *Grain Elevator and Farmland* (Fig. 73). Crown was impressed by the particular color of the earth on this flat farmland country and at times actually mixed the earth itself with acrylic medium and used it on the painting. The land exists on two horizons in this particular watercolor, and a large area above the second horizon is made up of a mixture of soil and acrylic. The bottom edge of the painting is used as a horizon constructed of a narrow stripe, a band broken only by some highly simplified renditions of farm buildings. On the very top edge of the paper is a red-orange continuous narrow stripe. These stripes, above and below, evoke a concept evolved later. The artist refers to them as "flags," and they were to be used mainly in his Taos landscapes. In addition, *Grain El-*

9. Ibid. 10. Tape 2.

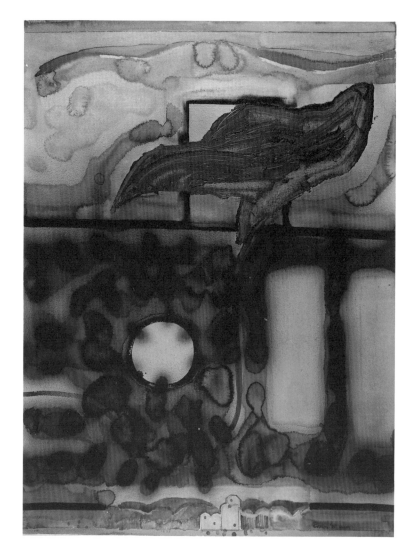

73. *Grain Elevator and Farmland*, 1971, watercolor, 30 × 22.

evator and Farmland illustrates how Crown had by this time controlled his spray technique so that it contributes significantly without overwhelming the painting.

There is a great range in the paintings done in Illinois in 1970–1971. *Blizzard in Illinois*, 1971 (Fig. 74), refers back to the so-called white-line paintings of the sixties. In this watercolor, however, the white lines are limited to the upper half of the painting and clearly are related to the snow and clouds connected with the blizzard. (Remember that such white lines are created by painting around them rather than by the application of a stop out.) Below the white-line zone are a starkly simple farm with hills beyond, a red sky, and black stormclouds. At this level the painting is surprisingly straightforward.

Another 1971 painting, *Fields in Illinois* (Fig. 75), seems unique. It is perhaps the most abstract and flat composition produced during this time. Indeed, except for the title this watercolor could be read as a nonobjective work, if Crown made nonobjective paintings. On one level the picture looks like the earth seen from some great height and curiously resembles some of the aerial maps Crown used in putting together his regimental history during the war (see Figs. 34 and 35). Such a resemblance could be gratuitous, but is it intriguing nevertheless. *Fields in Illinois* is also conspicuously decorative, although not in a pretty sense. There are biomorphic shapes reminiscent of Miró and relatively flat areas that evoke Matisse or Matisse via Milton Avery, the latter an artist Crown admires. The round and oval shapes in the very top band immediately call to mind the *Frozen Sound* paintings by Adolph Gottlieb in the fifties. While in general Crown stresses that he was not influenced to any major degree by the artists called Abstract Expressionists, he does admit seeing reproductions of the *Frozen Sound* paintings and liking them. "I admired one Gottlieb that reminded me of my sunsets on the sea—*Frozen Sounds*. I saw a black and white reproduction in *Art News* in the fifties or sixties."[11] However, these forms could have just as easily come from several landscapes John Marin executed in Maine showing sunspots or multiple images of the sun itself.

11. Tape 3.

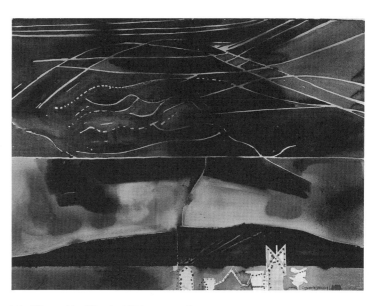

74. *Blizzard in Illinois*, 1971, watercolor, 22 × 30. Collection of Paul Kennedy.

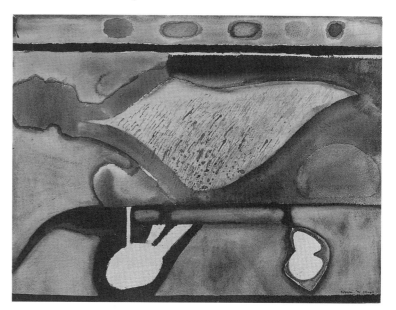

75. *Fields in Illinois*, 1971, watercolor, 22 × 30.

There are paintings fabricated in Illinois that illustrate Crown's rethinking of earlier concepts. One of these, *Round Barns*, 1971 (Fig. 76), has the white lines again but also has feathers glued to the surface of the painting. Feathers also appear on *Grain Elevators and Bean Fields with Feathers* of 1971 (Fig. 77). What is far more fascinating than the feathers in this latter work is the appearance of dotlike and/or dashlike strokes made with a twig or stick picked up while painting (using a bit of the landscape to paint the landscape).

Three watercolors, painted in three successive days in 1971 and all named *Soybean Field with Grain Elevator* (Figs. 78, 79, 5), are created in such a way that these points or dashes are decisive elements in the design and meaning of each. The strokes put on with a stick create areas of rhythm and contrast placed in a carefully thought-out pattern. These shapes also have a connection with the scene itself by echoing the stubble of the harvested soybean plants. The way in which these dots and dashes have both an abstract and a representational logic reflects Crown's understanding of what abstract—not nonobjective—art should be. "Abstracting," the artist stated, "means to me to find the essence [of the subject], and that's what originally the word *abstract* meant in terms of art." [12] For Crown, rightly or wrongly, nonobjective art is an anathema precisely because it loses its link to nature. And Crown loves nature too much to allow that link to break.

Crown's view of pure abstraction or nonobjective art is, appropriately enough, typically American. [13] About Mondrian he had this to say: "The effort of Mondrian to reduce all to a simple, impersonal solution is antithetical to nature. Nature does not have a simple order. There are no unrelated parts, but an infinite mobile-immobile expansion-contraction of animate-inanimate that is pure diversity, pure sophistication. Mondrian is marvelous, but by grasping a finite principal he wishes to succeed in reducing man to a vegetable to solve his problem

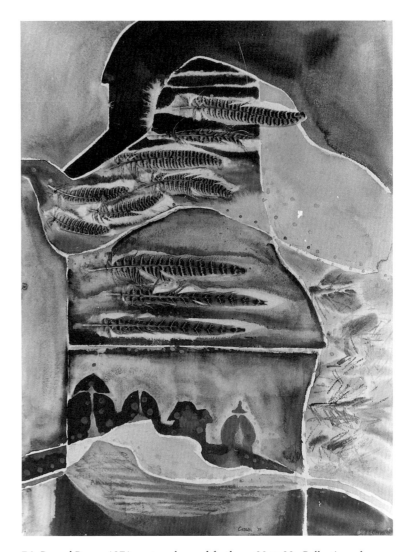

76. *Round Barns*, 1971, watercolor and feathers, 30 × 22. Collection of Patricia Dahlman Crown, Columbia, Mo.

12. Tape 8.
13. See Ruth L. Bohan, *The Société Anonyme's Brooklyn Exhibition: Katherine Dreier and Modernism in America* (Ann Arbor: UMI Research Press, 1982).

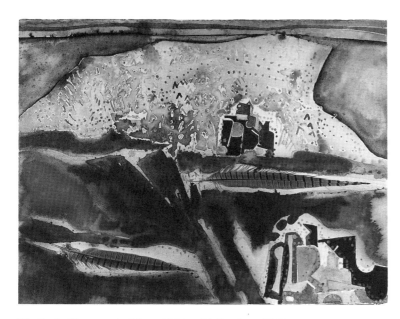

77. *Grain Elevators and Bean Fields with Feathers*, 1971,
watercolor, 22 × 30.

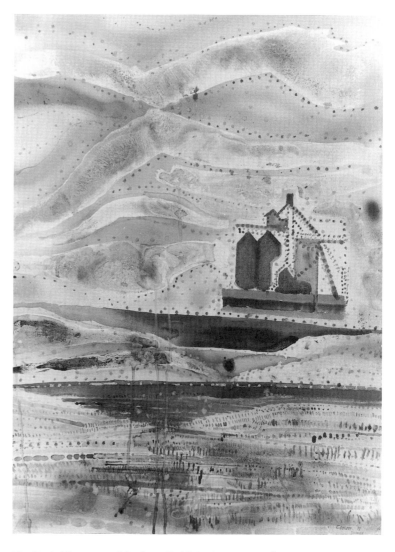

78. *Grain Elevator and Soybean Field, I*, 1971, watercolor, 30 × 22.

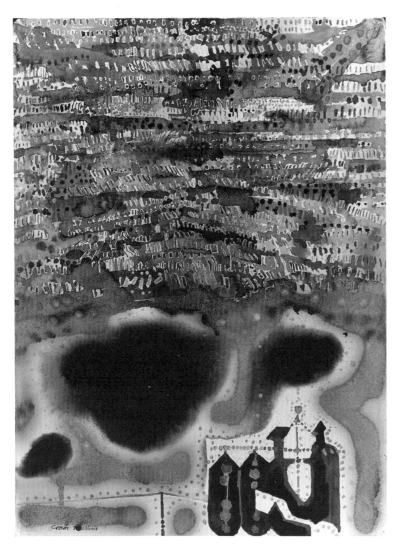

79. *Grain Elevator and Soybean Field, II*, 1971, watercolor, 30 × 22.

which is infinite for him."[14] In this statement Crown is concerning himself with the emptiness of final solutions.

In Mondrian, Crown does not see the mystic underpinnings of theosophy or a search for a deeper understanding of nature, but rather an artist who has reduced his paintings to a few given forms and colors. Crown firmly believes that the artist, the abstract artist, must be "stimulated to fresh ideas by the infinite, ever changing diversity of forms and colors in nature."[15] Crown trusts what is there, and his use of the dots and dashes in these watercolors exemplifies elegantly his connection to visual reality.

There is more to be said about Crown's painterly inventions. The dots and dashes clearly connect with his interest in Neo-Impressionism, and most especially Seurat. (Seurat was, after all, an idea painter who was abstract and never ventured into nonobjectivity.) Crown explained that he had adapted the pointillist brushstroke "to vary the texture and enhance the design." He was referring to earlier experiments in this direction, but his explanation is useful in the present context. "I used dots—not points—and the dots were in clusters—some clusters of large dots—some small—some in-between in size. Something totally different from Seurat who used uniform rather discreet dots that function not as dots, but as corpuscles of color."[16] So Crown was not emulating Seurat but borrowing part of the vocabulary for his own separate and distinct reasons.

I have mentioned that the dots and dashes of these Illinois works establish a certain measured rhythm. We are reminded of the language of music, and the analogy between art and music has a significant reality for Crown. Based on a drawing in one of his sketchbooks, Crown created a diagram of a tree tracing his artistic lineage. Above the tree are the names of recent painters and of John Updike. Just below these names, on the upper part of the tree, are the names of Copland, Stravinsky,

14. Sketchbook, circa 1969.
15. Tape 6.
16. Tape 8. In a sketchbook from about 1960 Keith made this entry: "Seurat a perfect artist—a great inventor, poet, draughtsman. When you see a painting of his in the right light at the right distance . . . it will create a sensation of space no one else has."

Ives, Debussy, Ravel, Mahler, and others. This diagram reflects the fact that music has more than a tangential relationship to Crown's art (see p. 118).

Crown elaborated on the musical elements of his work. "I like music because it's very similar to good painting because of its variations. They [the musicians] will play a theme and then they go so far and then do it in a somewhat different way—different instruments and colors and they'll play it backward and forward and upside down, and introduce other themes, and it's like Matisse, like any real composer. Well, here I was using a stick for those dots, and I would change colors. I might put three dashes of yellow, and then I would do another color. It was orchestrated, and I kept moving upward, and I would change from warm and cool to warm, warm, cool. I put a great deal of thought into it, and I painted the background around the dashes, which is really strenuous, a killing thing to do— weaving little white areas around."[17]

Among the artists Crown placed on his tree of artistic lineage is Claude Monet. It was my judgment that Monet, so dedicated to outer appearances, produced a purely retinal art and, therefore, that the connection with Crown seemed obscure at best. Crown quickly disabused me of that notion. "I find Monet full of ideas—theories about color, painting light and shade. The most important idea . . . is broken color which was done several different ways—the main result of all the ways was simply not mixing all the components of a complex color into a neutral mush, as did nineteenth-century academic painting—and Monet deserves most credit for those several methods. (Pointillism was certainly latent in Monet's work.) Helen Gardner [his art history professor] implied in the thirties that Monet's composition was good when he happened to have found a subject that was naturally organized (just an eye). Baloney!! I've seen many many many Monets—enough to be impressed—to realize he is a first class composer. (If he took things just as they were, how to explain the visible alterations in his works: trees eliminated, or shifted, etc.?) What I admire

17. Tape 2.

is perhaps the first painterly painter—the lover of sensuous laying on of paint (so much admired by the abstract expressionist era). I admire his experiments in pushing color near the nonobjective boundaries in making paint and color alone (without figurative definition) communicate his feelings."

Crown's ultimate point is that he not only admires Monet greatly but has also "been influenced (by his paint-mixing methods, and his sensuous paint surfaces), and [I] find him full of ideas from empiric experience of seeing for myself. I mean that I've seen a great deal of Monet, and find from this experience, that there is no lack of ideas, on his part, in his painting."

I had originally supposed that Crown might have felt a rapport with Monet because of a shared reverence for nature. Crown had much to say about the notion of reverence for nature. "Reverence is not a feeling I harbor for nature. Nature frightens me. I respect and am in awe of it. Nature is wild, brutal, impartial. A sylvan scene will hide rattlers, black widow spiders, prowling hawks, quicksand, poison oak, poison berries, poison mushrooms, a male wolf that killed his cubs— everything is eating somebody else."

This entire question arose because I want to point out that in the three *Grain Elevator and Soybean Field* paintings Crown distinguishes the different kinds of days on which they were undertaken—light blue, sunny, or with "cloudy-threatening" conditions. In Illinois he was happy with his entire situation, including the painting he was doing. In these Illinois pictures, therefore, the change in atmospheric conditions is based on observation rather than colored by emotional undertones.

Up to this point, the evidence of the paintings themselves implies that the complicated multiple perspectives used by Crown in his Los Angeles works of the early fifties were not regularly employed after 1960. In those early paintings it was the curved horizon, the looking to the sides and behind, that allowed Crown to penetrate beyond the single point of view of traditional landscape and still-life painting. Now, in Illinois he began to multiply horizon lines with a fresher, more original sense, one further from Cubism than the earlier devices.

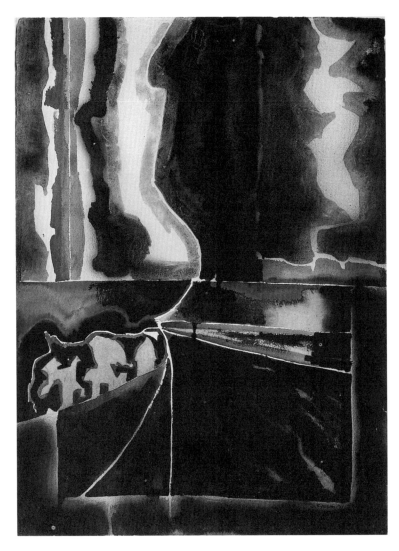

80. *Farmhouses and Fields*, 1971, watercolor, 30 × 22.

Crown surprised his colleagues at the University of Illinois by finding the countryside more than suitable subject matter. The landscape there is very flat, and the color is subdued. Crown attributes his success with this terrain to his experience painting the ocean. "The great thing about John Marin was that he could articulate a flat sheet of paper by just looking at this big sheet of water out there with maybe a boat and not much else. When you try to paint the ocean, or the desert or [the countryside in Illinois], then it takes a strain on the imagination to know how to do this. In part what I did of course was to use symbols." [18] His symbols are not codified and sometimes are purely opportunistic. He found feathers, so he used them. There was an abundance of butterflies while he was in Illinois, so he used them too, gluing them to the surface of some of his paintings.

One Illinois painting is signed so that the picture is horizontal, and signed again so that it is also vertical (Fig. 80). The artist began to use this concept regularly, and he developed related ideas of the landscape form—painting, for example, a mountain upside down from one perspective and right side up from another. We know Crown's determination to break through traditional single points of view in a manner of his own devising: the curved horizon of the fifties; the multiple horizons in Illinois. Similarly, at this point he developed the bent horizon, in which he simply bends the horizon so it goes down one side of the paper. This technique is illustrated in the 1975 *Ranchos and Taos Mountain* (Fig. 81), in which the mountain is seen straight and Ranchos runs down the left side of the paper.

Looking back at 1970–1971, Crown has mixed feelings. On the one hand, he knows the work of that period provided a definitive turn in his art. "I said at the beginning I would have to get all the language together and when I mastered all that, then I would be able to paint easily and that was true. I don't ever worry about structure anymore, because I don't have to. It would be hard for me to make a bad [painting] because I worked so hard to learn to do it right." [19]

18. Ibid. 19. Tape 10.

On the other hand, he feels "I peaked [this year of 1970–1971]. I reached a kind of plateau, and I don't think I got any better or worse. Maybe I was maturing as an artist, that I could do what I wanted."[20] In fact, Crown had not reached a plateau. Back in Taos great things were waiting for him.

Crown's achievement in Taos in the summer of 1972 is remarkable and can be demonstrated by selection of just a few paintings. All of the 1972 Taos watercolors show a marked change in color from Illinois as the artist responded to the high desert tableland and its crystal-clear atmosphere. In addition, the shapes are much more varied and dramatic than those he encountered in Los Angeles and Illinois. But the inventive vocabulary that reached fruition in Illinois is pushed further, to new limits, in Taos. His tie to the place was growing more intense, and, too, Taos was becoming home. It is hard for Crown to articulate just what keeps pulling him back to that northern New Mexico town, "but I keep coming back to that place. Part of [its hold] is the space there and the forms. But I also like the sounds."[21]

One of the very fine landscapes produced that summer is *Near Taos, New Mexico* (Fig. 82). The color with its emphasis on yellows, reds, green, and a wide range of blues reflects the color of the place. Typically, Crown's landscapes are uninhabited even when he includes the Taos Pueblo—always the buildings but not the Indians—as was his habit in a number of paintings that year: *Taos Mountain and Pueblo* (Fig. 83) and the splendid *Taos Pueblo* (Fig. 15).

In *Near Taos, New Mexico*, Crown created the sweep of deep space with his multicolored field receding at an angle from the picture plane. The centerpiece of the composition is the Taos Mountains in the distance in dark blue becoming almost black in parts. Above the mountains Crown makes masterful use of his spray to capture the *equivalent* of a New Mexico sky. Up to this point there is no intrusion of a curving horizon, more than one horizon, or a bent horizon. However, at the very top edge of the paper he has placed the mountains again upside down. They inexplicably hang suspended over the

20. Tape 9. 21. Tape 8.

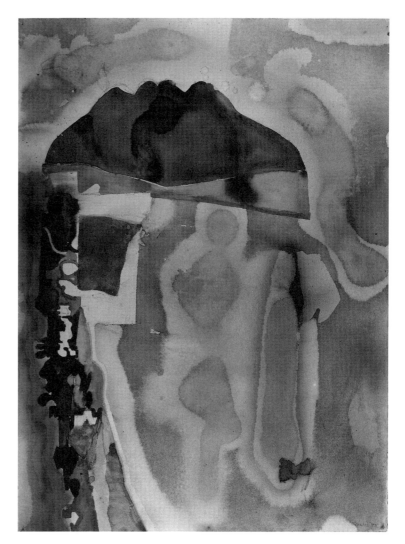

81. *Ranchos and Taos Mountain,* 1975, watercolor, 30 × 22. Collection of Sheldon Reich, Tucson.

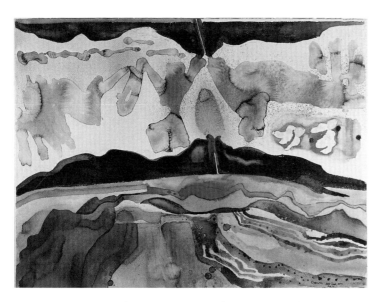

82. *Near Taos, New Mexico*, 1972, watercolor, 22 × 30. Collection of Patricia Dahlman Crown, Columbia, Mo.

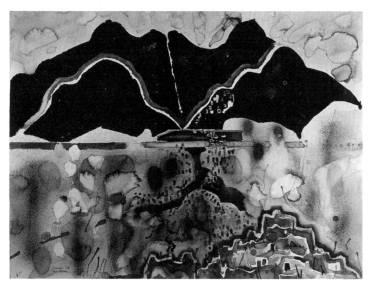

83. *Taos Mountain and Pueblo*, 1972, watercolor, 22 × 30. Collection of Patricia Dahlman Crown, Columbia, Mo.

lower rendition of the mountains, echoing their shape. It is a dislocation of ordinary logic, a kind of mirage.

Crown's aim is to capture a sense of this panorama without simply repeating what is there in a banal fashion. One of his reasons is that to represent literally what you see is totally inadequate to express the expanse and rhythm of this view on a piece of paper twenty-two by thirty inches. Thus, turning mountains upside down, or repeating them one above the other, has to do with the artist's struggle to create the equivalent of what he sees. Crown's explanation of how he attacks the enormous problem of scale in his Taos works further illustrates this point. "Using scale in painting has been an important thing with me. I use it a tremendous amount. I use it in different ways. I've often reiterated it if it is a Taos mountain. I'll do it quite big and then I'd do it small to exaggerate the bigness of the one."[22] He also states firmly, "Always it is reality (in its largest sense) that I'm striving for."[23]

Reality can take many forms, and there is a reality of the imagination as well as one of sight. *Near Taos, New Mexico* has the Taos mountain thinly sliced by a white line bordered in red. In *Taos Mountain and Pueblo* (Fig. 83) is this same slice but without the red border, cutting the mountain diagonally. These lines are suggested by drainage paths, but they have other, sexual meanings for Crown.[24]

22. Ibid. 23. Ibid.

24. It is important to make clear that dual meanings do not imply the use of fantasy in Crown's works. "As I understand the meaning of 'fantasy,' there is none intended in my painting—none whatever! Sometimes when I am conceiving visual equivalents for some real but invisible phenomena, or I intend to bring out the essential nature of some thing whose form belies its nature to a certain extent, then occasionally I believe my work takes on fantasy-like qualities. Always, though, it is reality (in its largest sense) that I'm striving for. I believe that is quite different from fantasy, which I believe intends to shy away from reality." To fully understand Crown's distaste for fantasy in art, we have to comprehend the precise meaning of that word for him. "Fantasy is considered, I believe, lighter in general meaning and intent—more fanciful than what I wish to do. I mean my ideas, where they deal directly with the reality of nature, to probe deeply for ways to express or symbolize my findings. Reality in my paintings is not shallow or superficial glancing and recording." If fantasy

He addressed the issue of the landscape as a sexual metaphor, referring specifically to *Taos Pueblo* (Fig. 15). First he noted that he has "a not uncommon belief (Freudian) that sex is the prime mover of human activity." And he offered a guide to the sexual signs and symbols in this painting, one that is applicable to many other of his paintings as well. "The blue mountain shape slyly has in the center a division like that of vaginal lips seen from a certain angle, and on either side are two large breast-like shapes. This interpretation came from observing the mountain for many years in Taos and vicinity. It always to me had these feminine attributes." Crown then pointed to the top zone of the painting, observing that it has "a larger reiteration or detail of the above second section with the division of vaginal lips suggested by mountain drainage lines."[25] Yet this painting, any of his paintings, has a formalistic structure that must be there to make symbolic references possible. Crown pointed to the architectonic structure of the *Taos Pueblo*. "The pueblo is placed against a green alluvial shape that leads upward structurally to pass into the next section [he sees the work as divided into three horizontal sections], which is a greatly simplified version of the whole mountain. The yellow repeats the green alluvial area below. The gray band against the blue mountain conveys a mist or cloudlike area of atmosphere often seen against mountains; it fits well compositionally or it would not be there."[26] All the successful paintings of that summer share the same force and logic.

William Wilson could not have seen any of these Taos pictures when he reviewed Crown's 1972 exhibition at the Jacqueline Anhalt Gallery in Los Angeles. Writing in the 21 April 1972 issue of the *Los Angeles Times*, he expressed admiration for Crown's works, which must have included paintings done in

Illinois. "There is an ever-growing spiritual density in the watercolors of Keith Crown. The local veteran hints of landscape with Oriental authority of placement." Wilson also recognized that Crown stood outside the new wave (and there is always a new wave), that he had missed "the bandwagon [of] fame."

Gordon Hazlitt, in 1974, had the chance to see the full range of Crown's recent work in another exhibition at the Anhalt Gallery. Hazlitt was deeply impressed and moved by what he saw. "Crown's bold mixtures of treatment and subject matter—recreations of landscapes merging on fantastic still life—vibrate off the walls. In their vivid colors and broken imagery, they seem psychedelic in origin, but they are the creations of a 50 year old [*sic*] teacher of painting at the University of Southern California." Hazlitt went on to place Crown in a larger scope, as one who still believes that "art should 'speak' to the viewer. It's extroverted; it attracts our attention." He reacted positively to these qualities, comparing them with the density and impenetrability of the younger artists then in Los Angeles. Hazlitt concluded by asserting that Crown "has reached a point of great freedom and certainty, a combination which used to be labeled mastery."[27]

Hazlitt's reference to "psychedelic colors" echoes Wilson's observation in the 1969 review mentioned in Chapter 2, and even in 1974 the phrase might have seemed quaintly old-fashioned, but in 1979 a reviewer for the *Taos News* used that same parallel.[28] Crown, however, has never used mind-altering drugs. His imagination and intensity of vision need no chemical assistance. Describing the 1972 summer in Taos and the work executed there, Crown summed up this aspect of his work more succinctly than any art critic. "These Taos things are exploding. Everything is kind of exploding and shifting away from the anchor to reality. But they keep a kind of distant context."[29]

Of course, Crown was spending much time in Los Angeles,

finds no place in Crown's lexicon, imagination most definitely does. "*Taos Pueblo* [Fig. 15] has certain ideas in back of it that are imaginative. They intend to inform the viewer of certain feelings, insights I receive from the pueblo and vicinity. They express personal beliefs about the human condition in general" (all quotations from ibid.).

25. Ibid. 26. Ibid.

27. "Screams and Whispers," *Art News*, December 1974, p. 60.
28. Robin McKinney, *Taos News*, 16 August 1979, p. B3.
29. Tape 9.

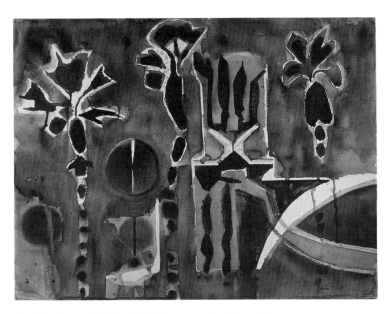

84. *Hot Day at the Beach*, 1971, watercolor, 22 × 30.

85. *The Sky Toward Steeple Aston, Oxfordshire, England*, 1973, watercolor, 22 × 30.

resuming his professorship at USC. He painted the familiar places in the vicinity of Manhattan Beach. For example, from the fall of 1971 comes *Hot Day at the Beach* (Fig. 84). But Crown added new subjects, industrial subjects, to his repertoire of themes in Los Angeles, and these will be considered as a group later in this chapter.

Crown had gone to Taos alone that pivotal summer of 1969 when he painted his hundred watercolors because Pat was in England doing research for her dissertation. In 1973 it was necessary for her to go to England again for research, but because it was to be an eight-month stay Crown took a sabbatical from the University of Southern California and accompanied his wife abroad. He had been in the Pacific during the war and in Mexico in 1951, but this was his first visit to Europe. While the Crowns made short trips on the Continent, most of the time was spent in England, and all the paintings Crown executed during this visit were done in England.

Crown indicated he felt more at home in Florence than in England. But in England there was much he wanted to see, including the works of Constable and Turner. His watercolor *The Sky Toward Steeple Aston, Oxfordshire, England* dated September 1973 (Fig. 85), may be a sort of tribute to the skies of Constable. He was also distressed to learn that John Ruskin, after Turner's death, had destroyed some sexually explicit pictures by the artist (whom Ruskin considered to be *the* great modern of his time).

Painting England presented to Crown a challenge of a magnitude he had not previously faced. It was simply that England was so different from what he had used before as subject. The closest prior experience was that summer of 1970 in Oregon. Compared to much of England, Portland's atmosphere was dry; nevertheless, the Portland pictures are the closest in character to the paintings done in England.

Tower Bridge, London, made in August 1973 (Fig. 86), is reminiscent of those Oregon watercolors of a bridge over a river. This time, however, it was a historically significant bridge of substantial age over the Thames, not an anonymous railroad

86. *Tower Bridge, London*, 1973, watercolor, 22 × 30.

87. *Burning Fields—England*, 1973, watercolor, 30 × 22.

bridge over the Willamette. As freely as the sky and water are depicted in the London watercolor, the bridge is more directly representational. The fact that the bridge has a mirror image is explainable by the phenomenon of reflection on the water, unlike the imaginative idea of a mountain facing itself. This painting has, therefore, none of the magic of those suspended mountains in *Near Taos*.

In its stately, calm, classical quality, *Burning Fields—England* (Fig. 87) recalls some of the farm scenes done in Illinois. This watercolor is essentially divided into three horizontal bands that contain the landscape elements. The lowest strip is dark with a light articulated biomorphic shape set in it, suggesting a pond. Above this layer are the burning fields—farmers simply burning off vegetation before cultivating the fields—painted in warm tones of pink and orange with dark shapes that could be black or a very dark blue. In this same register there is a lighter, fluffier blue area that might be interpreted as

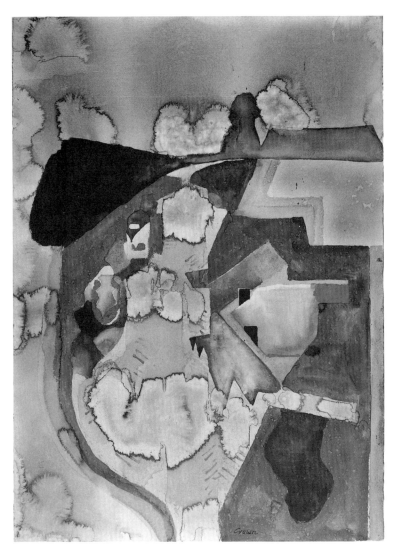

88. *Oxford Canal at Lower Heyford*, 1973, watercolor, 30 × 22.

either sky or water. On the very top edge of this central and largest zone, hills are silhouetted against their own sky. But this sky, the third zone, is fashioned by careful vertical brushstrokes of diluted black leaving areas of paper in this strip untouched. What we see in this painting is Crown using the multiple horizons invented and applied so brilliantly in the 1970–1971 Illinois watercolors.

Crown acknowledges that many artists, faced with unfamiliar material, may return to a more conservative manner. John Marin had expressed a similar philosophy about the New Mexico landscape when he arrived in Taos for the first time.[30] Indeed there are English watercolors that weakly echo the splendid paintings from Taos the year before, and *Oxford Canal at Lower Heyford*, done 23 August 1973 (Fig. 88), is one of these. It abstracts architecture and landscape into forms resembling those in the Taos works, but the color is pale.

Crown was awed by the antiquity of the country as reflected in its architecture. "Every village had a Norman Church going way back to 1300 or something like that. It took me a while to get used to the idea that the churches were so old. And people worshiped in these marvelous ancient churches."[31]

The subject of one of his watercolors is not an old parish church but a cathedral. It took some effort on his part to take liberties with such venerable churches as Worchester Cathedral, but he did it nevertheless in the painting named *Worchester Cathedral* (Fig. 89). The gothic outlines of the building and adjacent houses evoked a geometrization of form more complicated and more interesting than that of *Oxford Canal at Lower Heyford*. The gothic configuration of the church and surrounding houses is contrasted to a second depiction of the church. Above, painted in very pale pink, a little green, and some yellow-green, is a schematic rendition of the cathedral itself isolated on a black field. Crown explained how he arrived at this: "I drew a sort of caricature profile of the cathedral—then I drew it again upside down so that parts of the below and above rendi-

30. Sheldon Reich, *John Marin: A Stylistic Analysis* (Tucson: University of Arizona Press, 1970), p. 183. 31. Tape 8.

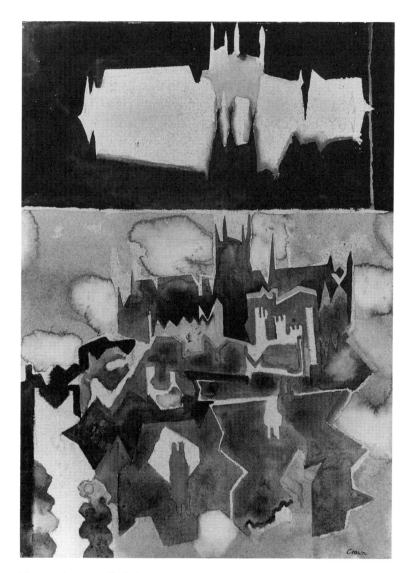

89. *Worchester Cathedral*, 1973, watercolor, 30 × 22.

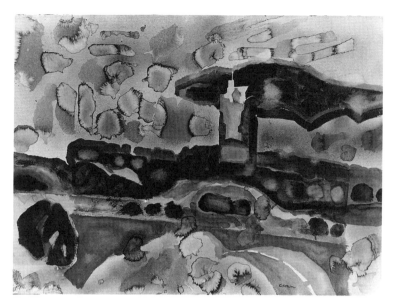

90. *Steeple, Aston, Oxfordshire, England*, 1973, watercolor, 22 × 30.

tion touched. When the two profiles were filled with black paint this left a white negative shape that I thought beautifully said *Worchester Cathedral* and went with the lower, more usual portrayal of the cathedral and environs."

The only element that provides any possible connections between the zone below and that above is a narrow red line that goes from the top to the bottom edge of the black sector. We see the origins of this solution in some of the Taos paintings, but here the color in its low range and subdued intensity lacks the crackling dynamism of the New Mexico paintings. A painting closer to the Taos watercolors is the quite beautiful *Steeple, Aston, Oxfordshire, England*, dated 22 July 1973 (Fig. 90). In this picture the color is more sprightly, and the reason for this could be as simple as the fact that it was sunny on that day.

Crown was fascinated with another aspect of England's more recent past—the industrial revolution. Enshrined in her

architecture were the grimy coal-mine and manufacturing towns of the nineteenth century. Some of these sites were still operating, and one is the subject of *The Smelter near Oxford*, dated October 1973 (Fig. 91). (The irony of this symbol of man's ravaging of his environment existing near a great center of learning did not escape Crown.) The smelter is a negative white shape in an envelope of black. The smelter's stack spews forth smoke that permeates the surrounding countryside, painted mostly in browns. I don't know if this particular smelter was abiding by any environmental controls, but the poisoning of the planet was much in Crown's mind these years. "I think my painting is partly about a kind of sadness, because I think mankind is destroying everything quickly. We're accelerating destruction very fast and nature is so beautiful."[32] Later, in Los Angeles, Crown was to work out an artistic program to deal with this concern.

During periods between travel Crown painted pictures of themes that he had rendered almost from the start of his move to Los Angeles in 1946. But his painting had come an enormous distance in vision and style from those earlier times. The newer watercolors (by 1973 Crown had abandoned acrylics) are wet and fluid and different from the work he was doing in the fifties and even the sixties. In a sketchbook dated 1979, Crown has recorded this quotation about watercolor by author Henry Miller (an amateur watercolorist and great admirer of John Marin): "Watercolor has affinities with the sonnet or haiku, rather than with the lament. It grasps the essential rhythm, the bouquet, the perfume not the substance. Above all it portrays the environment."[33] Crown does not agree with Miller's contention that watercolor cannot produce the substance of a subject. Very bluntly, he labels that particular idea as "Millerian horse-shit. If an artist can penetrate to the substance of a subject . . . he can put it on paper with piss and a charred match stick. It's not the medium—it's the artist. If the artist can't get the substance in watercolor he's not going to get it in oil paint, or marble."

32. Ibid. 33. (Paris, 1962), p. 50.

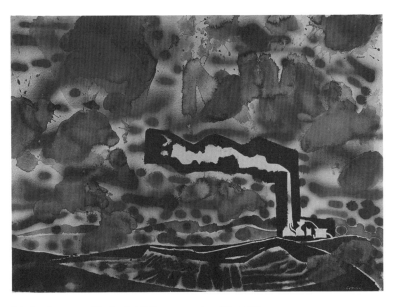

91. *Smelter near Oxford*, 1973, watercolor, 22 × 30.

By 1973, Crown was painting Manhattan Beach with the palm trees and the pier afloat in a world of blue, gray, red and yellow, all relatively subdued. In addition, his compositions of this period tend to be clearly divided into separate and distinct horizontal sections. This sectioning of the paper is reflected in such English paintings as *Worchester Cathedral* and, in fact, predates his 1973 English sojourn. A good example of this kind of design is *Manhattan Beach Pier with Sun Track and Palms*, which was executed in January 1973 just prior to the trip to England (Fig. 92). Occupying three-quarters of the space are palm trees and the pier. These are placed against a liquid blue that could stand for the ocean, but there is no mundane mind at work here, since the trees sprout up from the bottom edge of the painting, their trunks delineated as negative, barely touched areas, of the white ground. Crossing these trees is a path through water or sky or land, to the pier. The pier is an inset; one could be deceived into thinking it has been cut out from some other painting and glued to the surface of this one

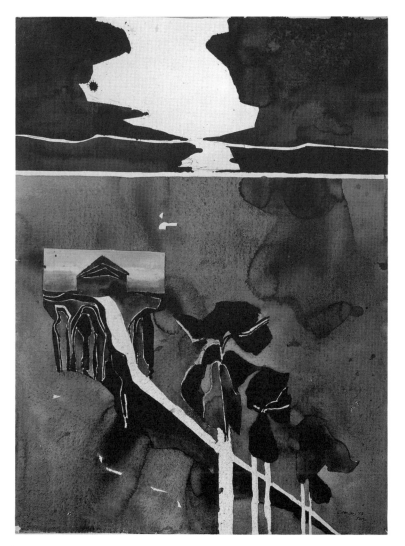

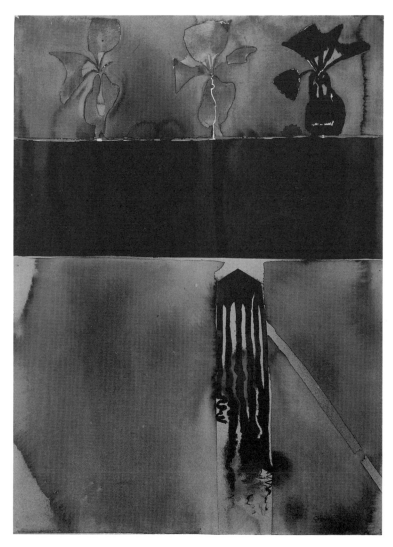

92. *Manhattan Beach Pier with Sun Track and Palms*, 1973, watercolor, 30 × 22. Collection of Patricia Dahlman Crown, Columbia, Mo.

93. *Manhattan Beach Pier, California*, 1973, watercolor, 30 × 22. Collection of Patricia Dahlman Crown, Columbia, Mo.

because the realism of the pier looks so alien in relation to the rest of the painting: it exists on the beach surrounded by ocean and against a sky. Above all this—water, trees, pathways, pier—is a horizontal white line and directly above it another such line. In this upper black zone is a negative white shape impossible to identify as a specific landscape form.

There are other watercolors from the same period that work with these ideas of liquid forms and fluid space. For example, *Manhattan Beach Pier, California*, dated January 1973 (Fig. 93), divides the picture plane into two roughly equal horizontal areas, with two small renditions of the pier existing one above the other on the right side of the composition. In this painting, and in many others of this time, what Crown learned from his brief experience with what he called his white-line pictures of the sixties now finds an important role.

In his 1972 review of Crown's work, William Wilson referred to Crown's placement of elements as devised with an "Oriental authority," a statement that reflects the openness of design of these beach paintings of the seventies. The words of the artist himself establish Wilson's statement as correct. "It is a floating world," Crown stated, "and you begin to lose the sense of the real earth—of being earth bound. Things seem to float apart out there. The value contrast between the sand, the beach, and the water often gets lost. These two elements appear to interlace so that you lose the sense of earth and sea. Things lack a feeling of substance and the illusion is of masses floating." [34]

The impact of the sun in these scenes seems played down or even lost. If we look again at the beach paintings of the sixties, we note how important to Crown was the disk of the sun. Speaking of a painting done in the sixties, the artist explained, "I think I was trying for the power, the brilliance of light and the power. I was chasing the ocean with the sun going down in front of me." In this same explanation, Crown spoke about the "thousands of people" who were at the beach and the "parking lot full of cars and people running up and down." [35]

It is not correct to generalize that Crown filled his beach scenes with people at an earlier time, or that he would not do so occasionally later. Whether or not people are present in earlier depictions of the beach, however, they are often implied, or at least they could inhabit his vistas of the shore. This is not the usual case in paintings done in the first half of the seventies. For example, *Palm, Pier, Ocean* of 1974 (Fig. 94) is painted in muted tones of blue and gray with the pier dominated by what looks like a suspended giant phallus (which it is, although viewed upside down it is a palm tree). In efforts like these Crown creates a world not even remotely connected with the teeming beaches of Los Angeles.

As if to prove the rule, there exist two major departures from his quite abstract paintings of objects in a universe of floating forms. In 1976 he created *Warm Summer Day by Manhattan Beach* (Fig. 95) and *Cars, Palms, Pier and Ocean* (Fig. 16). In the former the intense disk shape is both sun and pier. The composition clearly delineates the beach (in quite fanciful colors of green, yellow, and blue) with people present. About this particular watercolor Crown said: "Here I am at the Manhattan Beach Pier in the summer on a very hot day. The place is packed with people on the beach, and it is an exciting sight. I felt that these people are as much a part of this view as the sun, water, and pier. I would see them as decorative or interesting forms that had a humanistic feeling. They evoked people, but also became expressive decorative shapes in the same spirit I use with architecture in my paintings." [36]

Crown succeeded in integrating people and beach in the very impressive *Cars, Palms, People, Pier and Ocean*. Talking about this fine painting, Keith noted, "I was painting the pier at the beach—it was a brilliant, beautiful day and it was packed with all these beautiful women and men in beach clothes. I thought it would be a crime not to paint them and also the cars parked there. I thought it would be absolutely totally wrong to not have this jam of people and jam of cars. I did a rather abstract painting of the pier in the sun. However, I painted the

34. Tape 10. 35. Ibid.

36. Tape 2.

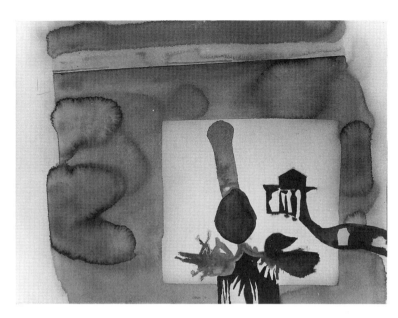

94. *Palm, Pier, Ocean*, 1974, watercolor, 22 × 30.

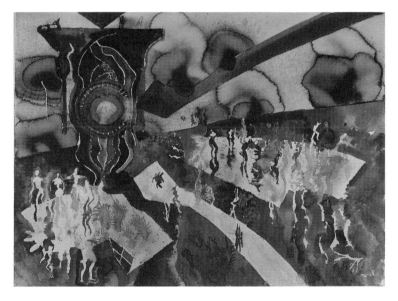

95. *Warm Summer Day by Manhattan Beach*, 1976, watercolor, 22 × 30.

pier consistent with the way I did the figures. I felt better about the way I did them with the style, than I did with anything else. It takes a tremendous mental energy to do that kind of stuff— to figure how to integrate figures into a style if you haven't developed them from the start."[37] It was not a problem he attacked often. Like many of the works of older landscapists he admired, from Constable to Cézanne to Marin, in Crown's landscapes figures, when they appear at all, are frequently of minor or no significance. Even J. M. Turner could not deal with the human figure in a conventional way; according to Kenneth Clark, "he could sometimes indicate it with a genial calligraphy."[38] While Crown, as we have seen in the preceding chapter, could draw the figure in the conventional manner, his success in integrating the figures into these two 1976 beach paintings was achieved through "a genial calligraphy."

It is important to mention that at this same time, while Crown was putting such effort into his beach scenes, he was also once more executing still-life compositions. An interior scene, *Manhattan Beach Interior* of 1974 (Fig. 96), is quite distinct from the very early still lifes. The shapes are clustered into a thin vertical, unsupported in the wet field of the paper. Another, *The Kitchen at 633 27th St., M.B.*, executed in May 1975 (Fig. 97), differs a bit by presenting the viewer with a corner of reality—a pot on a stove—but one just as mysteriously suspended in the dreamlike space. Both of these still lifes are stylistically related to the more numerous beach pictures of the same period.

Crown had painted an oil of the Con Edison Plant located in Redondo Beach several miles from his residence in Manhattan Beach in 1950 (Fig. 98). Such themes did not appear regularly, however, until the seventies. On one level, the artist explains his interest in such industrial motifs in the same fashion

37. Tape 4.
38. *Landscape into Art* (Boston: Beacon Press, 1961), p. 106. Crown, relating the difficulty he experienced trying to incorporate figures into his landscapes, stated, "I noticed many of Turner's figures do not seem to be a really integral part of the painting, but an addition ineptly painted" (tape 2).

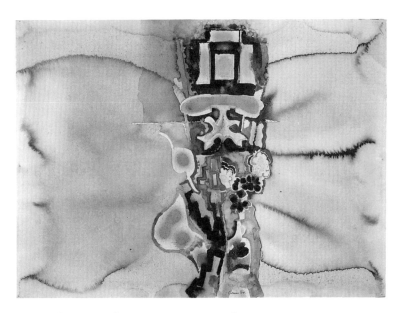

96. *Manhattan Beach Interior*, 1974, watercolor, 22 × 30.

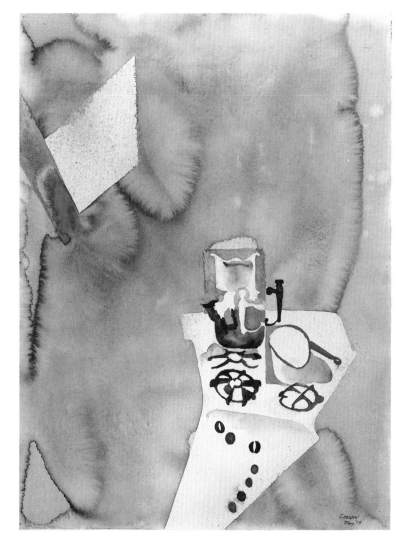

97. *The Kitchen at 633 27th St., M.B.*, 1974, watercolor, 30 × 22.

Sir Edmund Hillary explained why he climbed mountains—because they are there. "If it had been something else, I would have painted that," according to the artist. He did admit that the subject would have to be worth painting by his standards. "For example," he said, "in music I've read criticism of what they call good music—symphonic music—and they might say that Mozart has [composed] some really interesting music. . . . What the hell [do you suppose] they are talking about? What makes one little tune or one combination of notes more interesting than another I don't know, but it is as true in painting as well as [in] music. There is some material that's somehow more important or visually has more possibilities, and is more serious and worth doing. The [Con] Edison Plant with its variety of forms—big stacks and [another industrial complex], the back of the Hyperian Sewage Plant [with its candy striped stacks], and the long beach with its breakers of different sizes moving up against it, and a lot of wind, and a tub, [a] big ship, out there; a tanker of some kind from God knows where—

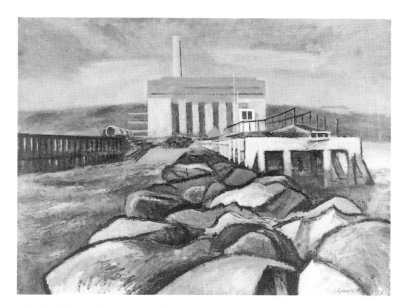

98. *Con Edison Plant*, 1950, oil, 25¾ × 35¾.

Mexico, Chile, or even Turkey—are all interesting material for painting. It doesn't have to be such fascinating subjects all the time. I've painted humble subjects as Van Gogh did. But Van Gogh, that true poet in painting, he can paint [a picture of] his shoes and pipe on a chair, and it's sure as hell not the Hyperian Sewage Plant or an oil tanker, but it is something gigantic, massive, powerful."[39]

Most of Crown's paintings of subjects like the Con Edison Plant and the sewage treatment building were done in the seventies. Since the subjects were there in the sixties or even earlier, the question arises as to why they became so important to him at this point in time. While discussing a 1972 watercolor called *Standard Oil, El Segundo, California* (Fig. 99), Crown answered that question. "Partly I meant [the painting] as a kind of protest against the pollution of the environment, and I've done a lot of paintings [addressing this same idea]. My intention in using such a subject was to make a painting that was . . . dirty and ugly."[40] The selection of subject, then, was in-

39. Tape 10. 40. Tape 2.

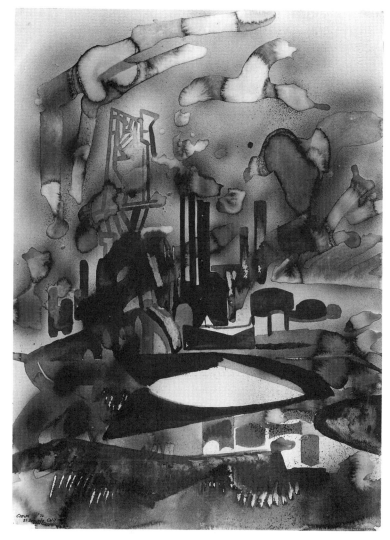

99. *Standard Oil, El Segundo, California*, 1972, watercolor, 30 × 22.

tended as a comment on the poisoning of the planet as seen in the microcosm of the city of Los Angeles. Crown firmly believes that painting has the power of literature in its ability to influence people. In the late fifties he wrote in a sketchbook, "We may speak to one another by sheer will power of thoughts. This [ability to communicate] is the vital characteristic of real art—that thoughts of the artist—particularly his inmost ones—speak to us as they are embodied—embedded in the medium."

To achieve the impact and meaning he intended in *Standard Oil, El Segundo, California*, Crown limited his color range to dark, somber, sour blues and blacks and dirty reddish browns that envelop the plant and its surroundings as toxic wastes pour out from its stacks. Yet, almost inexplicably, certainly not by conscious choice, all these elements come together in a certain order, and the painting is a beautiful one that effectively subverts Crown's stated goal. The impressive structure inherent in the architecture of the refinery and the artist's muted acid palette together add up to a picture of imposing stature. Instead of an indictment, the painting exemplifies that an artist, at least this artist, can extract reason from chaos and beauty from ugliness. And all this happened before the first trip to England.

With the English experience behind him, Crown had a broader range of related ideas to bring to bear on the entire concept. "I had been trying to make some of these industrial scenes ugly, and I discovered I couldn't do it. Such places [despite my aim] came out looking rather beautiful—or at least looking very good." He could now point to the analogy of the old manufacturing and mining cities of the nineteenth century that he had experienced in England, remarking, "A lot of these old collier things appear rather stark, beautiful monuments when you look at them now. I am trying [in Los Angeles] to paint a non-beautiful thing, but it is very hard because I've trained myself to find insights in the motif and show it in the finest way I can. And all of this [experience and training] goes against the idea of trying to make a critical statement of what is

being done to nature."[41] Despite the truth of his own confession, Crown has something to say about all his subjects and adheres to the Baudelairean concept that the task of the modern artist is to deal with the modern world.

Sometimes Crown envisioned romantic associations with at least one of his industrial subjects. He had painted the Con Edison Plant at Redondo Beach in 1950. The directness of the 1950 picture gives way in a 1975 rendition (Fig. 100) to an abstraction in which the plant becomes a motif and countermotif that remind us of certain Taos pictures of 1972. The complications of the modern structure are symbolized by white lines suggesting the maze of pipes and machinery. In the surrounding space are pale depictions of the towers that carry the electricity generated to the city. The space utilized here is the same free organic kind in which things appear suspended rather than fixed. This 1975 painting builds on the influences of Taos, Portland, and England. In my judgment it succeeds to a far greater degree than do the paintings done in Portland or England and equals the superb accomplishments of the summer of 1972 in New Mexico. It is strong and complex and fixed in the reality of Los Angeles. (After all, Crown had been painting that city since 1946. What artist could know it better than he?)

The romantic associations of the Con Edison plant refer to an early discovery Crown made of a no longer used structure that carried huge pipes aboveground into the ocean (Fig. 101). The fact that the structure was abandoned and partially in ruins fascinated him. "It reminds me of the massiveness of Stonehenge. I hadn't yet seen Stonehenge [when I discovered this structure], only pictures of it, and it reminded me of that. The Edison Plant structure looked like a strange religious relic of some lost civilization."[42]

The artist produced some interesting cityscapes during this period. They tend to reveal the industrial skyline of the city from the vantage point of Manhattan Beach and its environs. One such painting, also from 1975, is the *Palmeri Bakery, El*

41. Tape 6. 42. Tape 4.

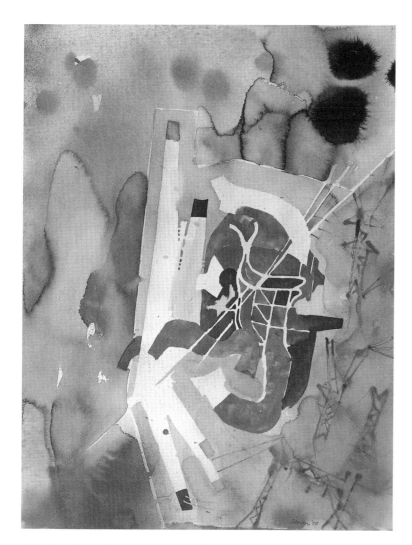

100. *Con Edison Plant*, 1975, watercolor, 30 × 22.

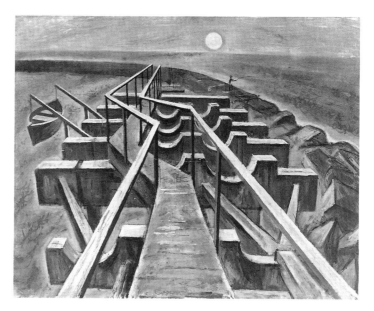

101. *Abandoned Edison Plant Structure*, 1948, oil, 39½ x 52.
Collection of Haine Crown Gresser, Kensington, Md.

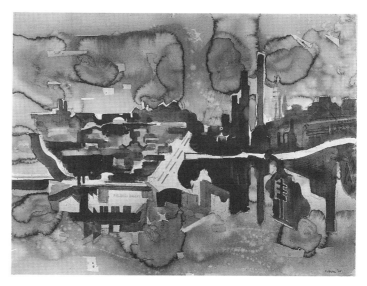

102. *Palmeri Bakery, El Segundo, California*, 1975, watercolor, 22 × 30.

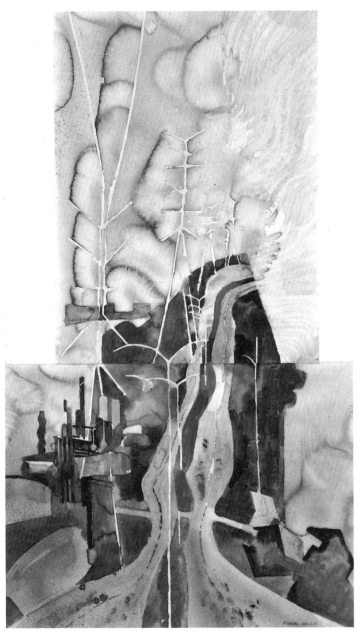

103. *Rosecrans Boulevard, Manhattan Beach*, 1975, watercolor, 52 × 30.

Segundo, California (Fig. 102), distinguished by the fact that the name of the bakery appears handlettered in a commercial signpainter's style in pale red. Except for the sign, the painting does not seem to emphasize the bakery over any of the other buildings rendered. But Crown was to incorporate many signs in his work, particularly traffic signs.

A street in his neighborhood, Rosecrans Boulevard, appears among Crown's city scenes in the seventies. One of these is created in the form of an inverted T. In the previous decade he had painted at least one composition in the same format, but it was smaller and cut to that shape from a single sheet of paper. In *Rosecrans Boulevard, Manhattan Beach* of 1975 (Fig. 103), Crown created this format with two separate sheets of watercolor paper. He was becoming increasingly more daring in devising unusual formats, especially, as we shall see shortly, in his paintings of the Los Angeles airport, but the bulk of his work accepts the rectangular shape of the single sheet of paper.

This particular version of Rosecrans Boulevard is rich and complex, and the choice of the inverted-T format is not a random one. "I chose arrangements of paper that I thought appropriate to the subject. For instance, in the T-shaped Rosecrans painting I thought the T appropriate because there would be many telephone poles and other wire carrying structures of a family of T shapes in the painting."[43]

This simple explanation by the artist reminds us that an important part of painting for him is the intellectual process, and that intellectual process is most clearly manifested in the formalistic power of a work. In 1976, Crown wrote, "Formal ideas make painting an art. The ideas that I employ strive to create an exciting unique appearance, but not an easy access to its meaning. My hope is that the authority and prominence of the appearance will lead to careful, pleasurable study of the work and in turn some state of understanding."[44] Form, struc-

43. Tape 6.
44. Statement included in the exhibition catalogue titled *California White Paper Painters 1930s-1970s*, Art Gallery, California State University, Fullerton, 25 April-20 May 1976.

ture, appearance lead to comprehension. Crown's intention has *never* been obfuscation. He wants desperately to establish meaningful communication with the viewer, but never at the price of making things simplistic.

Since the El Segundo oil refinery was so close to the artist's house in Manhattan Beach, it was inevitable that he would observe the tankers moving to and from the refinery. If the refinery itself was a proper subject matter for Crown, then, of course, so were these tankers. "Oil tankers anchored out there. They anchor right off of Manhattan Beach. I can walk down there and paint those [ships]. I'd drive down there and then I'd paint and paint, and the paint would be so wet that I couldn't drive up that steep hill to get them home. I'd leave my paintings [in the car] to dry, eat dinner and then Pat and I would take a walk down there in the evening, pick up the car and drive home."[45]

There are different approaches to the theme of the oil tanker: the tanker itself out at sea, and the tanker anchored by the refinery. When Crown depicted the boat in the distance, he usually painted it small to indicate the deep space from the picture plane to the ship, but he would contradict the deep space by the way he treated the surroundings. *Oil Tanker and Gray Day*, 1974 (Fig. 104), illustrates the vessel small in the distance and delineated chiefly as an unpainted area of white paper, although there is one green shape on it. The expanse of ocean on which the ship moves was originally applied by spraying, a technique that lends itself perfectly to rendering clouds or water. However, the artist clearly worked over the sprayed areas with pastel used directly on a very wet surface or dipped in water, enclosing the tanker in a dreary gray. At the top edge of the gray are two bands, stripes, one black and the other red. Sometimes John Marin would symbolize forces in nature in his seascapes painted in Maine; for example the fog rolling in from the North Atlantic rendered as rectangles. Certainly Crown's stripes look nothing like Marin's. But Crown is one of those

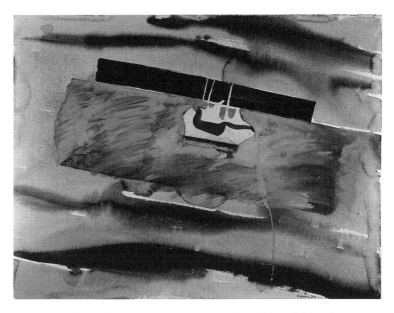

104. *Oil Tanker and Gray Day*, 1974, watercolor and pastel, 22 × 30.

artists who can study profitably the work of others and never imitate them.

Marin was an artist who, like Crown, had a great respect for nature, but he was never satisfied to imitate her appearance. Crown said about this particular painting, "It has what I want with unusual means. It has the real feeling of the kind of day; a kind of gray day, low clouds [and] they look like they might rain a little bit; and it's clear, crisp, cold bluish-gray light, but in my terms. I would rather be dipped in syrup than paint it blue-gray though it comes out gray. When I look at the painting it evokes for me that beach. I think it is an attractive painting of a rather *unattractive* subject."[46]

45. Tape 6.

46. Tape 10.

A more impressive example of this genre is the 1976 *Portrait of—Oil Tanker at Anchorage* (Fig. 105; the dash in the title is Crown's). This work is one signed twice to indicate that it can be looked at either as a horizontal or a vertical composition. In the picture's horizontal position the oil tanker seems to be painted in dark blues and reds, while its mirror image is rendered in much lighter values. The separation of ocean and sky is difficult to determine, not unusual for Crown's work. But a dark blue zone, running diagonally from left to right when the picture is hung as a horizontal, results in a crisp edge that reads as a horizon line.

Looked at vertically, the composition is considerably more abstract. What might be the reflection of the tanker seen horizontally now looks like a ghost image of the ship. This orientation relates to suspended mountains in the Taos pictures already discussed. There is also something of Taos in the way the artist treats the shore in *Tanker Anchored in South Bay* of 1974 (Fig. 106), clearly a tanker anchored in close proximity to the El Segundo Standard Oil Refinery. The stylizations of shapes on the beach and even the color call to mind Taos landscapes. And combining the tanker with the refinery is another way Crown approached this theme.

A 1977 watercolor titled *Tanker and Edison Plant* (Fig. 107) is a very impressive picture and seems to break the mold seen in most of the others. (We will see some related paintings from around the time when Crown had his second and last visiting professorship at the University of Illinois.) This watercolor is done in high-key colors ranging over near-white grays and pinks and pale yellows that turn into saturated yellows in parts. Like the 1976 *Portrait of—Oil Tanker at Anchorage*, seen horizontally, this work has the same daring diagonal sweep of a darker strip of water with two ships on it. But above, in the area one would ordinarily identify as sky, there is the specterlike image of another tanker. The schematic treatment of boats and the industrial complex, along with its high-key color, imparts to this painting a decorative character not to be discerned in many others of this theme. Crown, we recall, sees nothing wrong in decorative values.

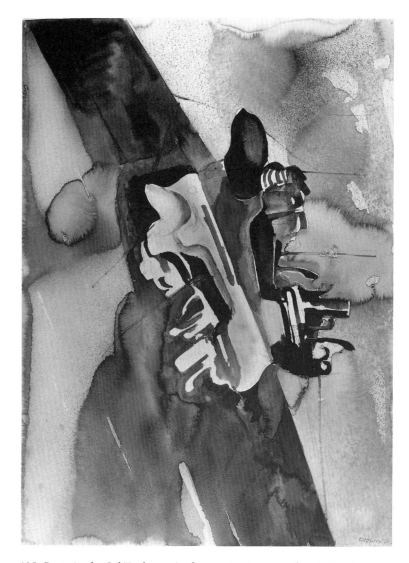

105. *Portrait of—Oil Tanker at Anchorage*, 1976, watercolor, 30 × 22.

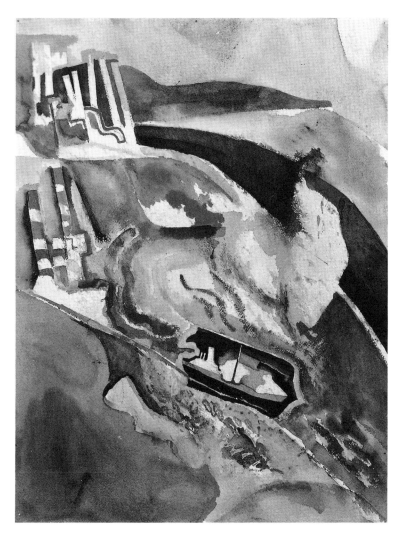

106. *Tanker Anchored in South Bay*, ca. 1974, watercolor, 30 × 22.

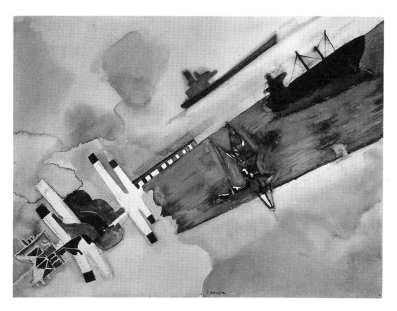

107. *Tanker and Edison Plant*, 1977, watercolor and pastel, 22 × 30.

The paintings of these oceangoing oil tankers, "tubs" as Crown sometimes refers to them, had a reality to the artist in their proximity to where he then resided. Speaking specifically about *Portrait of—Oil Tanker at Anchorage*, but generalizing from it, he explained, "It is a tanker anchored off Manhattan Beach. It was a problem to make it like a tanker, and to have the feeling of a tanker. They even have a smell when you're offshore. While I am standing looking out at it and the breeze is blowing [toward shore], you can smell oily rope and the oil and the trash, the whole thing. A tanker smell."[47]

A theme that first appeared in Crown's work in 1975 is the Los Angeles International Airport. "I did a lot of [paintings] of the airport. I paint what's there. [My house in Manhattan Beach] is about four minutes from the L.A. airport. The airport is right next to El Segundo and El Segundo is where those big oil refineries are. The airport is right there, and there is a beautiful place to go that overlooks the airport."[48] Crown described

47. Ibid. 48. Tape 6.

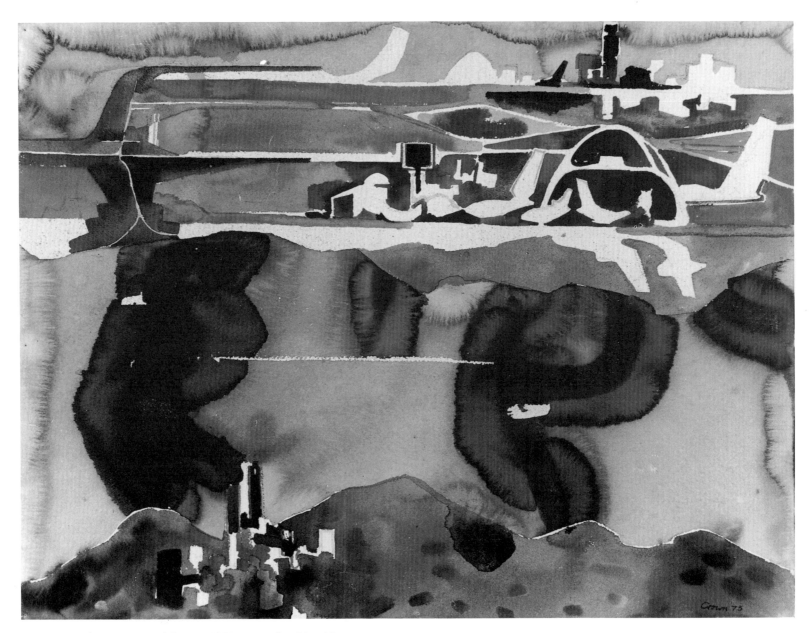

108. *Los Angeles International Airport*, 1975, watercolor, 22 × 30.

his favorite locale for painting the airport as "a hill with a public parklike overview of busy LAX I paint there. I also paint at several other sites closer to the landing strip."[49]

Crown did not concentrate his efforts on the landing and taking off of the jets but instead focused on the large sprawling terminal itself (see Figs. 108, 109, 110). It is quite possible that no other artist of Crown's stature in Los Angeles considered the airport suitable subject matter. Thus, in a very real sense, his choice of motif—the El Segundo Refinery, the Hyperian Sewage Plant, and oil tankers—was at least as radical as his style. An insight into the artist's sense of the suitability of such a subject as the Los Angeles airport can be illustrated by a statement written in a 1972 sketchbook. "Design," he wrote, "must make of material . . . something fresh and strikingly stimulating. The imagination and sensibilities of the artist must see the subject from the artist's own personal knowledge of all that will be part of that painting." He verbally related that when some watercolors of the airport were exhibited, a well-known Los Angeles art critic said they were like industrial designs rather than paintings. Crown thought the comment was bizarre since the element of "industrial design" was inherent in the design of the terminal itself, and was in fact what he was after in the painting.

In my judgment, the airport paintings are stronger than those of the oil tankers and equal to the very impressive representations of the El Segundo Refinery and the Con Edison Plant. It is possible that the airport pictures are so fine because the airport itself is a subject of greater complexity and richness than the tankers. Certainly there is also the factor that Crown was never aboard an oil tanker but had used the airport many times. In such strong paintings as the 1975 *Los Angeles International Airport* (Fig 108) and *LAX II* dated the spring of 1977 (Fig. 109), the terminal buildings are negative, unpainted portions existing in a darkly painted somber milieu because he was "trying to get the pollution [in] the L.A. environment."[50]

Both watercolors reflect and emphasize the fact that the Los Angeles airport looks like an elaborate set for a science-

49. Tape 10. 50. Tape 6.

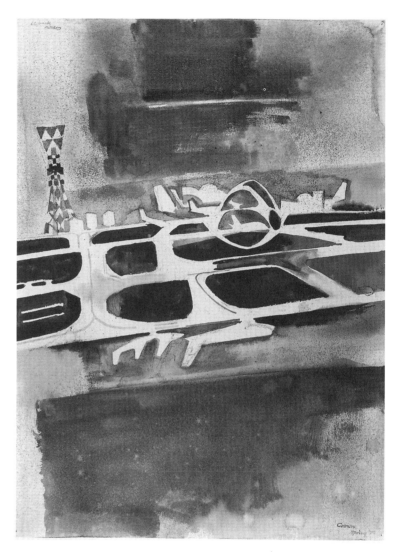

109. *LAX II*, 1977, watercolor, 30 × 22.

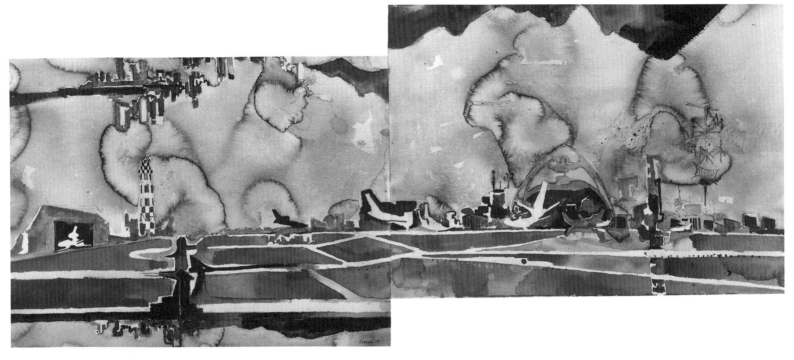

110. *LAX*, 1975, watercolor, 28 × 60.

fiction film. In addition, the 1977 painting introduces a variation on Crown's interest in variable orientations for a single picture: This one is strictly a vertical, but either edge can be the top. Once again, Crown transmitted that fact by signing and dating the work both top and bottom.

Crown was aware of the architectural tackiness of the airport terminal but enjoyed depicting the docked aircraft with their giant tails rising over and around the terminal like petals of a flower.[51] The airport is a compelling subject for the contemporary artist. Baudelaire in 1845 had suggested that the artist must "seize what he found to be the epic, heroic qualities of

51. Tape 10.

modern life."[52] While Baudelaire was not referring to airports, Crown's choice of such a subject seems to be close in spirit to the poet. Crown stated that the airport is "certainly a subject that Cézanne or Van Gogh couldn't do because they didn't have an airport. [The airport] is a *subject of our time*"[53] (emphasis added).

Crown's exploration of the Los Angeles airport coincided with his renewed interest in unorthodox formats and very large paintings. In terms of scale, Crown explained, "I have always

52. Robert Rosenblum and H. W. Janson, *19th-Century Art* (New Jersey: Prentice-Hall, 1984), p. 279.
53. Tape 6.

done a few outsized watercolors when I felt the need of more elbow room for projecting my ideas. Also, I've been curious as to whether watercolors of extreme size would become too attenuated for me."[54]

Another watercolor titled *LAX*, this one from 1975 (Fig. 110), is an example of one of those "outsized" watercolors—a painting consisting of two separate sheets of paper that together measure twenty-eight by sixty inches. There are others that reach eight or nine feet wide. Crown's usual procedure is to mount these multiple sheets on a canvas. Large single sheets of watercolor paper are available now, but Crown most often remains with this system of making up a composition out of several sheets. For one thing, his attachment to piecing pictures together gave him the opportunity to invent unusual formats. We have already noted the inverted T-shape of the 1974 *Rosecrans Boulevard*; in *LAX* he links the two halves in a staggered fashion, as the illustration clearly shows.

Thus, the desire for more room and unusual formats explain these large works. To put these concepts in perspective, it should be noted that such pictures are relatively rare in Crown's oeuvre. A note to himself in a 1979 sketchbook states unambiguously, "The size of a painting is not its casual outer dimensions. The size of a painting is its inner scale; and that scale can be—should be—poetic."

Before leaving the Los Angeles paintings (and soon Crown himself was to move to Columbia, Missouri) we might look at one more example titled *Baldwin Hills, Los Angeles* painted in 1980 (Fig. 17). Its most prominent feature is an oil pump. Also included are power lines and the towers that support them, telephone poles carrying their wires, and a wide boulevard cutting diagonally across the foreground with its divider lines clearly included. At the lower right is a sudden reversal—some telephone poles and a hill are upside down. The watercolor is a perfectly orchestrated composition, a composite of Baldwin Hills held together by an intersecting network of lines (wires), geometric forms (power and telephone towers), the

oil pump looking as always like some strange, enormous bird, and the daring of that road with not a car on it. It is Los Angeles abandoned!

Baldwin Hills, Los Angeles is a fine example of how complex in terms of space and time Crown's work has become. In the following statement, the artist was not referring specifically to this 1980 painting, but his words will help to demonstrate that his art is hard work. "It takes quite something to put all that material together into a picture that goes together and has unity. Because I was taking material from all around and it was a vast area. I had to collate all of that into a painting. It is a difficult problem."[55]

Compared to the sea level of Los Angeles, beautiful beaches adjacent to sewage plants, electrical generating complexes, smelly oil tankers and dirty air, Taos provided a perfect foil with its high altitude, clean air, and magnificent countryside. Claire Morrell described, in part, the sheer beauty of Taos. "But it is the great northern skyline of the Sangre de Cristo mountains that sets the drama of the Taos scene, a skyline the first startling sight of which, as one comes out of the [Rio Grande] river's canyon onto the high plateau, has sent many a sophisticated traveler into an effluence of admiration. Here, on this desert shelf a mile and a third high, lie the three neighbouring adobe villages: the Indian pueblo of San Geronimo de Taos, the Spanish hamlet of Ranchos de Taos, and the Spanish-Anglo village of Fernando de Taos, the last known simply as Taos. The mountain range, an abstraction in pyramids, soars nearly seven thousand feet more above the mesa, circling to the east and south to partly enclose the cluster of hamlets."[56] No written description of that locale, no matter how fine, can prepare a visitor adequately for the breathtaking beauty of northern New Mexico.

That Keith was captivated by the splendor of nature in the Taos vicinity is clear in a letter he wrote me dated 13 No-

54. Letter to author, 13 November 1981.

55. Tape 6.
56. *A Taos Mosaic* (Albuquerque: University of New Mexico Press, 1973), p. 3.

vember 1982. "Taos was seemingly more beautiful than ever. The weather there under ordinary circumstances is remarkable. The past two months were all days of extremes: brilliant light, and deep darkness, mind bending gales, and absolute stillness; large separate rain-drops; fine, separate pellets of snow. A primitive smog, of wood smoke, hovered above the old village many mornings, and a layer of wintery clouds divided the peaks from the base." His love of this place is ambiguous at times. In this same letter he concluded, "I'm always caught between a desire to get the hell out of there, and a great affection for the old village, and wish to stay forever."

The great success of his work in Taos in 1972 did not preclude Crown from matching or surpassing his efforts of that earlier time. A watercolor he estimates was created about 1974, *Ranchos de Taos* (Fig. 111), uses some of the brilliant devices crafted in 1972: mountains suspended above the horizon line, or upside down, and schematic delineation of the architecture. (In this particular painting a simplified small-scale rendition of the famous Saint Francis church in Ranchos is identifiable.) Unmistakably, however, the dominating shape of this design is an enigmatic vertical form, swelling toward the top. This form is possibly an imaginative rendition of mountains and sky that evolved while the artist was working on the picture before the motif. (It is quite important to keep in mind that no matter how abstract Crown's paintings are, they are almost never studio productions.) A very similar shape appears in a watercolor dated 1977, *The Sangre de Cristo Mountains and Ranchos de Taos* (Fig. 18; because this watercolor is dated 1977, I think the *Ranchos de Taos* watercolor might be later than Crown remembers.) The specific feature of both is a bilateral symmetry having no immediate identity with the landscape itself. We have seen very abstract Taos landscapes, and the very nature of the place seems made to order for an artist working in an abstract mode.

Georgia O'Keeffe is not an artist about whom Crown ordinarily speaks, but he did make an analogy between O'Keeffe's flower paintings and his shapes in these two watercolors. His

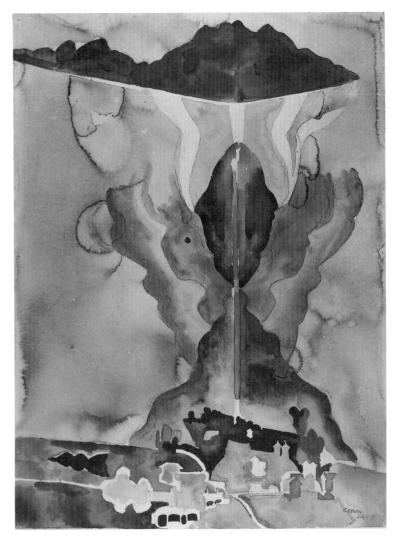

111. *Ranchos de Taos*, ca. 1974, watercolor, 30 × 22.

analogy is based on his firm conviction that her flower paintings—those in which the flowers have been greatly enlarged—are symbols of female genitals.[57] (After all, Crown did tell us that he believes in the Freudian concept of sex underlying almost all human accomplishments, and his belief is a given factor in interpreting the use of such elements in his paintings.) Thus, the flowerlike shapes in *Ranchos de Taos* and *The Sangre de Cristo Mountains and Ranchos de Taos* seem to be quite deliberately evoked as vaginal forms. Crown is a sensual man and has a great fascination with the sexual imagery he sees inherent in the landscape; he occasionally carried it to the degree of including mountain shapes that suggest women in sexual postures.

Most of Crown's work is sexually neutral or at least so subtly sexual that the sexuality does not intrude in an obvious way. One example of the latter is the 1976 *Taos Farm* (Fig. 112), stabilized by being designed as a series of horizontal planes. To point out stability and calm in a work by this artist is to understand that we are speaking in relative terms. Except in some very experimental paintings of the sixties, Crown avoids geometry. (And even in this example of balance, there is an enticing little ballet of elements going on in the region of the sky.)

On the other hand, Crown could imbue his pictures with great dynamic energy that is anything but stable. For a brief time in the summer of 1976, Crown visited his daughter and her husband in Nebraska and while there painted one of his most dramatic and energetic works: *Farmland near Peru, Nebraska* (Fig. 113). This watercolor is still grounded in the colors the artist used when painting in Taos. Even in Los Angeles he could break the mold and paint something as exciting as the *Edison Plant and Wild Seas* (Fig. 114), executed not with the somber palette he reserved for so many of his industrial sub-

57. O'Keeffe has vigorously denied that interpretation from the moment it appeared in print in the twenties. Many years later, when I had the opportunity to spend a day with her in Abiquiu in connection with my research on John Marin, she was still unhappy with such interpretations.

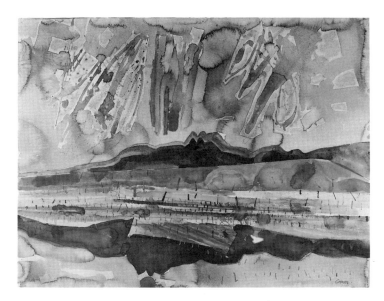

112. *Taos Farm*, 1976, watercolor, 22 × 30. Collection of Patricia Crown (daughter).

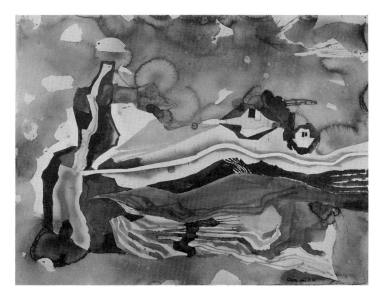

113. *Farmland near Peru, Nebraska*, 1976, watercolor, 22 × 30.

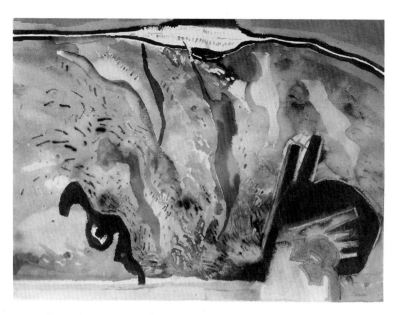

114. *Edison Plant and Wild Seas*, 1976, watercolor, 22 × 30.

jects but with a brilliant color range more typically found in his Taos works.

There is no doubt that Crown fits his own definition of an abstract artist. And so does Cézanne. Yet Cézanne declared that his objective was full penetration of reality. Crown, too, looks deeper than the mere surface of the landscape. To re-create the landscape's profounder dimensions it is necessary to change and distort what is there. He summed up this principle: "Some people are afraid to alter nature. I find this alteration takes me away from the natural arrangement, but it also gets much closer to it because I really get what I comprehended." [58]

Pursuing the issue of the relationship and balance between nature and art a bit further we can turn to Alfred Stieglitz, [59] who called photographs he was making of sky and clouds *Equivalents*. That word is perfect for describing almost the entire body of Crown's art, and, in fact, he used it himself in describing his color choices. Wishing to avoid color clichés, he sought "insights into the nature of the place I'm painting. The foliage may be green, but what other color is present in the green to give it its particular character? What can I employ instead of the commonplace, the obvious color, to achieve an *equivalent* that is unexpected, dramatic, poetic" [60] (the emphasis here is Crown's).

In the school year 1977–1978 Crown once more joined the faculty at the University of Illinois as a visiting professor. After the brilliant results of 1970–1971, he felt let down by his artistic accomplishments during the second visit. "I was really glad to get back to Illinois, because I enjoyed it though I was in a lesser mood [than during the first visit] and at the end of a cycle." [61]

Crown's feeling has some justification in fact. For a num-

58. Tape 8.

59. See Sue Davidson Lowe, *Stieglitz, A Memoir/Biography* (New York: Farrar, Straus & Giroux, 1983). Also see Dorothy Norman, *Alfred Stieglitz: An American Seer* (New York: Random House, 1973), and W. I. Homer, *Alfred Stieglitz and the American Avant-Garde* (Boston: New York Graphic Society, 1977).

60. Undated notebook. 61. Tape 6.

ber of reasons, he was less productive in 1977–1978 than he had been in 1970–1971. "I did less painting because I had exchanged jobs with an Illinois prof. this time, and I had more hours to teach, had all the other extra duties. Above all I had arranged the exchange to be near my beloved who was just starting teaching at the U. of Mo. So I had far less time to paint, and be consumed with painting problems."

Of the watercolors he did, many are not among his strongest efforts. For example, a farm scene of 1977 titled *Farm and Grain Elevator, Illinois* (Fig. 115) seems a weaker echo of the extremely fine 1970–1971 paintings of the soybean fields. *Farm and Grain Elevator, Illinois* along with *Designing a Road for Illinois* (Fig. 116; an enticing title), both dated 1977, are competent and expertly crafted works, but they lack that touch of genius present in so many paintings done in Los Angeles and Taos. Some of these later Illinois paintings may look too mechanical, as if, for example, the artist was substituting automatic responses for a greater personal engagement.

Nevertheless, he did paint several watercolors that year that rival his earlier achievements in Illinois. In a 1977 watercolor simply called *Illinois Farmland* (Fig. 117), the farm rests on a vertical wedge of land suspended in an abstract space that could be sky and clouds. Referring to this painting and several others closely related, Crown explained that he "was standing by a field in Illinois one day, and I was standing looking down the road so the line of the field went right straight down vertically. There was another edge of the field beside me that went off at right angles. You couldn't see the other right angle because it cut across on a diagonal; it curved enough so that you just saw a triangle and I started using that idea."[62]

This idea was responsible for one of the strongest of the works from this year in Illinois. *Illinois Farms—Winter*, 1978 (Fig. 118), represents a snow-covered landscape that gives the entire work a ghostly, chalky appearance not common in Crown's work. In the near-white ground is a relatively narrow

62. Tape 2.

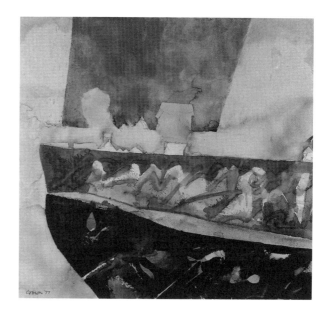

115. *Farm and Grain Elevator, Illinois*, 1977, watercolor, 22 × 30.

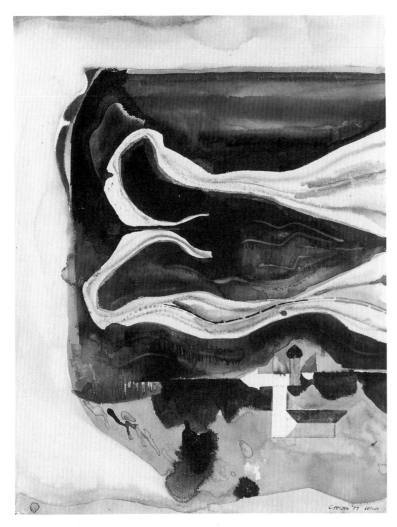

116. *Designing a Road for Illinois*, 1977, watercolor, 30 × 22. Collection of Haine Crown Gresser, Kensington, Md.

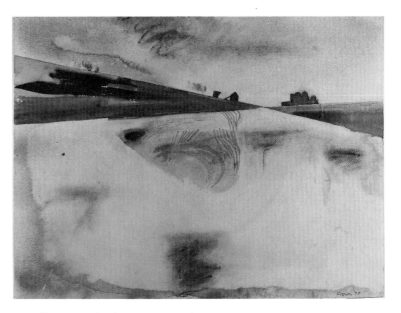

117. *Illinois Farmland*, 1977, watercolor, 22 × 30.

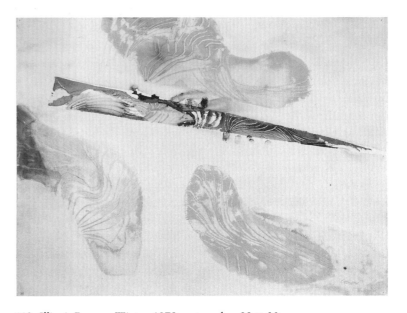

118. *Illinois Farms—Winter*, 1978, watercolor, 22 × 30.

wedge that is a diagonal—this is the farm down to the linear patterns that represent the plowed earth. But larger than the farm are three enigmatic, organic shapes with their own linear patterns. This painting moves as far toward pure abstraction as Crown is ever likely to go.

Stopping in Taos in 1977, Crown had time to paint such fine pictures as *Taos Pueblo II* (Fig. p. 1). At the top and bottom of this painting are two flag-like bands of color that symbolize the subject. Suspended from the top band, Crown drew the simple essentials of Taos Mountain upside-down. Drainage lines start on the mountain and, as in reality, descend to sustain the pueblo below. The soft lines of the ancient adobe building are carefully caricatured and then repeated, like a mirror image, upside-down. The whole of this makes an unusual decorative shape, the first true example of Crown's "flag" pictures.

At this time Crown also painted *Taos Canyon from Llano* (Fig. 119). In Los Angeles in 1980, we recall, he painted the strong and complex *Baldwin Hills, Los Angeles* (Fig. 17). At the same time he wrote to himself, "I have seen and done some very interesting things. I have traveled and lived many places on earth. I'm having a very interesting life."

It is not surprising that Crown, essentially a landscapist, admires the work of John Constable. Kenneth Clark wrote something about that great realist landscape painter of the nineteenth century that seems as if it could apply to Crown as well. Clark stated that Constable "recognized the fundamental truth that art must be based on a single dominating idea and the test of an artist is his ability to carry this idea through, to enrich it, to expand it, but never to lose sight of it, and never to include any incidents, however seductive in themselves, which are not ultimately subordinated to the first main conception." [63]

On a personal note, we can conclude this chapter with a 1979 statement written by Crown only for himself. "I am 61 now. There are still many hangers on of my generation, but the world we fashioned had a character now mostly changed. I move with the new, but I remember the old. I am one of those between two worlds—literally and figuratively—when I was a youth—life stretching infinitely before me—I did not often think I would some day be an old man. Youth never does. The thing unique about the generation change I'm experiencing seems to me to be that more than ever before the youth of today wants everything now—as if they are a special species—the young—and I was born old—always will be old. The old are the enemy. Take away the prerogatives of age—give them where they belong—to youth."

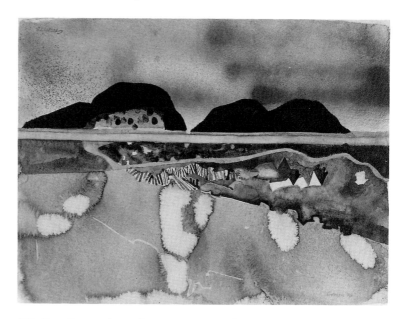

119. *Taos Canyon from Llano*, 1978, watercolor, 22 × 30.

63. *Landscape into Art*, p. 76.

4. Recent Work

In the opening years of the new decade Keith Crown created his last pictures of the environs of Manhattan Beach. In 1980 he painted *Manhattan Beach Pier with Palm Trees* (Fig. 120), giving this familiar subject a dark and mysterious mood; the ocean is transformed into a great pyramid against a somewhat sinister sky. Another 1980 watercolor, *El Segundo and Refinery* (Fig. 121), is a pyramid on a pyramid with a road leading down from the upper triangle—a landscape divided into two distinct shapes. In 1977 Pat Crown joined the faculty at the University of Missouri and was apart from Keith for long periods. Possibly these pictures reflect, metaphorically, that enforced separation.

There is nothing sinister or even sad about several interior compositions Crown created in 1980. Such pictures fit directly into a group of like paintings he had created over his entire career. If they differ, it is possibly in the degree of geometry they possess, especially the one titled *Crown Living Room* (Fig. 122). Indeed, this painting resembles synthetic Cubism more than any other Crown picture since about 1955. It was in 1980, as well, that he created a puckish self-portrait needed for a specific exhibition (Fig. 123).

Crown did not produce a large number of watercolors during Pat's short trip to England in 1980 to pursue research in eighteenth-century art. But the paintings executed in England in 1980—for example, *London from Lambeth Bridge* (Fig. 124)—appear more stately, more restrained, and, thus, more classical than most pictures from this same period. Yet there is a disquieting note in *London from Lambeth Bridge*; as in some of the Los Angeles landscapes of the same year, there appears to be something strange lurking just beneath the surface. This painting, with its restricted color range, communicates a sense of distress despite the easily recognized image of Westminster.

It is possible that Crown was struggling with himself as an artist; that he felt he had not progressed since the halcyon days of the sixties and seventies. In a letter dated 13 November 1981, Crown wrote he had fallen into "one of those dreaded slumps painters drop into occasionally that I have so aptly referred to as 'tight-assed' painting." A single example of a 1981 Taos watercolor vividly illustrates the artist's frustration. *From Ranchos de Taos* (Fig. 125) has all the components of a Crown painting but lacks any sense of life. This watercolor could almost be viewed as a pale echo of the brilliant paintings created in Taos in the seventies.

There is no question that Crown was concerned about his art in 1981. Yet as recently as February 1985 he observed that in "the last few years I've been thinking that I haven't noticed any real change in what I've been doing. And I wondered [if] that's the end; that maybe I've reached that point in my life where I won't have changes anymore of a large kind."[1] Crown even considered working in the mixed media of watercolor and pastel to recover some of the joy "of things I did in the summer of 1969."[2] However, as we will see, changes were taking place in his work. And, by 1982, as the pictures testify, he was no longer in a slump.

In 1975, with aid of Pat, his stepson, Paul, and his daughter Katie and her husband, Guy Webster, Crown had built a small house on his seven acres in Talpa, a village adjacent to Taos. From that point forward, where Crown would stay when in

1. Tape 12. 2. Ibid.

Taos was no longer a problem. A door was closing behind him in Los Angeles, and, though England was a place to visit, it was Taos that always refreshed him and motivated him to create some of his best work. In a letter dated 12 April 1983, Crown wrote, "Nature is my antidote: Where it has evoked subconscious imagery, let the iconography become a blend of cause and effect. And for the rest: Sufficient allusion to the familiar: To visual reality: Nature."

One of the fine and very strong watercolors from Taos in 1982 is *Talpa, near Taos* (Fig. p. 5). Some of the firm structure found in the English watercolor discussed above is apparent in this painting as well. The underlying geometry is not quite as obvious as in *London from Lambeth Bridge*, but it is present all the same. In Taos, Crown's color, as it always has, responded to the landscape itself but was heightened to intensify its effect. The Taos mountain is on its side facing itself at the lower left.

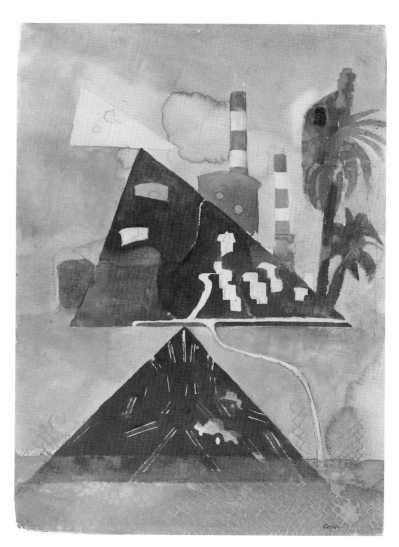

121. *El Segundo and Refinery*, 1980, watercolor, 30 × 22.

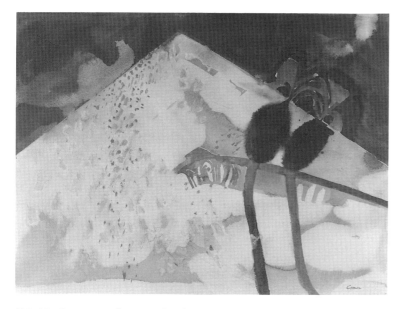

120. *Manhattan Beach Pier with Palm Trees*, 1980, watercolor, 22 × 30. Collection of John Barrett, Encinitas, California.

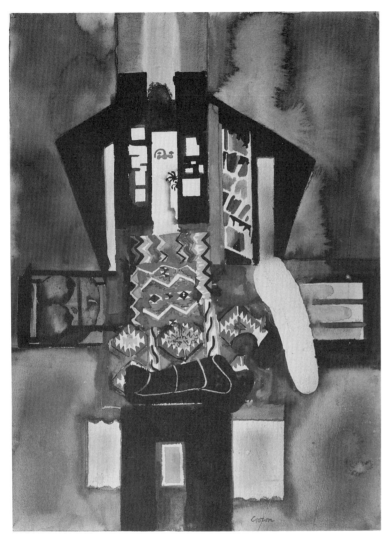

122. *Crown Living Room*, 1980, watercolor, 30 × 22.

123. *Self-Portrait*, 1980, watercolor, 22 × 30. Collection of Patricia Dahlman Crown, Columbia, Mo.

Between the two mountains a form suggestive of female genitals appears; so he has not abandoned the landscape as a sexual metaphor. He allows the architecture included in this vista to be symbolized as schematic, flat, white forms, almost as if they were miniature floor plans. And he employs the device of the bent horizon. Deliberately he manipulates the wet pigment so that it runs off both the top and bottom edges of the composition. Cryptically, Crown described this painting as "A virtuoso piece. Difficult. Fun to paint."[3] In a burst of joy he displaced the disquieting effect of some of the 1980 pictures.

The evidence suggests rather strongly that Crown was pushing himself to see the landscape in different ways. An example is the flat, decorative carpet treatment of *Fall—Taos—Orchard* from 1982 (Fig. 126). We must recall that, while Crown is a great admirer of Matisse and Milton Avery, he is

3. Notation in a slide list sent to me in 1984.

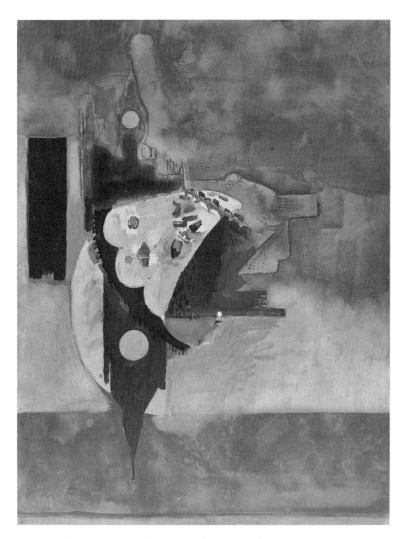

124. *London from Lambeth Bridge*, 1980, watercolor, 30 × 22.

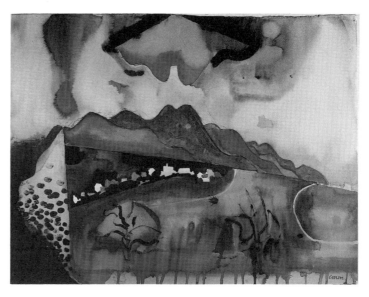

125. *From Ranchos de Taos*, 1981, watercolor, 22 × 30.

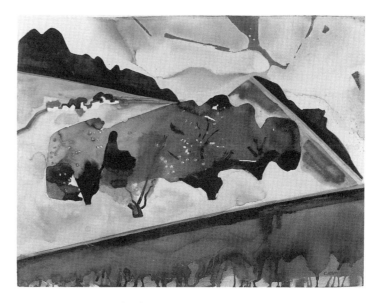

126. *Fall—Taos—Orchard*, 1982, watercolor, 22 × 30.
Collection of John Gordon, Los Angeles.

also a collector of rugs. Except for utilizing the dripping of the paint on the bottom edge, this watercolor is much simpler and more decorative than the *Talpa near Taos.*

Being in Taos in 1982 pulled Crown out of a depression caused by difficulties in his art. This conclusion can be readily documented in two letters that bracket that Taos stay. In the earlier one, dated 23 August 1982, the artist states: "I'm beginning to fret about not painting. It's nice in a way to sleep as long as one wishes, and generally loaf about, but the watercolors cease to pile up. . . . I am looking forward to attacking Taos again with brushes, etc." In a later letter, dated 1 November 1982, he reported: "I'm very happy with the twenty watercolors I've done over here so far. One idea that seems appropriate, and [one] I've enjoyed imposing on my paintings, is combining the conversion of houses into bi-symmetrical symbols of the architecture, [while multiplying the] number of edifices, impart[ing] an over-all effect suggesting a Navajo blanket design." The following entry was made in a sketchbook from 1979, but its ebullient meaning applies to 1982 as well: "By golly—the ideas are flowing like jaguar tits."

The same elements of adventure and pleasure resonate through the paintings from Taos in 1983. Several of the very best watercolors depict a field of wild sunflowers, a flower that was used as a subject by Van Gogh at Arles, and, even though Crown was not painting sunflowers as symbols of welcome for Gauguin, he saw them as emblematic of joy. We can look at two of the outstanding watercolors containing the theme of sunflowers—*Tres Orejas and Sunflowers near Taos* (Fig. 127) and *End of Summer near Taos* (Fig. 128)—and juxtapose them to Crown's explanation of how such a motif was selected by him. "Often I can see [a vista] is paintable—and many times what attracts me is the beauty of the scene. For example, there is a place where a whole bunch of sunflowers grow wild, and they are very beautiful now because all the petals are gone, and they just make these long, rather graceful stems with these dark seedpod things. And then you see a whole bunch of these; and you're looking through them as they go away and away; and

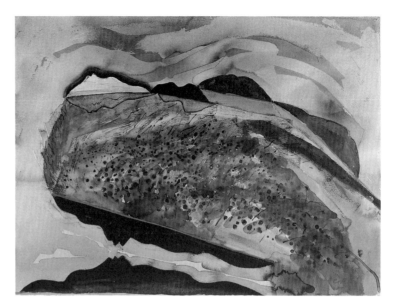

127. *Tres Orejas and Sunflowers near Taos*, 1983, watercolor, 22 × 30.

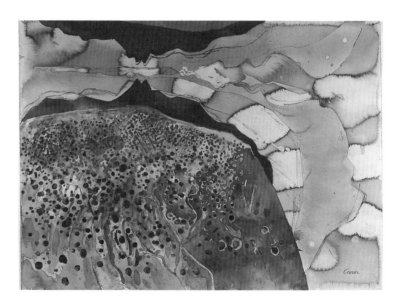

128. *End of Summer near Taos*, 1983, watercolor, 22 × 30. Collection of Mr. and Mrs. Robert Schmerl, Tucson, Ariz.

the whole thing makes a beautiful shape and I'm in it. God! They go up all around me and up against the sky and the pods are black against the sky . . . and visually to me it is a very, very beautiful thing. Many people confuse pretty with beauty, and I think beauty can be a scary thing but it has a kind of power and majesty. I don't think there is any relationship between pretty and real beauty."[4]

Crown's inventive powers were working again, and it was around this time that he produced more watercolors embellished with stripes on their top and bottom edges, on their side edges, or incorporated in the composition itself; and they look like flags. A good example of this concept is *Near Taos, New Mexico*, dated 1983 (Fig. 129). This particular painting has stripes on a diagonal to the bottom and the left in the design. The flag look is quite deliberate; he meant these stripes to stand for the landscape as flags stand for countries. "I use colors to represent, in a universal way, the scene I see, like a flag represents a country. I think that the colors used on the Mexican flag are tremendously appropriate and the red, white, and blue of the American flag is astonishingly perfect for our kind of culture and temperament."[5] A very accomplished version of this idea appears in the 1984 watercolor *The Flag of Talpa, New Mexico* (Fig. 19; see also Fig. 20). Here the left edge of the work contains blue, green, and orange stripes. However, the stripes are carried into the landscape itself—indeed into the mountain on the right side of the composition. As an artist, Crown offers the viewer a definition of flags built on insight rather than on science. But in the paintings themselves he does apply his carefully constructed scientific knowledge regarding color.

Crown's work took a decisive turn in 1984, but his life had taken a decisive turn in the late spring of 1983 when he took advantage of USC's generous offer to its senior faculty encouraging early retirement. The academic year of 1982–1983 concluded a teaching career that had begun thirty-six years before. Renting the Manhattan Beach house, he moved to Columbia, Missouri, where he bought a house and became no longer an

4. Tape 8. 5. Ibid.

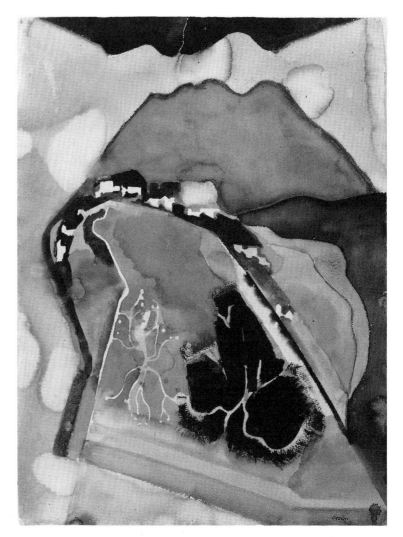

129. *Near Taos, New Mexico*, 1983, watercolor, 30 × 22.

official resident of Los Angeles. That fact still troubles him, since he is best known as an artist in Los Angeles; although he does still have a gallery affiliation there, he is concerned he will be forgotten.

From the beginning, the Missouri countryside simply did not appeal to him. (We will note that he turned that particular negative factor into a positive one.) Also, after having spent virtually his entire adult life in the mild climate of southern California, he was frequently prevented from working outside by the Missouri weather. Despite the pros and cons of the situation, he wrested some very good results in Missouri.

Quite naturally, after his wife joined the faculty at the University of Missouri in 1977–1978 Keith had visited her often and painted in Columbia and its vicinity. He spent evenings in an open studio set up by the art department pursuing his interest in figures (see Fig. 130). Crown had made prints very early in his career—the very first illustration of his extant work as a boy is an intaglio print (Fig. 32)—and he began once more. His chief vehicle for transmitting ideas, however, continues to be landscape painting.

Some measure of Crown's struggle with the uncongenial Missouri countryside can be gleaned by looking at *Winter Coming near Rocheport, Missouri* of 1981 (Fig. 131) and *Missouri at Easley* of 1982 (Fig. 132). Both of these watercolors show the artist wrestling with the unfamiliar terrain in two ways: First, he tries to render the Missouri countryside in his carefully developed landscape vocabulary. Thus, one finds upside-down hills and scenes with houses perched on a wedge of earth surrounded by sky on three sides. The striping on the latter watercolor could be thought of as of the genre of flag pictures. Second, the artist is allowing himself to respond more directly to the color and atmosphere of the locale, indeed exaggerating these to express *his* responses, and we note the color is very subdued, dour even.

Missouri at Easley and *Side Street Columbia, Mo.*, 1983 (Fig. 133), are, by Crown's standards, realistic. We recall him explaining that when confronted with new subjects the artist

130. Figure drawing from a sketchbook of about 1980, watercolor and pencil, 14 × 11.

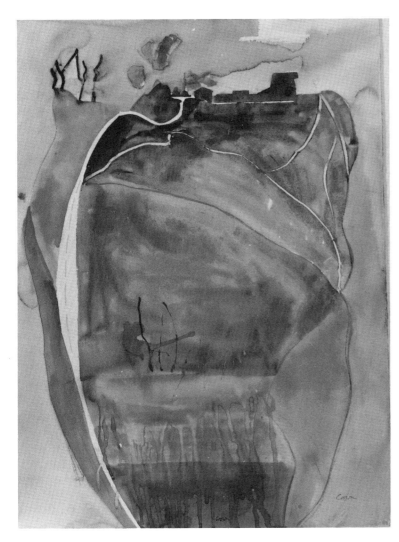

131. *Winter Coming near Rocheport, Missouri*, 1981, watercolor, 30 × 22.

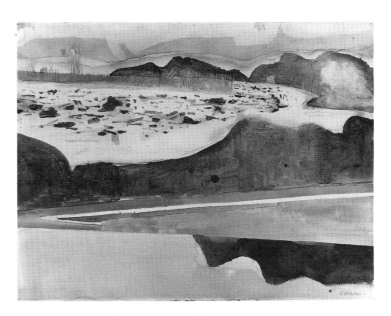

132. *Missouri at Easley*, 1982, watercolor, 22 × 30.

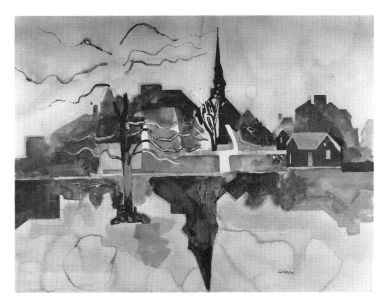

133. *Side Street, Columbia, Mo.*, 1983, watercolor, 22 × 30.

tends to fall back to a more representational position. The 1983 watercolor is a design quite stable and balanced, with the horizontal row of buildings and trees seemingly reflected in water.

Crown has been surprised by the favorable sales of his early Missouri pictures. The reason for such success undoubtedly lies in the fact that these paintings are tamer cousins of the wilder, more complicated ideas forged in California, New Mexico, and Illinois. However, in 1984 Crown achieved a major artistic breakthrough, and his work in Missouri will take its place as an equal partner with work done in New Mexico.

In a letter dated 16 September 1985, Crown stated: "Whether I want to or not, I am studying myself for signs of mental slippage in my late sixties. Ideas are still flowing spontaneously when I confront subject material. I'm taking on in recent years fresh subject matter, and additions and subtractions of painting material. These are all challenging phenomena that won't let my mind slip easily into sleep." It is in this way that the problems he experienced with the Missouri landscape became a positive factor. Painting the Missouri countryside was now a struggle that would help the artist keep intellectually agile.

To shake himself out of what he perceived as a rut, Crown turned to formal and technical problems. He was trying some oversized watercolors, he explained in a letter of 9 November 1983. These, however, were frustrating him: "Problems like how long to work in a single day, try to finish in one day's work. I felt rushed and frustrated."

A more positive result was achieved in another innovation. The artist began to take with him when he painted several juice cans with diluted color in each. "I take a very diluted color and I do a lot of brush work with that and I spray over that and the effects are astonishing. The spray of course not only lands on the part that I brushed on there, but it also lands on the outside around it."[6] This procedure, first worked out in Taos, is a significant factor in the change in the artist's more recent work.

Crown was "very excited about this technical invention. I was advancing on something that had been latent in my work, and suddenly I had started on a way of using it a lot as almost the backbone of a painting—*a way of communicating in a rather high key. Well that makes the color much more delicate*" (emphasis added).[7] Yet Crown was concerned that, for the very reasons emphasized in the above quotation, these watercolors could be interpreted as weak. We must remind ourselves that Crown defines the adjective *lyric* as meaning of lesser value. In his newer paintings "lyric" is not intended as a pejorative term; such a word is used to connote the enormous exuberance and subtlety they possess.

It would be a serious error to ascribe the changes occurring in Crown's art purely to technical innovation. Some suggestion of the 1984 work can be noted slightly earlier: in *Talpa, Vicinity of Taos*, executed in 1982 (Fig. 134), there is paler color in large areas of the painting in addition to a flattening of space. Conversely, *Talpa, New Mexico* of 1984 (Fig. 21) bears a strong resemblance to some work painted in 1982 and 1983. In *Chamisa* (Fig. 24), also from 1984, the new and the old converge. *Chamisa* has the exuberance of the new paintings, especially in its excited rhythms, but it maintains a sort of massive quality that points backward rather than forward. The icy blue color of the sky can be found in many of the paintings from 1984 and 1985.

It is possible to get a true sense of the accomplishments of 1984 in Taos by looking at three watercolors: *Taos and Taos Mountain* (Fig. 135), *Llano Quemado* (Fig. 22), and *Fields near Tres Orejas* (Fig. 136). *Taos and Taos Mountain* uses the lighter palette of this period, especially that cold blue. The massing of the landscape elements, however, calls on a monumentality Crown had arrived at in earlier pictures. On the other hand, *Llano Quemado* represents a sharp break from all the other works considered. The entire painting, with the exception of the almost black mountains, is done in the higher-key color of this time, and it is strikingly flat. Crown uses fa-

6. Tape 12.

7. Ibid.

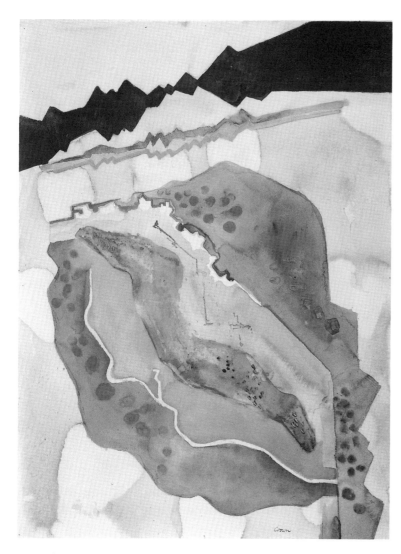

134. *Talpa, Vicinity of Taos*, 1982, watercolor, 30 × 22. Collection of Joan Teer Jacobson, Tucson, Ariz.

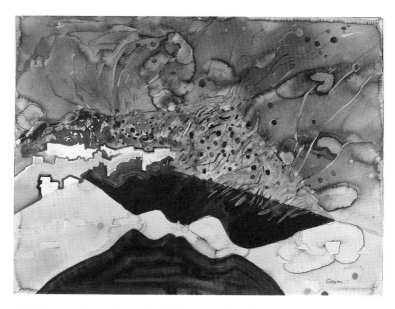

135. *Taos and Taos Mountain*, 1984, watercolor, 22 × 30.

miliar devices of sudden dislocation of space and shapes—with this new blue occupying the place in the center of the composition—and warmer tones in the sky. The checkered pattern on the left derives from a motif seen in Indian crafts. Crown accepts the idea that the checkerboard motif, familiar in Indian pots and rugs, derived from the experience of seeing the design made by different colored grasses in baskets. Thus this motif on the left of this watercolor is connected with the artist's interest in the arts of the Pueblo Indians. Unless one knows this fact, the pattern could be taken as arbitrary. But there are rarely arbitrary qualities in any of Crown's paintings.

As different as *Llano Quemado* appears, it is in *Fields near Tres Orejas* that the full impact in the evolution of Crown's work is felt. The solidity of forms is no longer a factor, so the monumentality of earlier work is replaced by many shapes, linear and calligraphic. In this watercolor the terrestrial zones of the painting consist of dancing brushstrokes. A calm light area

136. *Fields near Tres Orejas*, 1984, watercolor, 30 × 22.

appears over the mountain shapes, but it is very narrow. In the broader register of sky, the work is done mostly with spray.

There is no question that the result is lighter, more decorative, and alive in a way that has few parallels in his art earlier than 1984. More solidity without sacrificing this newly found delicacy is seen in *Tres Orejas in Fall* of 1984 (Fig. 23).

Allowing for different atmospheric conditions—for the altitude and the actual configuration of the countryside—the Missouri paintings enter the mainstream of Crown's art. Two splendid examples illustrate this: *Edgewood Avenue, Columbia, Missouri*, painted the spring of 1984 (Fig. 25), and *Farm near Easley, Missouri* of 1985 (Fig. 26).

The earlier watercolor is very close in spirit and form to *Fields near Tres Orejas*. Edgewood Avenue in Columbia is the street where Crown lives. "As you drive down the street where I live, there are big trees that come up and arch over this street— a narrow street—and it's a very beautiful thing. I liked the color of the leaves and they were there all fall and they are still there."[8] Crown did about six paintings of this theme, one reminding him of the American impressionist Childe Hassam. He criticizes a number of these Edgewood Avenue watercolors as being too realistic, and too lyrical. However, this example surely belongs with that group Crown called "really worked out, and I developed brushstrokes which go around to symbolize the trees way up above—they interlace—and you see through the branches the sky."[9]

Crown clearly desires to avoid painting pictures that are "lyric." In the 1985 work, *Farm near Easley, Missouri*, the contrast of values is greater than in the earlier painting, and the artist carves up the representational space in a more dramatic fashion. Part of the landscape sits on the bottom edge of the paper, sky is above, and more land is above the sky. In that letter of 16 September, Crown explained that he had once more picked up on the multiple-horizon concept—but with a variation he calls the "Interior Horizon." "Last spring (1985) painting in central Missouri . . . I was pondering the very hilly,

8. Tape 8. 9. Tape 12.

palisaded, forested Missouri landscape that masked the horizon from view. I began to perceive that as the land receded—flattened into the distance—there was in fact a very perceptible line at the foot of the hills, at the edge of the forests, at the bottom of buildings in that vicinity. I realized that this discernible line was the prelude to the actual horizon I could imagine a little above the former line, and behind the obstacles—hills, forests, etc. Since the line I discovered was just beneath the true horizon, and in front of the obstacles, it was within the landscape—an 'Interior Horizon.'"

Crown stated that the idea was employed in some of the paintings he executed in April and May 1985, while he was artist in residence at Bethany College in Lindsborg, Kansas. Two superb examples of the Kansas stay are *Lindsborg, Kansas, from Coronado Heights* (Fig. 27) and *Oil Pump and Wheatfield, Kansas* (Fig. 137). "If you study some of the [Missouri and Kansas] paintings you should," he instructed me, "notice that putting what is above the 'Interior Horizon' on the bottom of the paper, and what is below the 'Interior Horizon' being moved to the top edge of the paper is easy enough for me. [He had used the shifting horizons before.] A more serious problem aesthetically is the decision of what shape the juncture of sky, and landscape foreground shall take somewhere more central to the paintings."

While Kansas and Missouri in spring are different—and the colors and values in Crown's paintings emphatically reflect these differences—the paintings indicate that Keith has become interested in the question of texture, thus linking these works to the sensuous paintings of the sixties. Yet the texture now is deliberately rendered, not by painting around twigs and weeds placed on the surface, but to define representational elements such as waving cornfields and forested hills.

What lies beyond these works cannot be said. But some inkling of his plans is known. Crown has struck up a working relationship with the ceramist at Bethany College, Ray Kahmeyer, and Kahmeyer is making useful ceramic pieces that Crown then decorates directly from nature. The artist also plans to continue

137. *Oil Pump and Wheatfield, Kansas*, 1985, watercolor, 22 × 30.

his efforts in lithography and intaglio printmaking. Beyond that, he recorded in the same 16 September letter, "I've got five sizes of w.c. paper, and five different kinds (makes). I left a large four panel screen in Columbia because of lack of space [this letter was written in Taos]. I intend to do it in acrylics. I hope to get some ceramic sculpture [done]—I've about 20 lbs of clay." The artist, in addition, is exploring the possibilities of combining pastel and watercolor, but not to repeat what he did in the fifties and sixties. All of this hardly describes a man who is, to use his own word, "slipping." Keith Allen Crown's creative power and enormous energy remain intact.

In a letter posted from Taos on 24 September 1985, Crown took stock of where he stands: "My main thrust is the same. I had that very right from the beginning, and that won't change. But how I achieve it will be my steady companion to the end." In this same letter he said: "All that has changed is the accumulation of experience and knowledge. I feel no loosening of the power of strength of concentration—in other words I believe my painting is stronger by being more informed." He concluded on this note: "I'm being ever alert to some breakthrough idea."

In an article in *Southwest Arts* titled "The California School," Janice Lovoos deals exclusively with watercolorists of southern California.[10] Lovoos includes Phil Dike, Millard Sheets, Joan Irving, and Rex Brandt, and she concludes with this statement: "There are numerous excellent watercolorists in California whose work and teaching have influenced students, as well as tastes, through the years. But Dike, Sheets, Irving and Brandt jointly, represent all the qualities that have made the 'California watercolor school' important, vital and enduring." All the evidence, however, indicates that no list of major watercolorists of southern California, or of the entire the country, can be complete without including Keith Crown. Indeed, his artistic strength transcends medium. He is, in the American tradition, an artist who belongs to no specific school or "ism." Crown's talent and accomplishment mark him as an artist of uncommon quality.

10. January 1982, pp. 110–19.

138. Keith Crown's rendering of his artistic lineage.

Appendix

Writings of Keith Crown

Review of M. E. Chevreul, *The Principles of Harmony and Contrast of Colors and Their Applications to the Arts* (New York: Reinhold, 1967), reprinted from *The Art Bulletin* 51 (1969):408–9.

Micheal Eugene Chevreul (1786–1889) was born eighteen years before Delacroix and died a year after Josef Albers was born. The foremost expert of the period on animal fats, he isolated stearic and oleic acids. As superintendent of dyes of the royal manufactories at Gobelins he did the research that resulted in *The Law of Simultaneous Contrast of Colors*, published in 1839. A new edition, published by Reinhold, is based on the first English edition of 1854. Birren supplies a short biography of Chevreul, an introduction, and remarks which accompany most of Chevreul's text.

The book reminds one of extravaganzas produced by Hollywood in the thirties and forties that tried to overpower by sheer lavishment of extras and box-office names. The star in this one has become obscure, enduring though some of his credits are. His accomplishment appears to diminish steadily as knowledge of color and vision increases rapidly.

The new book is addressed primarily to the art market and intends that the art world should not forget its debt to Chevreul. It also informs us of the injustice done Chevreul by science, which today ignores his contribution to scientific study of light and vision. The book is generously packed with black and white and color (twenty-eight) reproductions, a portion of which are from an early volume by Chevreul, and some photographs of Chevreul by Nadar—the same Nadar who lent his studios for the first Impressionist exhibition. All of this is to the book's credit.

Amongst so much novel and visual richness there are also eight large color reproductions of paintings: *Sunday Afternoon on the Grande Jatte, Bedroom at Arles, Burning of the Houses of Parliament*, and the like—tired old veterans of myriad color illustrated books. Enlarged details of a Seurat, a stippled Monet, color juxtapositions in a Delacroix would have been welcome and more to the point.

Birren, who has had many books published on color, has a great fund of information which informs this volume. Unfortunately his excessive zeal in seeking credit for Chevreul brings forth some statements that cannot be confirmed. He displays also in his introduction what appears to be the old "sanity in art" prejudice toward modern art. He says, for instance (p. 33): "The Impressionists and Neo-Impressionists took all inquiry into color to heart and many became quite technically adept. Yet the day would come—the time of Fauvism, Abstract Expressionism, and other isms—when all disciplines would be rejected." The Impressionists and Neo-Impressionists *did* study Chevreul's theories and employ them, especially Seurat and Signac, favorites of Birren's. Signac in particular is oft mentioned, oft-quoted. This is the same Signac with whom Matisse spent the summer of 1904 in St. Tropez the year before the exhibition that established him and a group of young painters as the Fauves; the same Signac who purchased the Neo-Impressionist-influenced *Luxe, Calme et Volupté* which Matisse painted on his return to Paris after that summer; the same Signac whose Neo-Impressionist discipline is so apparent in the early Fauve works of that group. (Mrs. Michael Stein told me that Matisse said he felt forced to employ the Neo-Impressionist techniques by the proximity and persuasive personality of Signac that summer of 1904).

Other excessive and curious statements by Birron (p. 33): "Delacroix, however, had a high regard for Chevreul's principles and practiced them conscientiously" (p. 37); "Delacroix had religiously studied Chevreul. The Impressionists did likewise, but in a more intuitive way, after grasping the principles of the law of simultaneous contrast." Birren himself writes (p. 33) that "according to a story told by Paul Signac who once visited Chevreul, Delacroix had written Chevreul expressing a desire to talk over matters of color science. The painter was in ill health at the time and the meeting never took place." René Huyghe (*Delacroix*, New York, 1963, 343) says that while he was classifying files devoted to Delacroix in the Louvre he came across a notebook written by someone who had attended Chevreul's lectures. Huyghe speculates that these notes were used by Delacroix for areas of color exploration he was to undertake. None of this establishes anything approximating a "religious" or even conscientious interest in Chevreul's color investigations.

It is, alas, abjectly true that, valid and in use as some of Chevreul's discoveries are, science ignores his contribution, and Chevreul, if mentioned at all, occupies only an occasional paragraph or footnote in art books. While not history, nor precisely science, Josef Albers's *Interaction of Color* (New Haven, 1963) contains a chapter (VIII) entitled "Why Color Deception—After-Image, Simultaneous Contrast." Chevreul is not mentioned. And somehow it doesn't seem important. Birren himself says (p. 35), "Before Chevreul's time, however, other painters had in small or large measure discovered the vibrancy that could be achieved with divided or broken areas of color." This is true. The painters knew the unexplained; Chevreul explained the known. Chevreul's theories about vision and light have been revised, improved, and assimilated into the huge and rapidly growing body of knowledge about these subjects. And, if you insist, he does live on, for the average city or college art library contains an early English edition of *The Principles of Harmony and Contrast of Colors*, albeit rather obsolete amongst its twentieth-century companions of like subject.

From "The Watercolor Page," *American Artist* (October 1978): 44–47, 100–101, reprinted with permission from Billboard Publications, Inc. © 1978. All rights reserved.

There is an unusually even, speedy, unbroken line in certain of John Marin's watercolors. I was amused to read that this Master employed a medicine dropper to get those lines. A medicine dropper has proven useful to me in many situations, particularly for the removal of watercolor from a delicate, overloaded area. Conversely, I also occasionally use it to inject color into wet areas.

If ever I'm shipwrecked, I'll probably be found swimming to shore with a sketchbook—obviously, my most valued possession—in my teeth. A miscellanea of news clippings, quotations, recommended recordings, and addresses go into it—along with finished drawings. But the majority of pages are covered, front and back, with crude warm-up diagrams, my preparations for painting. As soon as an idea begins to form itself, I move to the watercolor paper so I won't leave my live thinking in the sketchbook.

Currently I sketch (on a Strathmore 11 × 14 sketchbook, Series 500) with a pencil dipped in water. Yes, a pencil. If necessity is the mother of invention, then accident is the father. Once while sketching—with a borrowed pencil (an All-Stabilo No. 8008)—an ancient Norman church in a fine English drizzle, I discovered the pencil dissolved in water and produced a dense black. I've been using it ever since.

I generally ease into painting by groping about a bit on the watercolor paper with vine charcoal. I've also used a reed dipped in color for this purpose, a pencil, and a small brush. The summer of 1969, however, I did an even 100 watercolors in Taos, New Mexico, using no preliminaries whatever except to contemplate the landscape before I began. (Incidentally, each of the paintings was at least partially done with a Badger airbrush, and some of them entirely so.)

For actual brushwork I like Grumbacher's one-inch and half-inch aquarelle red sable brushes very much. I use round red sables—No. 5 through 8—for finer definition. Generally these are not from one specific manufacturer but are selected for the length and springiness of the bristle—and their decency of price. I also use several sizes of synthetic-bristled brushes made for painting

with acrylics. These are tough brushes that will do things that would ruin a sable brush. I also use a sponge, which I slice into a variety of shapes. I paint with it occasionally, about as I would with a brush.

I use tube colors—large tubes—and, since Winsor & Newton is an old firm of good repute that puts out beautiful, transparent colors, I use that brand for the most part. From time to time, however, I find myself purchasing certain colors in other brands. I like to shop for colors because an unusual hue often motivates a painting. Currently my palette includes Winsor yellow, cadmium yellow pale, aureolin, aurora yellow, cadmium orange, cadmium scarlet, Winsor red, permanent rose quinacidrone, cobalt violet, Winsor violet, permanent magenta quinacidrone, manganese blue, cobalt blue, cerulean blue, French ultramarine, Winsor blue, Winsor emerald, cobalt green, oxide of chromium, Winsor green, yellow ochre, burnt sienna, light red, warm sepia, sepia, Davy's gray, charcoal gray, Payne's gray, neutral tint, lamp black, and Chinese white.

There may seem to be some repetitions in that list, but, while many pigments appear to be exact duplicates, each pigment and its binder are chemically different and will act differently in water and mixtures. These differences, like a calligraphic alphabet of chemical actions, give expressive breadth to my painting style.

I am a collector of handmade paper, most of which is cotton rag paper—although I have found a little of the now almost extinct linen rag paper. Generally the papers are of 140 lb. weight; a small amount is 200 lb. and 300 lb. Among the watermarks are Cotman, Fabriano, Whatman (extinct), and Grumbacher (by Fabriano). There are some 300 lb. linen rag papers from England and some 200 lb. cotton rag from India with no brand name. All sheets are 22 × 30. In addition to this collection of handmade papers, I have a lot of machine-made cotton, 140 lb. and 300 lb. Arches (22 × 30), and some 26 × 40 and 29 × 40 Arches, approximately 200 lb. and 300 lb., respectively.

I stopped stretching paper, because it pained me to see 5% of it, including nice deckle edges, vanish under tape. Generally I tautly attach dry paper to a Celatex board with eight large, straight pins. Even the heavy papers I use warp naturally during a painting—and I often make use of this phenomenon. To paint, I place my board on a folding "bridge" table.

A writer-painter friend, Peter Plagens, once asked me about my studio as we browsed in my garden. I remember stretching my arms upward and saying, "All out-of-doors is in my studio." The comment was meant to be amusing, but actually, for over 25 years, a Volkswagen van or equivalent has served as my mobile base of operations out of which—or in which, depending on the weather—I work. In short, I always paint directly from my subjects—generally landscape.

Non-subjective painting or pure abstraction is absolutely antithetical to my concept of art. It is to me, as Paul Klee said of virginity, "of no use." While I want my work to be unconventional and a product of considerable imagination, I also want it to have the impact one gets when confronted by truths—although I'm not speaking of truth as being Wyeth-like photographic imagery. ("The camera never lies," they say. It just doesn't tell the truth.)

In my tender, formative years I saw great works of art almost daily, especially of the Impressionists. To this day I still envision those good men struggling out to their motifs with great packs of equipment on their stout backs, so, with the same determined spirit, I go out on pleasant and rainy days, in freezing cold and extreme heat, strong winds and fog.

The strong physical evidence of weather in my work may be unique. I like this bridge between nature and man. Yet I am free *in* nature. My subject is before, behind, above, below, on all sides. I endeavor to make visible much that cannot be seen but is there. While I am specific about the light, it is the place—what is there: the patterns of reality—that, Rorschach-like, compels more personal imagery.

Around Champaign-Urbana, Illinois, the land is unusually flat and endless. The farm and grain storage architecture have a stark uniqueness and seem to stand smack on the horizon. The day I painted *Farm and Grain Elevator, Illinois* [Fig. 115], was bright, gray, and threatening. I tried to get that starkness into the fields and architecture, all of which I put afloat in the gray afternoon.

Nearest me the soil was dark with moisture, and wild plant life thrived. I defined the plants by painting muscular, dark strokes around them. Into this I plowed more wet color with the airbrush. A similar process was used for a vast field of unharvested corn at the top. Between these a pinkish field undulated suggestively. I used a slightly tilted plane of Davy's gray in the sky to define an after-image of buildings.

Two farmers nearby were burning debris—old fence posts and the like. The fires smudged as it began to rain. I let it rain on the painting a bit, then packed up, and headed home.

Luther Smith's photograph of me at work outdoors reveals a box with legs on which sits my palette. Most of my equipment is in that box, including sponges, scissors, razor knife, water can, stout pins, masking tape, atomizer, spray bottle, pliers, matches, clamps, drawing clips, string, nails, etc. It also contains the tool I believe has lent the most distinguishing character to my painting, besides my innovative imagination: an air tank, hose, and airbrush.

Paint sprayers were first developed for industry and meant for quickly covering large surfaces with a smooth coat of paint. The airbrush, developed specifically for commercial art, is for finer work and is a very flexible, controllable mechanism. No serious painter I know of has investigated sprayers or airbrushes, beyond conventional usage, for any latent potential as a painterly tool.

In 1947 I began bringing the then novel aerosol cans to my motifs. These were used with mixtures of Duco enamel and oil paint. I sprayed lines, spots, and produced wet-into-wet chemical reactions—similar to the way aerosol cans of paint were used by the "Vandals Graffiti School" from the '60s on.

In the mid-'60s I bought a Badger airbrush specifically for watercolor. What I had done with aerosol cans I applied to the Badger. Both performed closer to sprayers than airbrushes, and much of the best work I've done with watercolor employed the Badger, a simple, inexpensive mechanism—which I operate by attaching to my spare tire—that is easily repaired. Now I have the more refined and variable Paasche Airbrush VL3.

An airbrush filled with watercolor will spray on top of and through layers of paint. It spatters broadly and makes wispy mists. It makes distinctive lines, spots, and shapes. The airbrush cup loaded with clear water can plow a fine, light line through delicate or heavily painted areas.

One of the unique things I've done with the airbrush was to spray the different colors of a planned mixture, one by one, onto a wet area of clear water. In some places the mixture produced a lively, smooth color; in other places the colors of the mixture subtly dispersed. The overall effect is pearlescent. The background of *Taos Pueblo II* [Fig. 1] is an example of this method. Clear water was brushed on the background judiciously, leaving some dry areas. Onto this I sprayed, separately, red and blue.

It seems inevitable that to describe painting methods out of context with the act of painting will read like a bag of tricks, and watercolor more than any other medium attracts the slick performer. I don't believe, however, that clever performance is my message. I'd rather be dipped in chilled molasses than have it so.

Chronology

1918—Born 27 May, Keokuk, Iowa. His parents were living in Gary, Indiana, before he was born. His mother went to Keokuk to be with her family for the birth and returned with her infant son to Gary shortly afterward.

1936–1940—Attends School of the Art Institute of Chicago.

1940–1941—Instructor at Luther College, Decorah, Iowa.

1941–1945—Inducted into U.S. Army, 16 June. Serves with the 161st Infantry Regiment, 25th Division, in Pacific theater of war. Unofficial artist for the regiment and field correspondent for army weekly magazine *Yank*. In January 1945, while in Luzon, marries Helen Elaine Talle with William Walker serving as proxy. Honorably discharged in August.

1945–1946—Enrolls at the School of the Art Institute of Chicago under provisions of the G.I. bill. Completes academic requirements for a B.F.A. from Art Institute, at De Paul University, Chicago, downtown evening school. Has two separate exhibitions of his World War II works in the school and in the museum, both early in 1945.

1946—Joins faculty of University of Southern California in Los Angeles as an instructor of art.

1947—First daughter, Helen Elaine (Haine) born 21 November. One-man show at the M. H. de Young Museum, San Francisco.

1949—Becomes a member of the California Watercolor Society in August. Moves to Manhattan Beach. First one-man show in Los Angeles at the Fraymart Galleries.

1951—Daughter Katherine born 21 July. Visits Mexico with Edward Taylor prior to her birth. Trip stimulates a continuing interest in pre-Columbian art.

1953—Daughter Patricia born 20 October. Elected to Founding Board of Directors, Los Angeles chapter of Artist Equity. One-man show at the Los Angeles County Museum of art from during the war. One-man exhibition as Pasadena Museum of Art.

1956—Takes first sabbatical leave the fall semester. Goes with

family to Taos, New Mexico; stays about four months. Visits Paul Burlin in New York. Goes to Washington, D.C.—Helen's father a congressman from Iowa—and attends the inauguration of Eisenhower.

1957—Stops working in casein.

1958—Elected first Vice-President of the National Watercolor Society (then called the California Watercolor Society).

1959—Elected President of National Watercolor Society.

1960—Spends summer as Visiting Associate Professor of Drawing and Painting, University of Wisconsin at Madison. Has an exhibition there.

1962—Separates from first wife. Has one-man exhibitions in Los Angeles, San Marino, and Gainesville, Florida.

1963—Divorced by first wife.

1964—Takes sabbatical leave. Spends summer as Visiting Professor of Painting, University of Wisconsin at Milwaukee. Accompanied by Patricia Dahlman and her four-year-old son, Paul Kennedy. From Milwaukee they go to Williamstown, Massachusetts. Visit New York, Maine, and the Adirondacks.

1965—Painting titled *Taos* and dated '65 indicates he was in Taos. Loses over one hundred of his oil paintings through an act of vandalism.

1966—Marries Patricia Dahlman. They reside in Manhattan Beach with his stepson Paul Kennedy. Has a major one-man show at the Long Beach Museum of Art. Late this year, or at start of the next, begins to work with airbrush in watercolors.

1967—Is Visiting Professor of Painting, University of Calgary at Alberta, Canada, during summer.

1968—Is at University of North Carolina at Chapel Hill for the summer as Visiting Professor of Painting. Does not respond well to the North Carolina landscape. Gives lecture-demonstration at Pennsylvania State University at College Station.

1969—Book review of a new English edition of Chevreul published in *Art Bulletin*. Spends summer in Taos and produces 100 watercolors, 8 canvases, and a movie of himself at work. Pat in Europe doing research for her doctoral dissertation.

1970—Spends summer as Visiting Professor of Painting, Portland State University, Oregon. Buys seven acres in Talpa, New Mexico. Spends academic year 1970–1971 as Visiting Professor of Art, University of Illinois at Champaign-Urbana.

1972—Spends summer in Taos. Rents house near Andrew Dasburg.

1973—Takes a full-year sabbatical from USC. Accompanies wife to England and the Continent for an eight-month stay. Visiting Artist, University of Illinois, Champaign-Urbana. Visiting Artist, University of North Carolina at Chapel Hill.

1974—Spends summer in Taos.

1975—Builds house in Talpa. Gives lecture-demonstration at Louisville Art Center, Kentucky.

1976—Spends summer in Taos. Briefly visits daughter Katherine and her husband, Guy Webster, in Nebraska. Gives lecture-demonstration at the University of Oregon, Eugene.

1977—Spends summer in Taos. Spends 1977–1978 academic year as Visiting Professor of Art, University of Illinois, Champaign.

Pat Crown commences teaching in the fall at the University of Missouri-Columbia. Crown visits her often and starts painting the Missouri countryside.

1978—Spends summer in Taos. Gives lecture-demonstration at the University of Utah at Salt Lake City. Visiting Artist, Haystack Summer Art School, Portland State University at Cannon Beach, Oregon.

1979—Spends spring semester as Visiting Professor at the University of North Carolina at Chapel Hill. Gives lecture-demonstration at East Carolina University at Greenville, North Carolina.

1980—Does workshop for the Miami Watercolor Society, Miami Beach, Florida. Travels to England with his wife.

1981–1985—In Taos part of each year.

1983—Retires from USC at end of spring semester. Moves to Columbia, Missouri. Later designated Professor Emeritus of Art at USC. Visiting Artist, Atelier Gallery watercolor workshop, Santa Monica, California. Purchases a house in Columbia.

1984—Visiting Artist, Fairbanks Summer Arts Festival, University of Alaska.

1985—Artist in Residence, Bethany College, Lindsborg, Kansas.

Exhibitions

One-Man Shows

1945 Art Institute of Chicago
1946 Art Institute of Chicago
1947 M. H. de Young Museum, San Francisco
1949 Fraymart Gallery, Los Angeles
1951 Graywood Gallery, Manhattan Beach, California
1951 Hoagland Gallery, Manhattan Beach, California
1952 Santa Monica High School, Santa Monica, California
1952 Corona del Mar Art Gallery, Corona del Mar, California
1953 Stanford Research Institute, Palo Alto, California
1953 Oakland Municipal Art Gallery, Oakland, California
1953 Los Angeles County Museum, Los Angeles
1953 Pasadena Museum of Art, Pasadena, California
1954 Orange Coast College, Costa Mesa, California
1954 Palos Verdes Community Art Gallery, Palos Verdes, California
1956 Sirod Gallery, Los Angeles
1957 University of Southern California, Los Angeles
1958 Lighthouse Art Gallery, Hermosa Beach, California
1958 Streeter Blair Gallery, Los Angeles
1959 Santa Monica High School, Santa Monica, California
1959 Bakersfield College, Bakersfield, California
1959 Gallery of Drawings and Prints, Long Beach, California
1959 University of Southern California, Los Angeles
1960 University of Wisconsin, Madison
1960 Paul Rivas Gallery, Los Angeles
1961 Palos Verdes Community Art Gallery, Palos Verdes, California

1962 Marymount College, Palos Verdes, California
1962 Xanadu Gallery, San Marino, California
1962 University of Florida, Gainesville
1962 University of Southern California, Los Angeles
1963 San Diego State College, San Diego
1964 Eastern Oregon College, La Grande
1964 Plymouth State College, Plymouth, New Hampshire
1964 Comara Gallery, Los Angeles
1966 University of Southern California, Los Angeles
1966 Long Beach Museum of Art, California
1967 University of Calgary, Alberta, Canada
1967 San Bernardino Valley College, San Bernardino, California
1967 University of Massachusetts, Amherst
1968 Fleischer-Anhalt Gallery, Los Angeles
1969 Cerritos College, Cerritos, California
1969 Occidental College, Los Angeles
1970 Portland State University, Oregon
1970 Jacqueline Anhalt Gallery, Los Angeles
1970 Humboldt State College, Arcata, California
1970 Palos Verdes Art Museum, California
1971 University of Illinois, Champaign-Urbana
1971 Erie College, Painesville, Ohio
1972 Jacqueline Anhalt Gallery, Los Angeles
1973 Brand Art Museum, Burbank, California
1973 Center for Advanced Study, University of Illinois Champaign-Urbana
1973 Rosary Hill College, Buffalo, New York
1974 Jacqueline Anhalt Gallery, Los Angeles
1975 El Camino College Art Gallery, California
1976 College of the Redwoods, Eureka, California

1977 Jacqueline Anhalt Gallery, Los Angeles
1978 Museum of Fine Art, University of Utah, Salt Lake City
1978 University Art Collections, Arizona State University, Tempe
1979 Abraxas Gallery, Laguna Beach, California
1979 University Art Gallery, Virginia Polytechnical Institute and State University, Blacksburg
1979 Stables Gallery of the Taos Art Association, Taos
1980 Abraxas Gallery, Laguna Beach, California
1980 Davis Art Gallery, Stephens College, Columbia, Missouri
1981 Anraxas Gallery, Laguna Beach, California
1981 College of the Redwoods, Eureka, California
1982 University of Arizona Museum of Art, Tucson
1983 Atelier Gallery, Santa Monica, California
1985 Fine Arts Gallery, University of Missouri, Columbia (also shown were works of Patricia D. Crown)
1985 Birger Sandzen Memorial Gallery, Bethany College, Lindsborg, Kansas
1986 Ankrum Gallery, Los Angeles, California

Projected One-Man Shows

1987 Culver-Stockton College, Canton, Missouri, 26 March-21 April
1987 Retrospective Exhibit, Municipal Gallery of Art, Los Angeles, California, 11 August-13 September
1988 Quincy College, Quincy, Illinois, March

Invitational Exhibitions

1955 Santa Monica Art Association: *Some Artists of the Coast*
1956 Los Angeles Art Association: *Artists You Should Know*
1959 Pasadena Art Museum: *Artists of the Decade*
1965 Witte Museum of Art, San Antonio, Texas: *California Artists*
1966 Long Beach Museum: *Arts of California—Marine Painting*
1968 University of Texas, Austin: *Painting as Painting*
1968 Downey Museum of Art, Downey, California: *The Painting, Its Start and Growth*
1969 Doane College, Crete, Nebraska: *Second Invitational Exhibit*
1970 Rio Hondo College, Whittier, California: *Media 70*
1972 Chico State College, Chico, California: *Watercolor Invitational*
1973 Brand Museum, Glendale, California: *Four Watercolor Painters*
1974 Lang Art Gallery, Scripps College, Claremont, California: *The Lyric View*
1976 Springfield Museum, Springfield, Missouri: *Watercolor USA Invitational Exhibit*
1976 Museum of Fine Arts, Santa Fe: *Looking at the Ancient Land*
1980 Springfield Museum, Springfield, Illinois: *National Invitational Watercolor Exhibition*

Bibliography

Exhibition Catalogues

1965. *Selections from the Works of California Artists*. Witter Museum, San Antonio, Texas.

1965. *Marine Painting*. Long Beach Museum of Art, Long Beach, California.

1966. *Crown*. Long Beach Museum of Art.

1966. *Arts of Southern California XVIII: Watercolor*. Long Beach Museum of Art.

1967. *Crown*. University of Massachusetts, Amherst.

1968. *Painting as Painting*. University of Texas, Austin.

1976. *Watercolor USA*. Springfield Museum, Springfield, Missouri.

1978. *The Southern California School of Watercolor—1928–1978*. Fresno Art Center, California.

1979. *Keith Crown*. Abraxas Gallery, Laguna Beach, California.

1980. *Masters of American Watercolor*. Joslyn Art Museum, Omaha, Nebraska, and circuit.

1982. *Keith Crown—Watercolors 1944–1981*. University of Arizona Museum of Art, Tucson.

Books

Betts, Edward. *Master Class in Watercolor*. New York: Watson-Guptill, 1975.

Bromer, Gerald. *Transparent Watercolor: Ideas and Techniques*. Worcester, Mass.: Davis Publications, 1973.

Carhart, Mary. *Watercolor: See for Yourself—Subject Unit: Mountain Landscape*. New York: M. Grumbacher, 1983.

Goldsmith, Lawrence. *Watercolor Bold and Free*. New York: Watson-Guptill, 1980.

McClelland, T. Gordon, and Jay T. Last. *The California Style—California Artists (1925–1955)*. Beverly Hills, Calif.: Hillcrest Press, 1985.

Porter, Albert W. *Expressive Watercolor Techniques*. Worcester, Mass.: David Publications, 1982.

Reep, Edward. *The Content of Watercolor*. New York: Van Nostrand Reinhold, 1969.

Schink, Christopher. *Mastering Color and Design in Watercolor*. New York: Watson Guptill, 1981.

Articles

Crown, Keith. "Introduction." *Arts of Southern California XVIII: Water Color*. Long Beach Museum of Art, 1966.

———. Review of M. E. Chevreul, *The Principles of Harmony and Contrast of Colors and Their Applications to the Arts. Art Bulletin*, 1969, pp. 408–9.

———. "Watercolor Page: Keith Crown." *American Artist*, October 1978, pp. 44–46, 100–101.

Hazlitt, Gordon J. "Screams and Whispers." *Art News*, December 1974, p. 60.

Langsner, Jules. "Art News from Los Angeles." *Art News*, May 1957, p. 49.

McKinney, Robin. Review of exhibition. *Taos News*, 16 August 1979, p. B3.

Perkins, Constance. "Introduction." *Crown*. Long Beach Museum of Art Exhibition Catalogue, December 1966.

Plagens, Peter. Review of exhibition. *Art Forum*, February 1970, pp. 78–79.

Reich, Sheldon. "Keith Crown Watercolors, 1944–1981." University of Arizona Museum of Art Exhibition Catalogue, January-February 1982.

Weiger, Jay. Review of exhibition. *Olana Zlatnic Newsletter on the Arts*, March-April 1977.

Welch, Heloise. "Adventures in Rich Color." *Pasadena Independent Star and News*, 30 September 1962, Entertainment and Leisure Sec., p. 4.

Wilson, William. "Keith Crown's Works Shown at Occidental." *Los Angeles Times*, 16 November 1969.

———. "Art Walk." *Los Angeles Times*, 20 March 1970.

———. "Art Walk." *Los Angeles Times*, 21 April 1972.

Index